W9-BRE-872

Morristown Centennial Library
Regulations
(802) 888-3853
www.centenniallibrary.org
centenniallib2@yahoo.com

Unless a shorter time is indicated, books and magazines may be borrowed for four weeks, audio books on tape and CD may be borrowed for three weeks, and videos and DVDs may be borrowed for one week. All library materials may be renewed once for the same time period.

A fine of five cents a day every day open will be charged on all overdue library books and audio books. A fine of one dollar a day every day open will be charged for overdue library videos and DVDs.

No library material is to be lent out of the household of the borrower.

All damage to library materials beyond reasonable wear and all losses shall be made good by the borrower.

Library Hours

Sunday & Monday	Closed
Tuesday	9:30am – 7 pm
Wednesday	9:30am – 7pm
Thursday	10am – 5:30pm
Friday	10am – 5:30pm
Saturday	9am – 2pm

THE METROPOLITAN MUSEUM OF ART

The Renaissance in the North

THE METROPOLITAN

INTRODUCTION

BY

James Snyder

PROFESSOR OF ART HISTORY
BRYN MAWR COLLEGE

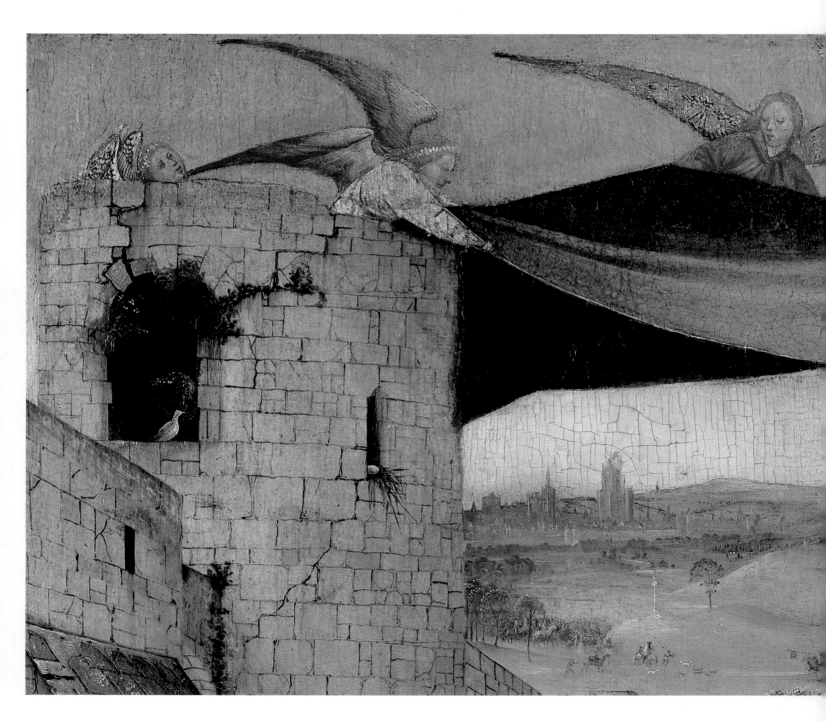

MUSEUM OF ART

The Renaissance in the North

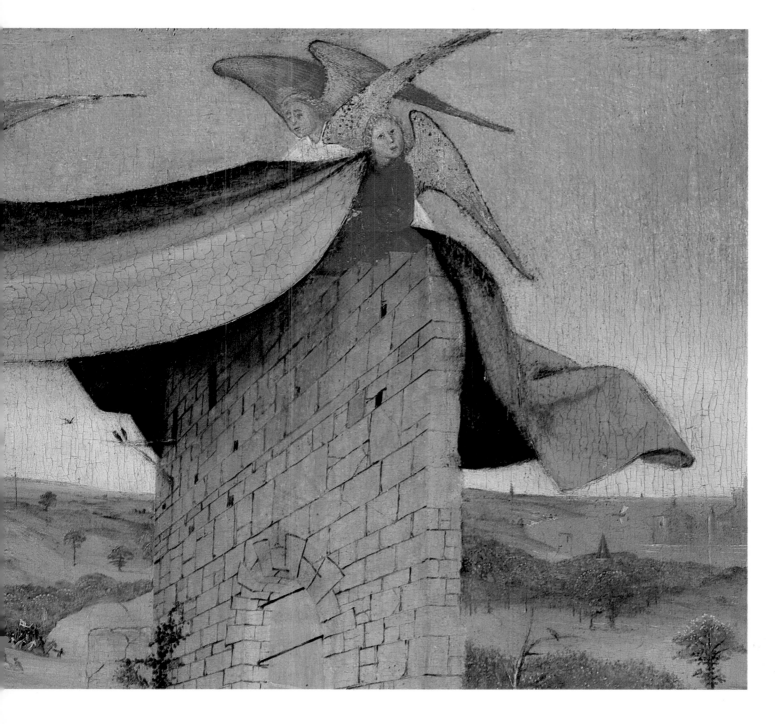

THE METROPOLITAN MUSEUM OF ART, NEW YORK

PUBLISHED BY

THE METROPOLITAN MUSEUM OF ART
New York

PUBLISHER

Bradford D. Kelleher

EDITOR IN CHIEF

John P. O'Neill

EXECUTIVE EDITOR

Mark D. Greenberg

EDITORIAL STAFF

Sarah C. McPhee

Josephine Novak

Lucy A. O'Brien

Robert McD. Parker

Michael A. Wolohojian

DESIGNER

Mary Ann Joulwan

———

Commentaries written by the editorial staff.

Photography commissioned from Schecter Lee, assisted by Lesley Heathcote: Plates 23, 24, 28, 39, 40, 42, 50, 53–55, 59, 72–76, 80–82, 86, 88, 90–94, 96, 100, 102–104, 106–109, 111, 113, 115, 116, and the image on this page. All other photographs by The Photograph Studio, The Metropolitan Museum of Art.

Maps and time chart designed by Irmgard Lochner.

TITLE PAGE

The Adoration of the Magi (detail)
Hieronymus Bosch
Flemish, act. by 1480–d. 1516
Tempera and oil on wood;
28 x 22¼ in. (71.1 x 56.5 cm.)
John Stewart Kennedy Fund, 1912 (13.26)

THIS PAGE

Cup and Cover, late 16th c.
Eberwein Kossman
German, 1575/76–d. 1584
Silver-gilt, 21⅝ x 7¾ in. (54.9 x 19.7 cm.)
Gift of J. Pierpont Morgan, 1917 (17.190.569ab)

Library of Congress Cataloging-in-Publication Data

The Metropolitan Museum of Art (New York, N.Y.)
 The Renaissance in the North.

 Includes index.
 1. Art, Renaissance—Europe, Northern—Catalogs.
2. Art—Europe, Northern—Catalogs. 3. Art—New
York (N.Y.)—Catalogs. 4. Metropolitan Museum of Art
(New York, N.Y.)—Catalogs. I. Snyder, James. II. Title.
N6370.M44 1987 709'.02'407401471 85-29691
ISBN 0-87099-434-4 ISBN 0-87099-435-2 (pbk.)

Printed and bound by Dai Nippon Printing Co., Ltd., Tokyo.
Composition by U.S. Lithograph, typographers, New York.

This series was conceived and originated jointly by The Metropolitan Museum of Art and Fukutake Publishing Co., Ltd. DNP (America) assisted in coordinating this project.

Copyright © 1987 by The Metropolitan Museum of Art

This volume, devoted to the arts of the Renaissance in Northern Europe, is the fifth publication in a series of twelve volumes that, collectively, represent the scope of the Metropolitan Museum's holdings while selectively presenting the very finest objects from each of its curatorial departments.

This ambitious publication program was conceived as a way of presenting the collections of The Metropolitan Museum of Art to the widest possible audience. More detailed than a museum guide and broader in scope than the Museum's scholarly publications, this series presents paintings, drawings, prints, and photographs; sculpture, furniture, and decorative arts; costumes, arms, and armor—all integrated in such a way as to offer a unified and coherent view of the periods and cultures represented by the Museum's collections. The objects that have been selected for inclusion in the series constitute a small portion of the Metropolitan's holdings, but they admirably represent the range and excellence of the various curatorial departments. The texts relate each of the objects to the cultural milieu and period from which it derives, and incorporate the fruits of recent scholarship. The accompanying photographs, in many instances specially commissioned for this series, offer a splendid and detailed tour of the Museum.

We are particularly grateful to the late Mr. Tetsuhiko Fukutake, who, while president of Fukutake Publishing Company, Ltd., Japan, encouraged and supported this project. His dedication to the publication of this series contributed immeasurably to its success.

Since its founding, the Metropolitan Museum has been the recipient of extraordinary gifts and bequests. Its collection of paintings, drawings, and prints from the Renaissance in Northern Europe has been enriched by such generous donors as Benjamin Altman, Jules Bache, George Blumenthal, Michael Friedsam, Mrs. Henry C. Goldman, Mr. and Mrs. H.O. Havemeyer, Robert Lehman, Jack and Belle Linsky, Henry G. Marquand, Junius Morgan, Felix Warburg, and Elisha Whittelsey. The Museum's collection of sculpture, decorative objects, musical instruments, and arms and armor of the Northern European Renaissance has been augmented by the gifts of, among others, Crosby Brown, the Hearst Foundation, Ogden Mills, J. Pierpont Morgan, Irwin Untermyer, and R. Thornton Wilson.

In addition to gifts of works from these donors, special purchase funds have enabled the Museum to acquire works on its own. Among these are funds established by Harris Brisbane Dick, Isaac D. Fletcher, Mrs. Stephen V. Harkness, Maria DeWitt Jesup, John Stewart Kennedy, Joseph Pulitzer, and Jacob S. Rogers.

In order to present the most comprehensive picture of Northern European Renaissance art as it is represented at the Metropolitan, the editors of this volume have drawn on the collections of several of the Museum's curatorial departments and on the expertise of their staffs. For their help in preparing this volume, we are particularly grateful to Guy Bauman of the Department of European Paintings, James Draper of the Department of European Sculpture and Decorative Arts, Janet Byrne of the Department of Prints and Photographs, Helen Mules of the Department of Drawings, Helmut Nickel of the Department of Arms and Armor, and Laurence Libin of the Department of Musical Instruments. Their help in reviewing the selections, photographs, and text was invaluable.

Philippe de Montebello
Director

THE RENAISSANCE IN THE NORTH

In the history of European culture, Renaissance (rebirth) has a special meaning, referring to the period of the grand florescence of the arts in Italy during the fifteenth and sixteenth centuries. The Italian Renaissance was stimulated and enriched by the revival of the classical art forms of ancient Greece and Rome. North of the Alps, the arts had reached a zenith a century earlier in the Gothic—the antithesis of the classical—with spiritual roots in the dynamic expressionism of the arts of the obscure nomadic tribes that swept into Europe from Asian hinterlands in the first millennium. And yet, even after the period of its Gothic glory, a golden age of art flourished during the fifteenth and sixteenth centuries in the North, in many ways as splendorous and revolutionary as the Renaissance in Italy. A true renaissance has usually been denied the Gothic North if only for the fact that the revival of the antique was not initially part of this development. But terms are deceptive, and perhaps one should seek out the basic differences in the arts of the North and South in the impressions of a contemporary authority on the Italian Renaissance, Michelangelo Buonarroti. The following discourse between the illustrious Florentine artist and a patrician lady, Vittoria Colonna, was recorded by a Spanish connoisseur, Francisco de Hollanda (*Dialogues on Painting*, 1548):

And smiling, she said: I much wish to know, since we are on the subject, what Flemish painting may be and whom it pleases, for it seems to me more devout than that in the Italian manner. Flemish painting, slowly answered the painter, will generally speaking, Signora, please the devout better than any painting of Italy, which will never cause him to shed a tear, whereas that of Flanders will cause him to shed many; and that not through the vigor and goodness of the painting but owing to the goodness of the devout person. It will appeal to women, especially to the very old and the very young, and also to monks and nuns and to certain noblemen who have no sense of true harmony. In Flanders they paint with a view to external exactness of such things as may cheer you and of which you cannot speak ill, as for example saints and prophets. They paint stuffs and masonry, the green grass of the fields, the shadow of trees, and rivers and bridges, which they call landscapes, with many figures on this side and many figures on that. And all of this, though it pleases some persons, is done without reason or art, without symmetry or proportion, without skillful choice or boldness, and, finally, without substance or vigor. Nevertheless there are countries where they paint worse than in Flanders. And I do not speak so ill of Flemish painting because it is all bad but because it attempts to do so many things well (each one of which would suffice for greatness) that it does none well.

Michelangelo's critique of Flemish painting seems harsh indeed, but his censures are cogent and exacting. His observations, it seems, were directed to the arts of the two leading Flemish painters of the fifteenth century—extolled by most Italian writers—Jan van Eyck and Rogier van der Weyden. It was Jan van Eyck who was famed for his exacting and detailed reproduction of the real world—his "microscopic-telescopic" realism, as art historian Erwin Panofsky has so aptly termed his style—whereby textured stones of buildings, glistening gems on garments, and bright landscape vistas capture our attention immediately; and it was Rogier van der Weyden who invented the tear in Northern art, an emotional expressionism that evokes the empathetic responses of young women, monks, nuns, and "certain noblemen who have no sense of true harmony."

But there is much more to be gleaned from Michelangelo's criticism. He strongly condemned Netherlandish painting for lacking reason or substance, offering instead stories of saints about whom we can speak no ill. This is important, for here we encounter the idea of the sophisticated Renaissance artist elevated above the Northern craftsman, who attended only to minutiae and offered multiplicity, not formal unity, in his work. For Michelangelo, the concept and idea were of utmost importance, and a work such as Van Eyck's irregular assembly of discordant panels in the altarpiece of Saint Bavo cathedral in Ghent would have violated the Italian sense of order and formal unity. And Rogier's emotional actors, writhing figures of joy or grief, elicited a far less ennobling response in a viewer like Michelangelo, who sought harmony and order in art. In these respects, Northern art does strike one as being Gothic, even at this late date. The

Ghent Altarpiece is like some misshapen cathedral that just grew that way—Chartres, for example. Rogier's mourning figures seem hieroglyphs of sweet-sad medieval piety.

There is, however, a basic distinction between Northern and Southern aesthetics that may easily slip past our evaluation here. For the Italians, great art was mural painting; works to be viewed from a distance as a grand design enhancing a huge surface. The figures were actors posed on a distant stage, transmitting narratives by means of eloquent rhetorical gestures against illusionary backdrops. Northern painting, on the other hand, was intimate and personal and had its aesthetic basis in the delicate and diminutive Book of Hours to be held close to one's heart, to be scanned slowly for its intricate details, its gemlike finesse, its refined preciousness. It is no wonder that Flemish painting reminds us of miniatures, with diminutive figures scattered about in dollhouses or in tiny gardens, lacking the grandeur and monumentality of the frescoes of Giotto or Michelangelo.

Despite these fundamental differences, it is remarkable how developments in Netherlandish art paralleled those in Italy. Indeed, it is possible to discern phases in Northern painting similar to those of the Italian Renaissance. The prelude, comparable to the trecento in Tuscany (Giotto, Duccio), can be seen in the anticipation of the International Style illustrated by the exquisite miniatures of Jean Pucelle (Fig. 1). A Parisian active in the first half of the fourteenth century, Pucelle has, in fact, been called the "Giotto of the North." His tiny *Book of Hours of Jeanne d'Evreux*, painted around 1325–27, anticipates later trends, as do the frescoes in the Arena Chapel in Padua painted by Giotto in 1305. But the differences are noteworthy. Pucelle painted tiny, elfin figures swaying under capricious draperies of late Gothic style; Giotto fashioned massive, tactile bodies that exhibit true monumentality like stony blocks covered with sheets. Pucelle elaborated the margins with spirited grotesques and naturalistic details; Giotto omitted such distracting secondary features. Pucelle delighted in building a diminutive, intricate dollhouse (a device borrowed from Duccio), complete with an angels' gallery and a trap door for the Holy Ghost; Giotto simplified the setting to blank stage coulisses moved into place to sustain the big figures. And whereas the Northern miniaturist exploited details in the main picture and in the margins to offer secondary, often symbolic, footnotes to their story, Giotto presented a drama within one unified field. We are attracted to the discursive and precious qualities of Pucelle's miniature, but we respond with an immediacy to the broad, bold design of Giotto.

Nearly a century later, from 1413 to 1416, the Limbourg brothers, painters to Jean, duke of Berry, executed some of the most memorable images of the so-called International Style. Their *Très Riches Heures*, now in the Musée Condé in Chantilly, is known for the astonishing landscapes on the calendar pages and the elegant miniatures of the life of Christ and the saints. The mannered qualities of Pucelle's draped figures reach an ultimate sophistication in the Limbourgs' art, with courtly figures performing for their noble patrons, and in their miniatures the first signs of borrowings from Italian antiquity can be faintly detected. The brothers had traveled to Italy in the early years of the fifteenth century and had recorded, in sketchbooks, motifs and compositions they had seen there. Surely of Italian inspiration are the engaging rinceau borders framing the Annunciation in the *Belles Heures* of the duke, painted around 1410, a masterpiece in the Metropolitan collection.

FIG. 1
Book of Hours of Jeanne d'Evreux
(Annunciation)
Jean Pucelle
French, act. ca. 1320–ca. 1350
Tempera and gold leaf on parchment;
3½ x 2⁷⁄₁₆ in. (8.9 x 6.2 cm.)
The Cloisters Collection, 1954 (54.1.2)

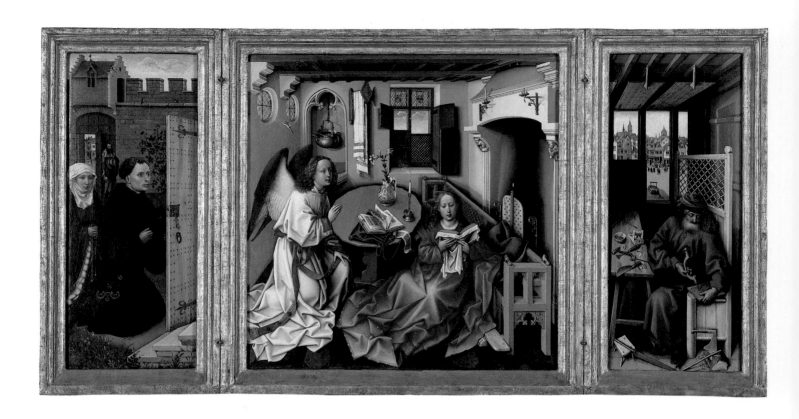

In the Burgundian provinces of Flanders, the developments in panel painting, the *ars nova* or new art, are directly linked to the accomplishments of the International Style, which preceded it. The courtly tastes of Pucelle and the Limbourg brothers were transmitted to later Flemish painters who worked for the courts, but the progressive tendency toward naturalism was exploited more by those artists who worked in the city guilds. They painted for the learned but rugged merchant class that was molding the economic and political life of the Low Countries into the bourgeois society that ultimately triumphed there. One of the most striking expressions of this new middle-class art is found in the *Mérode Altarpiece of the Annunciation* (Fig. 2), painted around 1425 by Robert Campin (ca. 1378–1444), a deacon of the guild of painters and a leading spokesman for the bourgeoisie in Tournai. This triptych not only preserves the rich color and elaboration of details inherent in the art of the miniaturists, but goes far beyond them in creating a natural world, filled with sunlight and atmosphere, that seems nearly tangible. Campin shows off his ability to create deep space by exaggerating the plunging perspective of the Virgin's living room. Campin's altarpiece is one of the earliest truly domestic Annunciations in Northern art. The chamber in which Mary humbly sits before a fireplace, reading her missal, is outfitted as a secular household complete with domestic trappings. Thus Campin has translated the Bible story into the vernacular by placing it in the everyday world: This is how the Annunciation would have appeared in fifteenth-century Tournai. Furthermore, Campin's angel and Madonna are robust peasant types, not elegant court figures, and two real people, the donor and his wife, kneel outside the open door of her room, observing the scene. Lest we forget the social milieu of Campin's art, Joseph, the husband of the Virgin, has abandoned his customary pose of quiet introspection, and is pictured at work as a carpenter in his shop; a true breadwinner for the family.

But Campin's realistic objects are also charged with loftier meanings, disguised but traditional symbols that add exciting comments to the simple narrative recorded in the Gospel According to Saint Luke. The wash basin and the towel hanging on the rear wall are symbols of Mary's purity; the snuffed-out candle on the tilted table and the tiny infant carrying a cross in the beam of light descending toward the Virgin inform us that the Annunciation is also the very moment of the Incarnation when the divine spirit infused human flesh, when God was made man within Mary's womb; and the coming of the Trinity is symbolized by the third bud of the lily that is about to blossom. Even Joseph's earthly profession as a guild carpenter is infused with higher meaning. In his shop window he displays for sale a mousetrap, a reference to his role as the bait to fool Satan on the momentous occasion of the Incarnation for, as Saint Augustine tells us, the marriage of Joseph and Mary was staged to deceive the devil just as mice are fooled by bait in a mousetrap.

At the same time that Campin completed the *Mérode Altarpiece*, Jan van Eyck was in the employ of the Burgundian duke, Philip the Good, in Bruges. There he enjoyed the life of a *valet de chambre* within the courtly pavilions, exempt from the restrictions of the guild and market. Van Eyck was as learned and cultivated as any Renaissance cour-

FIG. 2
Mérode Altarpiece of the Annunciation
Robert Campin
Flemish, ca. 1377–1444
Oil on wood;
central panel 25¼ x 24⅞ in.
(64.1 x 63.2 cm.),
each wing 25⅜ x 10¾ in.
(64.5 x 27.3 cm.)
The Cloisters Collection, 1956
(56.70)

tier; in fact, he was renowned for his knowledge of the arts and sciences, and served as a diplomat for the duke on several occasions. The great *Ghent Altarpiece*, a gigantic enterprise that involved the completion of panels begun by Van Eyck's older brother, Hubert, who died in 1426, was finished in 1432. Most of the paintings for the court, however, were of more modest format, although they all display the extreme refinement of Flemish realism, whose development is credited to Jan.

The unusual diptych, *The Crucifixion* and *The Last Judgment* (Plate 1), is an excellent example of the Eyckian style. Here Van Eyck displays his mastery of oil-based pigments, a technique often considered his invention. The ultrarefined detail and the enamellike finish of the paint applied in many superimposed glazes make the panel seem translucent and glowing. Here, too, we can understand what is meant by the phrase "microscopic-telescopic vision," for the details are so minute and the brush strokes so imperceptible that it is thought that Van Eyck painted with a hair brush, using a magnifying glass. The details of the distant landscape of Jerusalem are as crisp and complete as the robes of the figures in the foreground, and with his oil glazes Van Eyck achieved the effect of natural light spreading out across his deep landscape setting. Perhaps it was his delight in intricate detail that led him to compose the multifigured, historiated Crucifixion, with numerous pockets of interest packed into the tiny vertical panel. The panel depicting the Last Judgment is wondrous, with its myriad of infinitesimal forms —squirming masses of tiny demons, hybrid creatures of the most fanciful and intriguing varieties, that devour and attack the helpless sinners as they plunge downward beneath

the skeletal mantle of the grotesque image of death. Saint Michael wields his sword, driving the damned into hell, while above the stark horizon of land and sea, Christ sits majestically in judgment amid his heavenly court, which is arrayed in an orderly assembly against the crisp, blue sky. It was the Eyckian style that prompted Michelangelo to criticize Flemish painting for its excessive obsession with the "external exactness" of things, attempting "to do so many things well that it does none well."

When Jan van Eyck died in 1441, Rogier van der Weyden, a former apprentice to Robert Campin in Tournai, was enjoying the reputation of an illustrious city painter in Brussels. There, as a leading member of the painter's guild, he organized a large workshop that produced panels and altarpieces for the city as well as for noble patrons. No doubt Rogier learned much from his master—some of his early paintings were, in fact, formerly attributed to Campin—and from Jan van Eyck, but he fashioned a world that more fittingly responded to the tastes of the pious middle class. His work had an elegance and grace that epitomized the finest qualities of the late Gothic style, especially in the treatment of drapery and movement. At the same time, Rogier's art admirably fulfilled the needs of changing devotional patterns in a society given over more and more to the mystical precepts of the *devotio moderna*, or new devotion, that swept through the Netherlands in the fifteenth century. Although Rogier's world seems barren and abstract when compared to the richly textured and infinitely detailed pictures of Van Eyck, his genius lay in his incredible sense of design and emotional expression. His Madonnas are elegant ladies of high station who pose demurely; his donors are aristocrats with a certain aloofness and composure. In fashioning altarpieces for the new devotion, Rogier's inventiveness is especially apparent. He reduced complex narratives to abstract *Andachtsbilder* (contemplation pictures) by extracting the most poignant motif from the narrative context and isolating it in an iconic fashion so as to create one lasting emotional experience.

In a triptych devoted to the joys, sorrows, and glories of the Virgin (*The Altarpiece of the Virgin*, Staatliche Museen, Berlin-Dahlem), Rogier reduced the subject matter to three simple statements. The traditionally festive birth of Christ is distilled in the image of the young Mary adoring her newborn in a stagelike setting. The tragic anguish of the Crucifixion becomes a *Pietà*, based on a German sculpture group known as a *Vesperbild* (used for contemplation at evening prayers), with the Virgin again holding the body of her son, now lifeless, across her lap at the end of his earthly travail. The glories of the Virgin are epitomized in a rare depiction, *Christ Appearing to His Mother* (Plate 3), based on a mystic text that describes Christ's visit with the Virgin after his death to assure her of his triumph and resurrection. In the written version, Christ was accompanied by a host of angels and the redeemed from the Old Testament: Rogier reduces the touching farewell to the image of Christ and his mother alone in her chamber. This style of narration often assumed the appearance of a mystery play: Real people in the guise of biblical figures were placed before the worshiper as aids for mystical devotion through empathy. To enhance the the-

atrical effect in this work, Rogier painted a simulated proscenium arch that marks off the stage. Imitation sculptured voussoirs that carry diminutive stories from the later life of the Virgin complete the narrative. A tiny angel at the summit of the arch, who unravels a banderole informing us that Mary received the Crown of Life as the reward for her perseverance, is the visual equivalent of the player who extolled such virtues to audiences of the mystery plays.

ubsequent generations of Netherlandish artists were indebted both to Van Eyck and Rogier van der Weyden. Their styles—meticulous realism, on the one hand, rhythmic abstraction, on the other—form the poles between which subsequent styles vacillate. But it is not always easy to assess this assimilation. A good case in point is Petrus Christus, an artist who left his homeland in the northern Netherlands to settle in Bruges in 1444, three years after Jan van Eyck died there. Some have argued that Christus was the inheritor of Van Eyck's workshop, and that he completed some of Jan's panels; others maintain that Christus was initially drawn south by the attraction of Rogier's art. An unusual *Annunciation* in the Friedsam Collection of the Metropolitan Museum (Plate 2), for instance, has sometimes been attributed to Christus as a work of his early period when Van Eyck's influence was most marked. The work is definitely Eyckian in the meticulous treatment of the flora and the exacting perspective of the great Gothic portal—a reference to the Madonna as the church—seen from a high, oblique angle. On the other hand, *The Lamentation* (Plate 6), another painting certainly by Christus, clearly reveals the painter's debt to Rogier van der Weyden. The horizontal composition is a variant and somewhat reduced version of the famous *Deposition* by Rogier in the Prado. In addition to the influences of Van Eyck and Rogier, the influence of the artist's early training in the northern provinces is apparent in the doll-like treatment of the hushed figures about Christ's body, isolated clearly in space as if they were objects on a checkerboard in the expanded landscape background.

Deep space and immobile figures characterized the style of many painters from the northern Netherlands—regional differences perhaps due to their isolation from the flamboyant courtly tastes of the Flemish patrons. The foremost representative of these northerners is Dieric Bouts, born and trained in Haarlem, though later established in Louvain, one of whose earthy variations on Flemish Madonna types is represented in a small panel of the *Virgin and Child* in the Metropolitan Museum (Fig. 3). This northern Netherlandish style is also discernible in the *Adoration of the Magi* (Plate 8) by Joos van Ghent (van Wassenhove), thought also to have been a Dutchman who may have trained in Bouts's circle, and who settled first in Antwerp (1460) and then in Ghent (1464). The melodious interlocking of figures along the surface plane, so typical of Rogier van der Weyden, here dissolves into a loose, drawn-out composition; tall, puppetlike figures move hesitantly along diagonal axes into protracted space, toward the isolated Madonna and Child in the right corner. The subdued colors are due to the absorption of the pigments by the linen upon which the Adoration is painted, a rather unusual feature of this work. Soon after settling in Ghent, Joos became the sponsor of the great painter Hugo van der Goes, whose highly emotional paintings are some of the most expressive works executed in the Eyckian mode (see Plate 9). Joos then left Ghent to work at the court of Federigo da Montefeltro, duke of Urbino, taking with him his Netherlandish style. His Italian patron was greatly impressed by the Northern manner and, according to his biographer, particularly favored Joos van Ghent, the "famous painter . . . who was the first to bring to Italy the modern use of painting in oils." Joos van Ghent executed a number of portraits of famous men of the Bible and antiquity for the duke's study, and he included the likeness of Federigo himself in a large painting of the *Communion of the Apostles* (a variation on the theme of the Last Supper) that is still in the ducal palace in Urbino today.

The Netherlandish artists were renowned for their excellent portraiture, which was more meticulously descriptive of facial features as well as more psychologically revealing than those made in the Italian manner. Abandoning the more decorative profile portraits so popular in the earlier Italian courts, Netherlandish artists posed their sitters in three-quarter views focusing exclusively on the heads. Van Eyck reproduced likenesses with all details, including the stubble of the beard or the marks of a scar, rendered in microscopic detail. These lasting first impressions he then placed against dark, amorphous backgrounds so that the personality of the sitter emerges from a mysterious void, anticipating by two hundred years Rembrandt's penetrating portraiture. Rogier van der Weyden avoided descriptive detail in favor of a more abstract statement of social status. His elegant portrait of *Francesco d'Este* (Plate 4) no doubt accurately conveys the thin, pointed features of the Italian aristocrat, but all accidents and blemishes of the face are smoothed away in favor of a simple presentation of a type marked out with decisive lines and broad planes. He is shown against a light, abstract background that makes no reference to the here and the now of the sitter. Francesco is presented simply as a proud, cultivated, and self-satisfied son of the famous Estes of Ferrara.

With Christus the encroachment of the real world on the sitter was subtly introduced. His engaging *Portrait of a Carthusian* (Plate 5) reveals the features of the sullen face bathed in a sharply focused light that penetrates his darkened, barely visible chamber from an external source, anchoring the personality in a specific locale. Even more intriguing is the parapet below the monk, with the eye-catching detail of the fly. At first one is not certain whether a real fly has been deceived by the painting and landed there or if we are only being fooled by a painted insect. Very likely both associations of this trompe l'oeil are intended, for the fly is surely a *memento mori*, a symbolic remembrance that we, like this fragile creature, must die all too soon.

Hans Memling allowed even more of the outside world to encroach upon the sitter. This was the beginning of a trend that was to become established practice in the first years of the sixteenth century when, as in the portraits of Quentin Massys, sitters actually responded to stimuli in the real world

around them. Memling, in his *Portrait of a Young Man* (Plate 10), opened the interior through marble columns on the left to a view of a distant landscape. The warmth and idyllic qualities of Memling's summer vista add an even more approachable dimension to the sitter's world.

At times, however, Memling consciously drew upon earlier traditions. His portraits of the Italian merchant Tommaso Portinari and his wife Maria Baroncelli (Plates 12, 13) are invested with the quiet nobility and aristocratic poise of Rogier's types, and yet one can sense the Eyckian quest for exacting likenesses, although realistic detail is clearly tempered by the artist's concern to please his patrons. Memling's stylistic nostalgia, in fact, accounts for his important role in later Flemish painting.

Settling in Bruges in 1464, after spending some time in the atelier of Rogier van der Weyden in Brussels, Memling perfected a style that beautifully combined the manners of Van Eyck and Rogier (conditioned by a mystic quietism that he had inherited from his German homeland). He grew prosperous through his attractive variations on past Flemish themes that were still esteemed by the pious, often merely combining or repeating elements of earlier compositions and placing them in a sunlit landscape. A fine example is *The Mystic Marriage of Saint Catherine* (Plate 11), in which Rogierian figure types are sedately posed about the enthroned Madonna, hushed and a bit self-conscious, within an arbor and before a rich Eyckian brocade. Symmetrically placed on either side are Saint Catherine (receiving the wedding ring as the bride of Christ, as related in her legend) and Saint Barbara with her tower to the right. Two smaller angels stand behind them, smiling as they play music. On the left, the donor kneels quietly in the mellow landscape. Hushed, immobile, and wistful, Memling's Virgin among virgins registers no outward emotion, and while his paintings may strike us as being too restrained and idyllic, in his own age he was considered the "most accomplished and excellent painter in the entire Christian world."

This relaxation and calmness has sometimes been described as a *detente* in later Flemish art, and, to be sure, when compared to the more vigorous interpretations given the traditional themes by earlier masters, this quality of acquiescence is an apt characterization. Memling's haunting *Annunciation* (Plate 14) presents the event much as we find it in Robert Campin's triptych, within a domestic interior with all the accoutrements of a household. But in place of the stringent naturalism of the earlier painting, Memling's atmosphere is astonishingly hushed and serene. The tall, lithesome Gabriel enters the chamber like a ballet dancer; Mary rises slowly, gracefully, assisted by two elegant angels. The cool, translucent hues and the soft light add to the solemnity of the event.

This same quietism pervades the lovely panels of *The Annunciation* by Gerard David (Plates 23, 24), a Dutchman who settled in Bruges in 1484 and became Memling's successor there. David's figures have heavier proportions and fill the space with more weight than Memling's ethereal people, but the same sense of hushed immobility freezes them

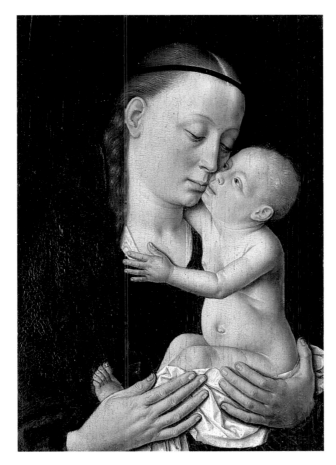

FIG. 3
Virgin and Child
Dieric Bouts
Flemish, act. by 1457–d. 1475
Tempera and oil on wood;
8½ x 6½ in. (21.6 x 16.5 cm.)
Theodore M. Davis Collection,
Bequest of Theodore M. Davis, 1915
(30.95.280)

in a timeless world. David's Northern training (he came from Oudewater near Haarlem) accounts in part for his greater concern with space and, therefore, with landscape. In one of his most charming works, *The Rest on the Flight into Egypt* (Plate 21), the growing interest in pure landscape painting is evident. Here a seemingly insignificant moment in the Infancy story, in which Mary and Joseph pause briefly during their flight from Bethlehem to Egypt, has been selected as a subject with a woodland setting of intimacy and refreshing solace. The theme, particularly popular at the end of the century, is a good example of the way in which many later Netherlandish painters chose secondary or marginal motifs in a drama for the sake of exploiting some secular interest—in this case, a stunning Flemish landscape. David's contribution to this new genre should be remembered when we look upon the vast cosmic panoramas with tiny religious figures produced during the first decades of the sixteenth century by such specialists as the Antwerp landscapist Joachim Patinir (Plate 29). In fact, many of the genres fashionable in seventeenth-century Netherlandish painting—including still life, banqueting scenes, and even such bawdy secular representations as "loose-living" and tavern parties—had their beginnings in such inversions of subject matter.

The fragile world of Memling and David was not to last, however. The violence of social upheaval and political turmoil that followed the demise of Burgundian rule in the Netherlands, the tensions within the Church on the eve of the Reformation, and the pervasive fear of an impending apocalypse were the factors that provoked a frantic spirit at the end of the century. Memling's late Gothic dream was transformed into a Boschian nightmare. Bosch painted a world of hellish torments across a parched earth punctuated with fanatical moralizing illustrations of man's damnation. His acute pessimism concerning the fate of man led him to invent incredible and fantastic hybrids, satanic forms, that invade a world fallen into filth and decay. Many controversies still rage among scholars as to the exact intent of Bosch's shocking proclamations in art; whether they were heretical pieces advocating a new society given over to witchcraft, demonology, and alchemy, or frightening, fanatical sermons in paint against the collapse of piety and morality in the new world. There can be little doubt, however, when looking at his *Adoration of the Magi* (Plate 20), a hallowed religious theme for centuries, that an impending doom, a scary isolation of man, and a threatening quiet before the storm seem to pervade the troubled figures; eerie ruins telescope backward beyond the lonely mother and child to a desolate landscape vista. This is not a festive or happy epiphany.

The styles of painting in the Netherlands that dominated Northern Europe influenced Spain as well, with such artists as Juan de Flandes (see Plates 18, 19), who was called to the court of Queen Isabella. In France, the Master of Moulins, responding to the melancholic expression of Hugo van der Goes, executed haunting portraits, such as that of the hapless Princess Margaret of Austria, daughter of Maximilian and Mary of Burgundy (see Plate 99), with its pale, phosphorescent flesh tonalities. Only Jean Fouquet of Tours and the artists of Provence in southern France resisted the magnetism of Flemish painting. Fouquet had been to Rome in

1448, and in miniatures that he executed later for the treasurer of France, Etienne Chevalier, one finds a surprisingly harmonious blend of Italianate clarity and monumentality with the Northern interest in landscape—often with the topography of France dominating the distance (see Plate 98).

 he grinding gears that marked the faltering shifts from the Middle Ages to the modern world resounded throughout Northern Europe from the late fifteenth through the sixteenth century. The collapse of medieval values can be clearly noted in the arts, but along with the agony of the death cries can be detected the throes of birth. The positive features of a new culture, while more difficult to describe, were there as well. A new world capital emerged overnight: Antwerp. And it was in Antwerp that the various trends met and were transformed and then dispersed even to the shores of the recently discovered New World. The harbors of Bruges, once the glory of Flanders, had silted up, those of Amsterdam were yet to be expanded, and so it was at the busy docks of Antwerp that international vessels, laden with every sort of merchandise, made port, and it was in Antwerp's bourse and banks that the world's trade was quickened and commerce prospered on a scale never before realized in all of Europe.

What impact did this new society with its vigorous economy have on the arts? The answers are inevitable and not always glamorous or promising. The guilds proliferated as a new class of patron, the businessman, emerged to replace the Church and its benefactors. The rise of a vast nouveau-riche market for the arts led to overproduction and overspecialization and, in consequence, a lowering of standards of quality. Artists and craftsmen flocked to Antwerp from all over Northern Europe to reap the profits of the new market, and this introduced an eclecticism that is one of the most characteristic features of Antwerp's art.

Three or four major trends can be discerned in the mixed character of Antwerp painting. First, an exaggeration of the swirling draperies of the earlier masters became fashionable, as did a certain coyness in facial expressions and a clutter of detail arbitrarily scattered across the panels, often incorporating imported Italianisms. Colors are bright and gay, and, in general, the affectations are so pervasive that many authorities have characterized this new style as "Antwerp Mannerism" (not to be confused with the Italian movement). Secondly, a distinct archaism can be noted in many works, perhaps resulting from the desire of the patron to acquire an old masterpiece. The revival of Eyckian types is especially noteworthy: In the *Virgin and Child with Saint Joseph* (Plate 28) by one of the leading Antwerp Mannerists, Joos van Cleve, the corpulent Child and the rosy-cheeked Madonna are copied directly from a work by Jan van Eyck, today in Frankfurt, painted nearly a century earlier.

The attraction of Italy and the prestige of things Italian, or done in the Italian manner, account for a third current of style, "Romanism," which flourished in sixteenth-century Antwerp. It was so-called because of its debt to the Italian Renaissance artists, such as Raphael and Michelangelo, who were active in Rome, and to the antiquities on which the Italian Renaissance was based. This period saw the beginning of

the tradition whereby a young artist served his *Wanderjahr* in Rome in order to gain firsthand experience of true art as practiced by the "Fine Artists" there. Jan Gossaert was one of the first of these Romanists.

Finally, the tastes of the new middle-class patrons, together with the gradual demise of religious art in the Reformation era, brought a demand for new subject matter, often secular in genre, such as landscapes, still lifes, business scenes (banking, etc.), tavern parties, and a variety of moralizing themes in the guise of Biblical parables—the Prodigal Son, for example. Many artists, such as Joachim Patinir, who was one of the first true landscapists, became specialists in a particular subject.

Just as Bruges had Jan van Eyck to extoll as a pioneer in art and Brussels could claim Rogier van der Weyden, so, too, did Antwerp need a founder of heroic stature. Quentin Massys became the artist of Antwerp's new culture, and nearly all of the four stylistic elements cited above appear in one or another of his works. *The Adoration of the Magi* (Plate 39) is a masterpiece of Antwerp Mannerism with its crowded, close-up composition of colorful figures filling the surface with sparkling metalwork, fantastic costumes, and exotic staffage. The gestures have become rhetorical and affected, and the drapery is creased and pressed into arbitrary patterns. Amid all of this surface embellishment, Massys showed off his knowledge of Italian decor with pseudoclassic adornments, and it has also been argued that the grotesque heads owe their inspiration to the physiognomic studies of Leonardo da Vinci.

Massys had a large workshop that produced countless altarpieces and panels in his style, but among his numerous followers only a few personalities can be isolated. One of these is Joos van Cleve, already noted as a leading Northern Mannerist, who came to Antwerp from the Rhineland, and established his own atelier. A charming *Annunciation* (Plate 27) demonstrates how ably Joos van Cleve accommodated his style to the tastes of the new patrons. His swirling draperies are manneristic extensions of those of Rogier van der Weyden, and he elaborated the domestic interiors of Campin with much finery, including a special triptych for Mary sitting on the cupboard with images of Abraham and Melchizedek (a type of Christ-Priest) painted on the wings as an allusion to man's salvation, vaguely related to the iconography of the Annunciation. This is a dainty and precious world, but it is colorful and bright and filled with fascinating details, all of which appealed to the new patrons.

Other artists, such as Pieter Coeck van Aelst and Bernard van Orley (who settled in Brussels) virtually became contractors of sorts, expanding their workshop productions to include stained glass and tapestries, which were specialties in the nearby centers of Arras and Brussels (see Plates 34–37, 41). The Antwerp Mannerist style pervaded all categories of art production, including sculpture, and it was carried beyond Antwerp to Brussels, Mechelen (where Margaret of Austria held court), and north to Holland. In Leiden the prolific Cornelis Engelbrechtsz created his own emotional versions of the Antwerp style.

It was during these years that a new art was established, the print. It was especially lucrative because of its attraction for middle-class patrons. In fact, at about this time, the idea of the private collector came into being, and how appropriate the amassing of a portfolio of prints—much less expensive than paintings—was for these early tycoons of the art world. Woodcuts and engravings were relatively new mediums that were developed after production of paper became economical in the North. The woodcut appeared early in the fifteenth century in Germany, especially in the Rhineland where the simple impressions (see Plates 59, 60) were often sold as pilgrims' souvenirs or playing cards, or used to illustrate books, especially those for the use and instruction of parish priests. At first the printing blocks were produced in carpentry shops, since guild regulations limited all woodwork to them, but as the market expanded, painters often took over the designing of woodcuts as miniature works of art, elevating the craft to a new status. Foremost among the artists who contributed to this change was Albrecht Dürer, whose great *Apocalypse* (Plate 65) with fourteen huge woodcuts illustrating the text of the Book of Revelations was entirely produced and published by the artist himself in 1498; it was a readily salable product in a world that feared the coming of the Last Judgment.

Another form of print, the engraving, also had a humble beginning in the goldsmith's shop, where it was soon discovered that incised patterns could easily be transferred from metal to paper merely by inking the grooves made by the burin and pressing damp paper across the plate. Engraving was rapidly elevated to the status of a fine art by the delicate and intricate designs of such Rhenish artists as Master E. S. (Plate 58) and Martin Schongauer. Indeed, the elaborate engraving of Schongauer's giant *Road to Calvary* (Plate 61) could rival the painted panel in its sophistication. Again, it was Albrecht Dürer who perfected the technique, and he found the graphic arts so profitable that, by 1515, he had abandoned panel painting almost entirely.

The burgeoning city of Antwerp, with its ready market, was a magnet to graphic artists. Plantin established his giant publishing house, The Golden Compasses, employing many illustrators, and Hieronymus Cock founded the press At the Four Winds. They turned out countless engravings after paintings (Bosch, Bruegel) and published books with romantic views of the antiquities of Italy. In a way, the systematic study of art history began with the prints published by Cock in Antwerp. Pieter Coeck van Aelst established his own publishing house in his workshop, printing books illustrating his own translations of the architectural treatises of Vitruvius and Sebastiano Serlio to instruct local architects in matters of classical vocabulary. In 1553, a set of woodcuts illustrating the *Manners and Customs of the Turks* (Plate 38) was printed posthumously by his wife. These fascinating woodcuts were taken from drawings Coeck had made in Constantinople, probably intended to serve as designs for exotic tapestry hangings.

In the northern Netherlands, Lucas van Leyden proved to be the precocious rival of Albrecht Dürer in the sale of engravings. Perfecting a remarkably delicate technique that gave the inked line a soft, silvery tone, Lucas became the leading graphic artist in Holland. In addition to numerous biblical series, which are remarkable for the inventiveness of their iconography, Lucas turned to a variety of subjects, including stories of mythological inspiration, illustrations of

the "Power of Women," and rustic pieces that have been considered the forerunners of the genre paintings of seventeenth-century artists. *The Milkmaid* (Plate 25) is seemingly a simple bucolic memento, evidence of the love of such secular themes by the Dutch, yet there may still be moralizing elements present in the juxtaposition of the buxom maiden and the crude farmhand with the cow and the bull which figure so prominently in the print.

Several of the transformations of subject matter that we have seen since the fifteenth century were in part due to the new demands and tastes of a society that was rapidly casting aside its preoccupation with themes hallowed by the Catholic Church. The Protestant revolution, sparked by Martin Luther in Saxony, had much to do with the fate of the arts in Germany and, to a lesser extent, in the Netherlands as well. The iconoclastic policies of the reformers—it became heretical to produce images of God and the saints and to adore them (following a strict interpretation of the Second Commandment)—served to stifle the arts in Luther's homeland to a great degree, at least as far as religious subject matter was concerned. But the Reformation did not occur overnight, and iconoclasm was not universally accepted by all who joined the movement. In fact, the ambivalence of many leading thinkers and artists on this point has yet to be studied properly, although the ultimate result of the reform —the demise of the pictorial arts—is all too clear in Germany by the middle of the century. A vigorous thirty years, however, immediately preceded the collapse of the arts.

It has often been argued that the true founder of the Northern Renaissance was Albrecht Dürer of Nuremberg, and there are many reasons to believe that it was he, in fact, who did bring Italy to the North in terms of the antique revival in both spirit and form (see Plates 62–68). Trained in the workshop of his father, a goldsmith, Dürer was early apprenticed in the huge workshop of the leading artist in Nuremberg, Michael Wolgemut, whose expertise ranged from the production of great altarpieces to the provision of designs for the woodcuts that filled the books of local publishers. During his *Wanderjahr* Dürer visited the Rhineland where his hopes of working as a journeyman under Schongauer were thwarted by the artist's death. He then spent some time in Basel, the leading center for humanistic studies in the North, before returning home. By 1493, Dürer was back in Nuremberg, where he became attracted to the humanist literati and was soon accepted into their elite circle. He then embarked on his first trip to Venice. Among the many rich experiences Dürer had there, one of the foremost was his realization that the status of the artist in Italy was not merely that of a craftsman but of the learned and gifted "fine artist." He also busied himself learning the secrets of perspective and proportion and immersed himself in the elevated ideas embodied in art theory. He took these ideas, as well as sketches, home with him the following year.

With the production of the Apocalypse woodcuts in 1498, Dürer's reputation as the leading artist in Germany was established, and he soon enjoyed noble patronage, including that of Frederick the Wise of Saxony. With his new fame came pride and ambition, and in 1506 Dürer set out for another visit to Venice, this time to prove his worth even to the Italians. In preparation for the second trip, Dürer engraved his remarkably detailed *Adam and Eve* (Plate 68), basing the two nudes on the Medici Venus and the newly discovered Apollo Belvedere to demonstrate his mastery of the principles of classical canons of proportion. But his Northern tendencies are apparent in the mysterious woodland setting, a favorite motif in Germany. He also incorporated the disguised symbolism of Northern art in the fauna about the Tree of Knowledge: the ox, cat, rabbit, and stag, symbolizing the four humors or tempers of man to be unleashed as soon as Adam takes the fateful bite of the apple. As if to proclaim his Northern heritage, Dürer signed his name in Latin on a *cartellino*, adding *Noricus* (Nuremberg), lest any should mistake his nationality. His second trip brought more honors, including the patronage of the wealthy German colony of merchants and bankers in Venice, and he returned to Nuremberg an acknowledged master both north and south of the Alps.

Dürer continued to work both as a painter and graphic artist, receiving commissions for the grandiose projects of the Habsburg emperor Maximilian I and from leading German merchants. His *Virgin and Child with Saint Anne* (Plate 63), a favorite German theme, is a good example of the religious subjects he continued to execute. But painting proved to be less profitable than graphics, and furthermore, the sympathies of the reformers in Nuremberg were turning away from works of art that in any way resembled icons or invited idolatrous devotion to Mary. Dürer never met Martin Luther, but it is clear from his writings—and certain works—that he was in sympathy with the German reformer. One of his most impressive engravings, *The Knight, Death, and the Devil* (Plate 66), may well be a tribute to Luther. The heroic knight, a *miles Christi* (soldier of Christ), is portrayed as an equestrian hero resembling the famous sculptures of *condottieri* by Donatello and Verrocchio that Dürer had seen in Italy. But the spooks and demons, emerging from their haunts in the overgrown forest to tempt and deter him, are monsters right out of German folklore. The identification of the knight has been an issue of some controversy, but it is probably close to the truth to see him as a spiritual portrait of Luther himself: the true Christian knight, who did not waver from the dangers and temptations about him on his mission. We know that later, when Dürer met Erasmus on a trip to the Netherlands in 1520–21, he questioned the humanist from Rotterdam on his stand, writing in his diary: "Erasmus...thou knight of Christ! Ride by the side of the Lord Jesus. Guard the truth. Attain the martyr's crown." Dürer was responding to rumors that Luther had just been taken prisoner and might be dead.

Among the many artists trained or directly influenced by Dürer was Hans Baldung Grien. Baldung settled in Strasbourg, where he specialized in paintings and woodcuts of witches and eerie images of Death and the Maiden, very popular themes in the Upper Rhineland, which was the center for the suppression of the heretical cults and sects. (The infamous *Witches' Hammer* [*Mallaeus Maleficarum*], a manual

for the use of inquisitors, was published there in 1486 under the papal imprimatur.) *Saint John on Patmos* (Plate 70), an exceptional work from a large altarpiece painted by Baldung, reveals the intensity of his religious expression. The seated Evangelist writing down his visions is clearly indebted to Dürer, but Baldung's own personality sharply emerges in the unusual color scheme—the Virgin's mantle is turquoise—and in the filmy landscape background that reveals his familiarity with the School of Danube painters.

Among the German artists indebted to the painters of the Danube school (Albrecht Altdorfer, Wolf Huber), whose specialty was romantic landscapes of river valleys and deep forests amid towering mountains, none is more problematic and important than Lucas Cranach the Elder, whose art clearly demonstrates the conflicts of humanism and reformation in Germany (see Plates 74–79). In 1505, after a youthful sojourn in Vienna, Cranach became the court artist to the elector of Saxony, Frederick the Wise, in Wittenberg, where Luther was a university theologian. The friendship between Luther and Cranach is well documented, and at times the art of Cranach reveals a strong Protestant bias, particularly after the events that led to Luther's excommunication in 1521. But Frederick's court had strong humanistic leanings as well, and a number of Cranach's paintings and prints treat mythological themes such as the curious *Judgment of Paris* (Plate 75), where his attempt to retell a classical story in Germanic terms seems colorful but naive. Paris, the hapless shepherd in the story, appears here as a courtly soldier decked out in the finest armor, while the three nude goddesses, Venus, Juno, and Minerva—who were to be judged by Paris for their beauty—are charming versions of classical female nudes rendered as sinuous ivory figurines who turn and prance in a seductive manner. Perhaps, as some have suggested, there is a moralizing overtone to the story, but the decorative eroticism cannot be missed.

A true Renaissance personality who served the elector's court in many capacities, Cranach is best known today for his dashing portraits of the members of the German nobility. *John, duke of Saxony* (Plate 77), is proudly posed in an austere black costume set against a strong red background that was used repeatedly by Cranach and his shop. His female portraits are more lighthearted: charming court ladies smiling amid fanciful plumed hats and stylish costumes, bedecked with jeweled necklaces and brooches. A number of Cranach's paintings of court life—hunting parties and tournaments—were repeated in woodcuts (Plate 79), often with topographical sites included. His designs also served as patterns for goldsmiths and sculptors.

Many of Cranach's religious works illustrate Old Testament stories, such as *Samson and Delilah* (Plate 76), which were less repugnant to the Protestants, since political allegories could easily be read into these themes. However, it should be noted that while his portraits of Luther, the discursive Allegories of the Law and the Gospels, and other blatant Lutheran themes add much to our knowledge of the Reformation in Germany, they also testify to a dimming of artistic expression caused by the severe restraints imposed on artists at the time.

The painter of Renaissance portraits par excellence was Hans Holbein the Younger, a truly cosmopolitan artist who lived and worked in three international cities: Augsburg, Basel, and London. After serving apprenticeships in their father's workshop in Augsburg, Hans and his brother Ambrosius left the Protestant city and traveled to Basel in 1514–15. For a time the brothers found a variety of jobs as painters of altarpieces, signboards, and houses, and their contacts became lucrative, especially for Hans, who developed intimate friendships with the members of the humanist circle in Basel. Among the friends to whom Holbein was introduced was Erasmus of Rotterdam, "king of the humanists." His many portraits of the famed scholar are elegant testimonials to the dignity and seriousness of the great theologian (Plate 85).

Holbein's few religious paintings display the same Gothic intensity as those of his father, but it was not through such art that his fame was established. In Basel, his patrons soon realized that his steady hand and sharp vision enabled him to execute portraits with an astonishing realism reminiscent of that of Jan van Eyck. As a scrupulously objective recorder, Holbein seems to have put aside any emotional involvement with his sitters, and his eye missed no details or blemishes. But there was more to his exacting realism than mechanical reproduction. One of his early portraits, *Benedikt von Hertenstein* (Plate 83), son of the mayor of Lucerne who was one of Holbein's patrons, was painted in 1517, the same year that the artist decorated the family's townhouse. The artist's keen vision and precise brushwork render a vivid likeness of the young man, who, five years later at the age of twenty-seven, was slain while serving with Swiss mercenaries in Italy. The military ambitions of the young Hertenstein are vividly conveyed not only in the intense expression in the eyes but also by the bold Italianate frieze adorned with a triumphal procession—an antique theme—that appears above his head.

Eventually, however, Holbein, like his friend Erasmus, was driven from Basel by the militancy of the Protestant reformers. He became disillusioned by the fate of the arts in the city, and in 1526, he abandoned his shop, leaving his wife and two young children behind, and traveled to Antwerp, where he met Quentin Massys, and then sailed for England. Equipped with a letter of introduction from Erasmus to Thomas More, Holbein resided for a time at More's country estate in Chelsea, where he painted the famous portrait of him, now in the Frick Collection in New York. He returned to Basel in 1528, but matters there had only worsened, and few patrons were to be found. The Protestants had made Switzerland and Germany cultural wastelands for painters and humanists, and in 1532 Holbein decided to return to England where he believed the religious policies of Henry VIII were less iconoclastic. But matters had changed there, too. Henry had been excommunicated by the pope; Thomas More and friends in his circle were in deep trouble with the king (More was beheaded in 1535); and at first there was little indication that Holbein, who had somewhat reluctantly joined the Protestant sympathizers, would eventually attain the status of court painter. However, he found numerous clients among the colony of the Hanseatic merchants, mostly Germans, who were prospering in London, and he painted their portraits in his unflinchingly realistic style, displaying

their costly costumes and swarthy features much to their satisfaction.

Especially noteworthy are the two portraits of Cologne merchants who sat for Holbein. The portrait of a young member of the Wedigh family (perhaps Hermann Wedigh III), dated 1532 (Plate 84), is one of the finest in the series, with its sure, crisp delineation of the youthful features, the sharp details in the book before him, and the clarity of the color areas—the dark costume silhouetted against the blue wall and the green tablecloth. With the same sharp clarity and boldness of vision, Holbein placed the older sitter, Dierick Berck, in a frontal pose (Plate 88). Only the curtain and the cord in the background detract from the compelling iconic features of this influential merchant.

Regional ducal powers, which had provided the patronage during the fourteenth and fifteenth centuries, gave way to the international empires in the sixteenth. Through marriage the Habsburgs had inherited the Netherlands in 1477; Henry VIII had proclaimed England free of Rome's influence by the time of Holbein's arrival there; and in France a descendant of the old house of Valois, Francis I, was determined to establish a Renaissance court in his new capital at Fontainebleau. For Francis, who knew Italy well, there was only one source from which his fountain of culture could be nourished, and that was Renaissance Italy. To that end he actively enrolled Italians in his cultural program. Leonardo da Vinci spent his last years at Cloux under Francis's patronage. Andrea del Sarto resided a year with Francis, and the famed metal sculptor Benvenuto Cellini and the architects Sebastiano Serlio and Giacomo da Vignola also worked for him. By far the most momentous impact of the Italian Renaissance was to be seen in the decorations of the royal palace at Fontainebleau.

Fontainebleau had been renovated from a Gothic hunting lodge into a many-chambered palazzo with galleries and courts. Italian sculptures and casts of famous works of antiquity were installed; the chambers were hung with paintings by many Italian Renaissance masters—Raphael, Leonardo, Titian, Parmigianino, Giulio Romano, Bronzino, and others; the walls were lined with great tapestries illustrating mythological subject matter; and the designer of the famous Galerie François Iᵉʳ (Gallery of Francis I) was the Florentine Mannerist Rosso Fiorentino. Rosso's scheme included tall stucco figures of male and female nudes, elaborate strapwork cartouches, and capricious paneling that enframed paintings illustrating the life and deeds of the monarch, spun out in an iconography that was incomprehensible even to the most learned scholars. Much of the decoration was completed by his gifted assistant Primaticcio, who assumed leadership of the project after Rosso's death in 1540. It was Primaticcio's style, both in the stucco figures in the gallery and the mythological subject matter painted on the ceilings, that set the fashion for later artists of the French Renaissance. His long-legged, smoothly textured figures with tapering, lithesome bodies are the hallmarks of the Fontainebleau style, charmingly portrayed in *The Birth of Cupid* (Fig. 4) by one of Primaticcio's followers. There is a subtle eroticism in this courtly style, but it is seldom overt, being submerged beneath a colorful veil of woodland and other bucolic settings that were so popular in French literature.

Court art must necessarily include portraiture, and at Fontainebleau it achieved a distinctive quality by developing as a splendid compromise between Italian and Netherlandish manners. The leading court portrait painter was Jean Clouet, a Fleming who brought with him a keen and sharp vision for detail. Clouet's portraits are distinctive in their understatement and simplicity, although his likeness of *Guillaume Budé* (Plate 109), a learned humanist and keeper of the royal libraries, is his only documented painting. His fame today rests on the many tricolored drawings of courtiers, executed in a soft, impressionistic style, that are often too generously attributed to the king's painter. Clouet's son and his many followers established a lasting tradition for elegant pastel portraiture in France.

Although the influences of the Italian Renaissance were filtering north to Fontainebleau, the severe tenets of Gothic art still lingered in France. An intense religious expression is found in many sculptures, especially in later works by Germain Pilon, and in some instances a violent mysticism bursts on the scene. Jean Duvet, active in Langres, a zealous religious center, designed engravings for an Apocalypse series that owed much to Dürer but was more explosive and expressionistic in the swirling spirals and packed patterns that spun and vibrated across his cramped compositions. He also executed similarly vivid allegorical prints (see Plate 112) for Henry II, the successor of Francis I at Fontainebleau.

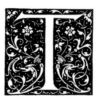 he court of Fontainebleau served primarily as a sieve through which much Italian art was filtered into the North, and the influence of the French artists, especially the printmakers, on the Netherlands of the late sixteenth century has yet to be studied properly. This is a complex problem, for it seems that the artists in Flanders and Holland were reluctant to abandon their heritage, and when they did, as in the case of the Haarlem Mannerists at the end of the century, the results were often stifling and eclectic. Among the later Netherlandish artists, one stands out in heroic proportions: Pieter Bruegel the Elder. Born in North Brabant around 1527, Bruegel trained with the leading Antwerp Mannerist Pieter Coeck van Aelst and became an accomplished designer of prints. Unlike his compatriots, Bruegel, who traveled in Italy in 1552–53, did not dwell on antiquities and Renaissance masterpieces; his sole preoccupation was the landscape, especially that of the towering Alps.

A new Renaissance philosophy appears in the works of Bruegel. His humanism is of a different sort, and, in fact, his art reveals more of the older Northern traditions of pantheism. Man, in Bruegel's paintings, is but another particle of a grandiose universe in which nature is the measure. His interest in human behavior led him to investigate the subjects of Netherlandish folk proverbs as sources of wisdom as profound as any Renaissance allegory. Rather than occupy himself with traditional religious themes, he sketched and painted the peasantry at work (see Plates 44, 45), at play, or engaged in vain and foolish occupations such as

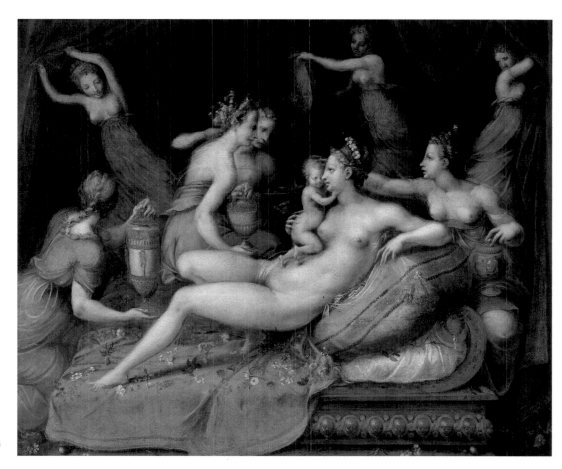

FIG. 4
The Birth of Cupid
Master of Flora
Italian, active at Fontainebleau,
second half 16th c.
Oil on wood; 42½ x 51⅜ in.
(108 x 130.5 cm.), including added
strip at top measuring 3½ in. (8.9 cm.)
Rogers Fund, 1941 (41.48)

alchemy (see Plate 46). His manner and technique reveal his mastery and understanding of the latest styles of the time, and it is impossible to characterize Bruegel's art as medieval, Renaissance, or even Mannerist, since his works seem to encompass all these expressions at various times. Like Bosch, whom he often imitated, he designed scenes of apocalyptic horror; on occasions he added early Flemish staffage to panoramic Patiniresque vistas; but more often he seems to have looked down upon the world from some high tower, recording the activities of antlike creatures who swarmed about busily in a cosmic landscape.

For Bruegel the higher power that governs the universe is not a personified God but a force that resides in the earth. His landscape is animate and has a kind of personality. The deity is likened more to a great mechanic who has put the earth into orbit, so that it just goes round and round forever, guiding and ruling the activities of man. Nature has moods that reveal its cyclical mechanism. The seasons come and go with regularity; the crops grow in rotation; the cycle of life from infancy to old age repeats itself again and again; and the rains, the winds, the bright hot sun alternate in their fashion. Bruegel is one of the first landscapists to display vivid weather conditions and their effects on the activities of man. Perhaps no finer statement of this pantheism in Northern art can be found than in a famous series of the "Months" painted by Bruegel in 1565 to decorate the resi-

dence of a wealthy banker, Niclaes Jonghelinck. There were probably six panels originally, each representing two months. Today, those that survive are scattered: *The Harvesters* (Plate 43) is one of the two masterpieces in the set, the other being the famous *Hunters in the Snow* in Vienna. *The Harvesters* probably represents July and August, when the days are long and hot and a mugginess slows down the activities of the laborers. At noon, when the scorched sky turns the blocky terrain of wheatfields into a bleached expanse of hot, golden tones, the workers grow sluggish and take a lazy recess to eat their meal or nap under the branches of a shade tree. Man and nature, after exerting energies during the previous months, now grow slothful, and everything slowly seems to come to a stop in the cycle of nature. There are no dramatic Alpine peaks to disturb the broad, geometric fields of wheat that extend languorously from right and left to the horizon. The conditions of nature, man, and climate are amazingly interwoven and conveyed through color and form. Bruegel's "Months" are some of the most memorable landscapes in Western art, and it seems strange indeed that in our discussion of the Renaissance in the North, what ultimately triumphs is not the image of man but the cosmic forces of nature.

James Snyder

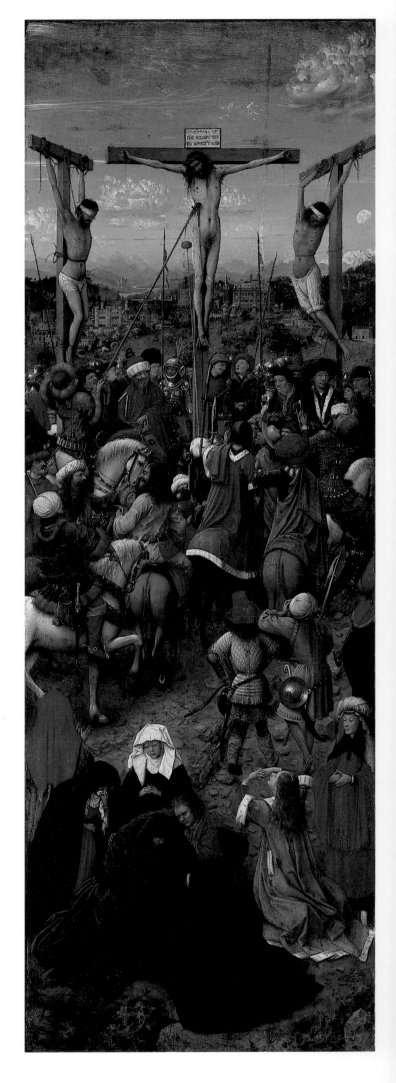

JAN VAN EYCK
The Crucifixion and *The Last Judgment*

Jan van Eyck, one of the greatest artists of the Renaissance, appears to have been the first painter to develop the full potential of the new oil medium. The subtle gradations of tone that oil allows make possible here the illusion of deep space, achieved not so much by foreshortening as by "atmospheric perspective," in which colors and dark–light contrasts decrease in intensity as our eye moves back in space. In the furthest distance of *The Crucifixion*, for example, the mountains and sky partake of virtually the same blue-green. Even in the foreground the colors and forms of the figures are softened by the application of numerous glazes—a filtering that gives the painting a unity that might easily have been disrupted in a composition of so many figures.

Though the panels are small, the artist has managed to render with great sensitivity the figures' emotions: for example, the poignant grief of the foreground group in *The Crucifixion* or the horror and misery of those in hell in *The Last Judgment*.

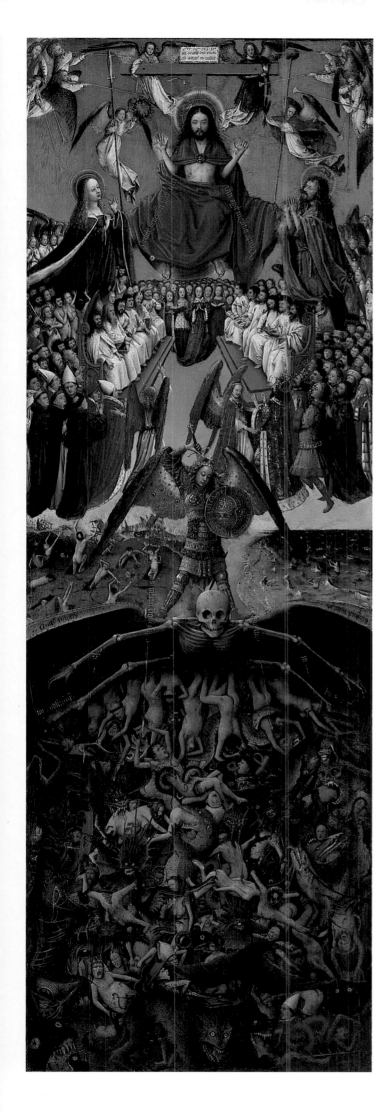

1 *The Crucifixion* and
The Last Judgment, 1425–30
Jan van Eyck
Flemish, act. by 1422–d. 1441
Tempera and oil on canvas,
transferred from wood; each panel
22¼ x 7¾ in. (56.5 x 19.7 cm.)
Fletcher Fund, 1933 (33.92a,b)

Page 20: detail, left panel
Page 21: detail, right panel

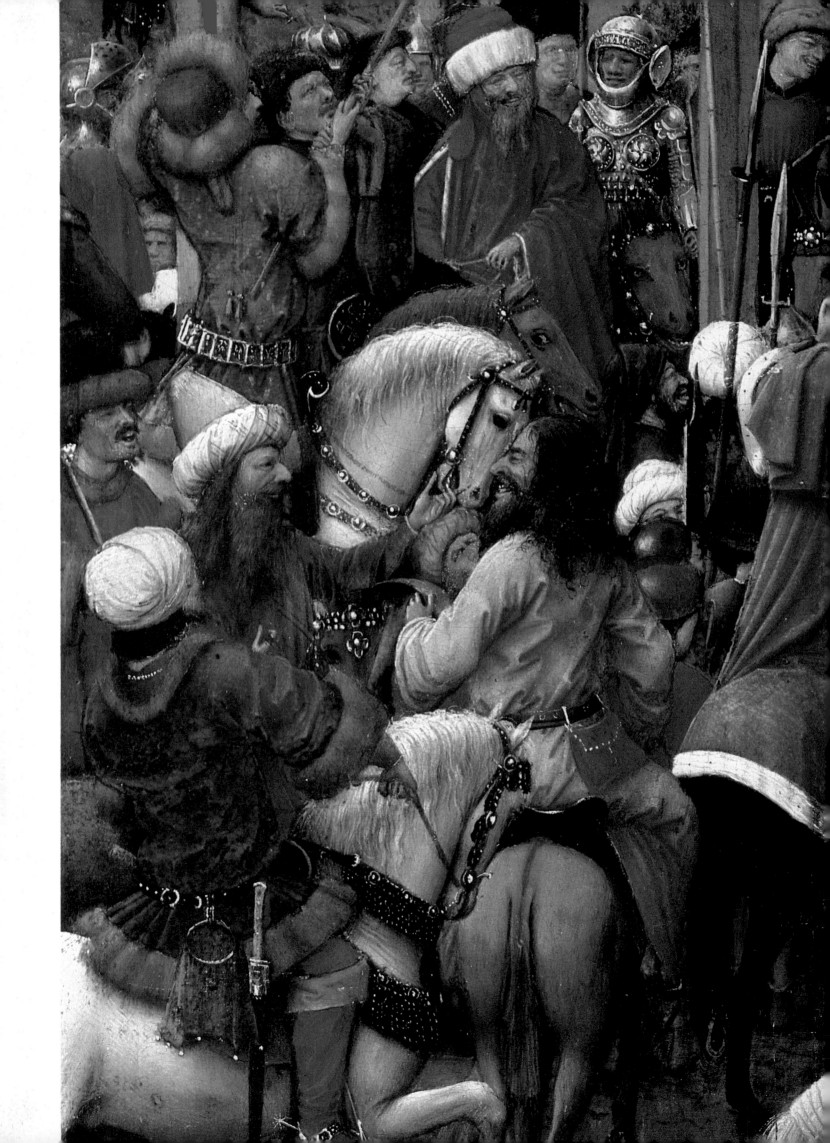

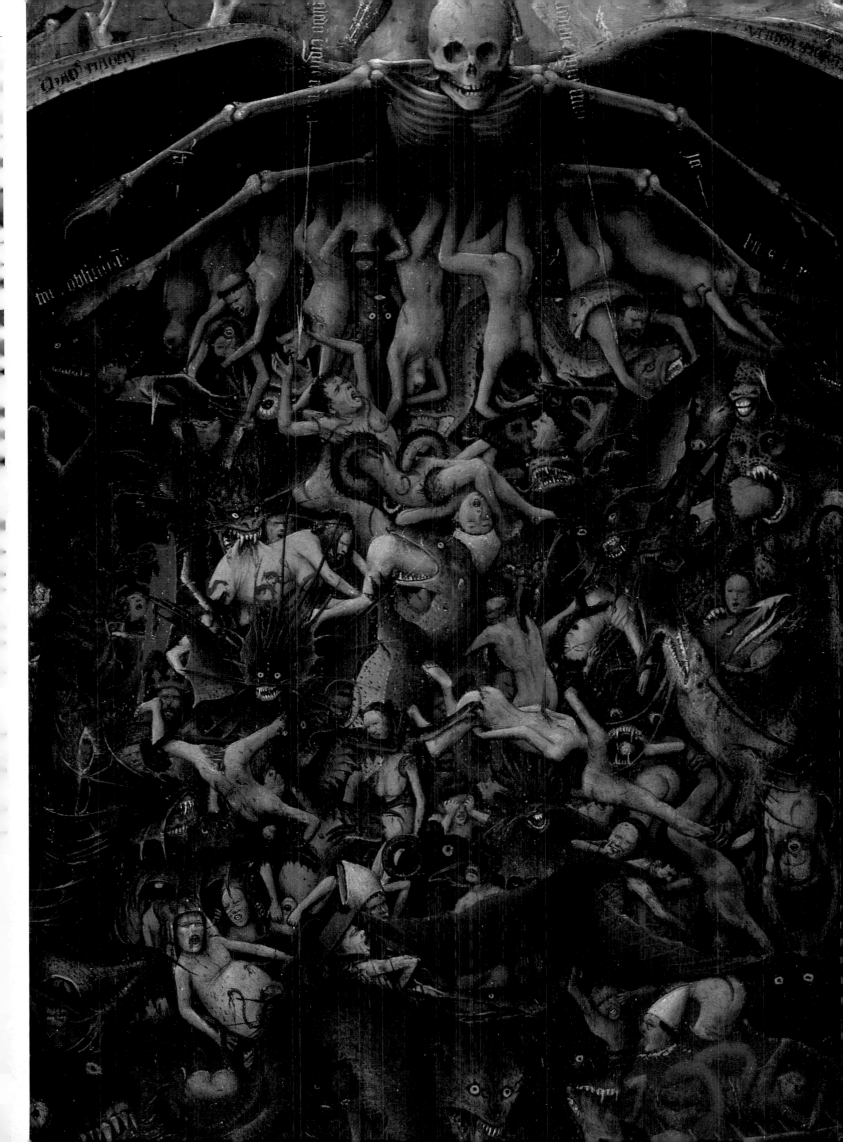

2 *The Annunciation*
Attributed to Jan van Eyck
Flemish, act. by 1422–d. 1441
Tempera and oil on wood;
30½ x 25⅜ in.
(77.5 x 64.5 cm.)
The Friedsam Collection,
Bequest of Michael Friedsam,
1931 (32.100.35)

ATTRIBUTED TO JAN VAN EYCK
The Annunciation

The Virgin of the Annunciation is usually represented seated in her room, reading. Here, however, the Virgin stands in a portal, book in hand, as the dove of the Holy Spirit descends and Gabriel announces that the Lord is with her. To the left of the doorway is a vase of lilies, a symbol of her chastity almost always included in representations of the Annunciation. The style of the buttress on the right side of the portal is Romanesque and that on the left is Gothic, symbolizing the transition from the era of the Old Testament to that of the New, a transition marked by the Annunciation.

Its high quality notwithstanding, the painting cannot be attributed to Jan van Eyck with complete certainty. It has also been attributed to Petrus Christus (see Plates 5–7), who is thought to have been active in Jan's workshop when the older artist died, as well as to Hubert van Eyck, Jan's older brother. Of exceptional beauty in this panel are the delicate landscape in the background and Gabriel's wings of blue, red, and gold.

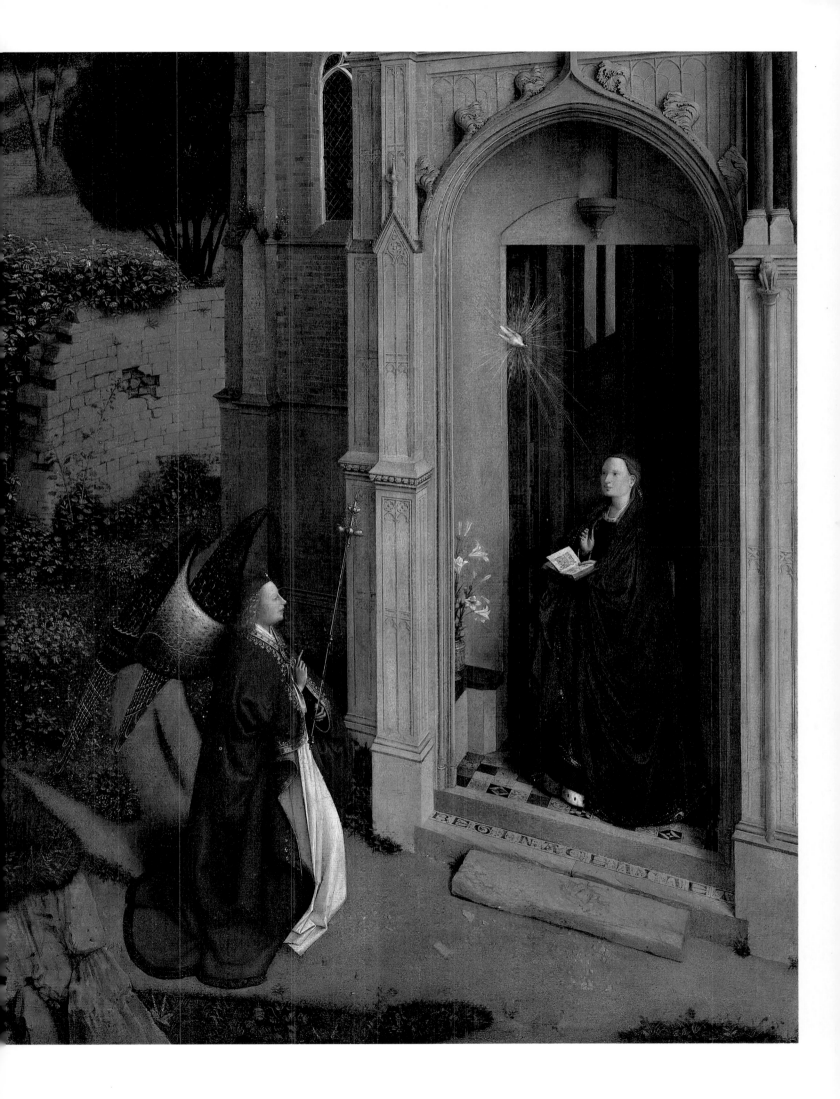

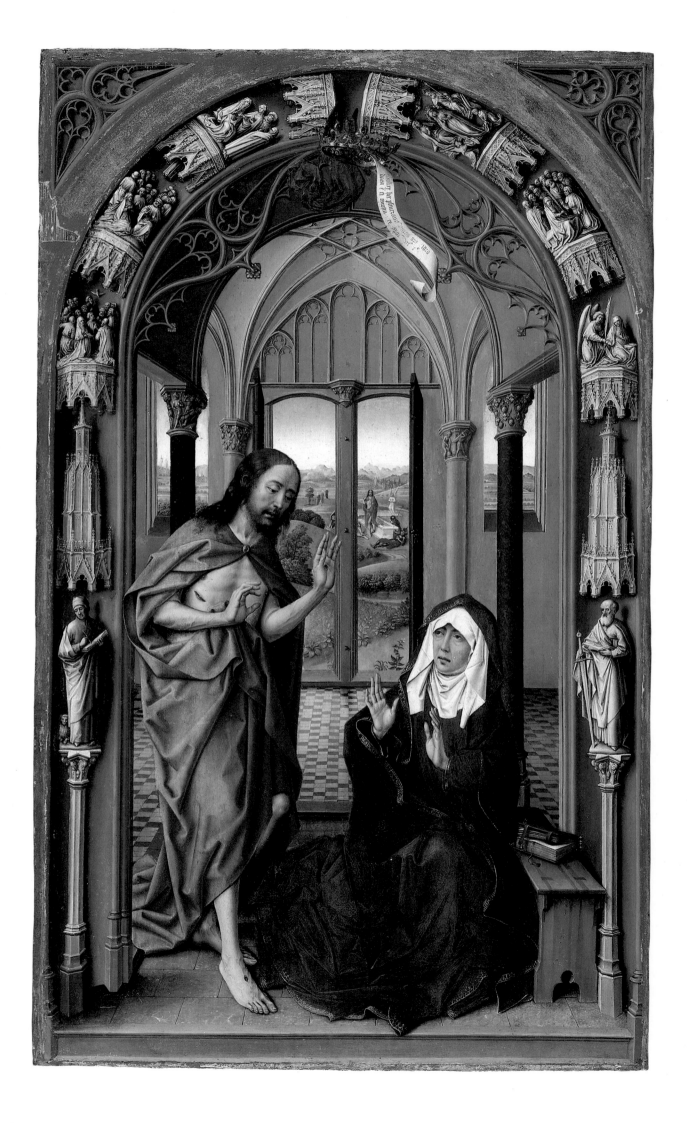

24

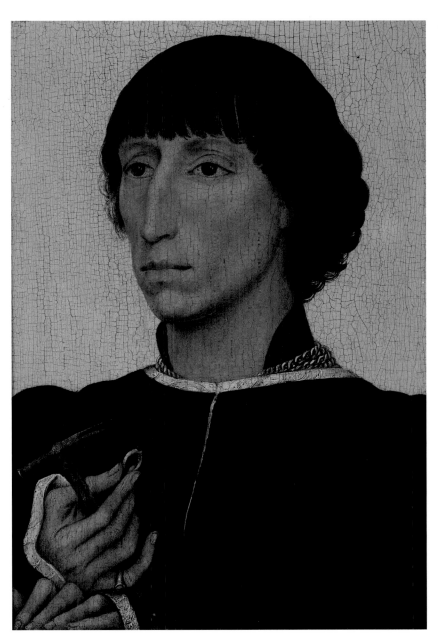

3 *Christ Appearing to His Mother*,
after 1436(?)
Rogier van der Weyden
Flemish, ca. 1400–d. 1464
Tempera and oil on wood;
25 x 15 in. (63.5 x 38.1 cm.)
The Bequest of Michael Dreicer,
1921 (22.60.58)

4 *Francesco d'Este*, ca. 1460
Rogier van der Weyden
Flemish, ca. 1400–d. 1464
Tempera and oil on wood;
11¾ x 8 in. (29.8 x 20.3 cm.)
The Friedsam Collection,
Bequest of Michael Friedsam,
1931 (32.100.43)

ROGIER VAN DER WEYDEN
Christ Appearing to His Mother

Between his Resurrection and Ascension Christ appeared on earth several times. His first appearance was to his mother. In this panel tears of mourning are still on the Virgin's cheeks as Christ greets her, displaying his wounds. The Resurrection is depicted in the landscape background. The capitals in the vestibule show Old Testament events that prefigure Christ's triumph over death, and the archivolts represent scenes from the life of the Virgin after the Resurrection. The angel above holds a crown and a banderole inscribed in Latin that translates: "This woman fulfilled all things triumphantly; therefore a crown is given unto her. From the Apocalypse 6:l."

This panel formed a triptych with two others in the Capilla Real (Royal Chapel) of Granada's cathedral. The triptych was presented to the chapel by Queen Isabella of Castile and León, who commissioned *The Marriage Feast at Cana* (Plate 19), now at the Metropolitan Museum.

ROGIER VAN DER WEYDEN
Francesco d'Este

Francesco d'Este (ca. 1430–after 1475) was an illegitimate son of Leonello d'Este, duke of Ferrara. He received his military training in Brussels in 1444 and spent the rest of his life in Burgundy in the service of Philip the Good and later Charles the Bold. This panel was probably painted about 1460, when Francesco was close to thirty. Far from a detailed physiognomic description, this idealized, simplified portrait is instead a delineation of character and social station: Francesco, with his elongated features and introspective gaze, is a paragon of aristocratic aloofness and elegance.

The hammer and ring Francesco holds may be emblems of office or may allude to a tournament victory. The Este coat of arms is painted on the reverse of the small panel. While the restraint and refinement of this portrait are typical of Rogier's work, the white background is unusual.

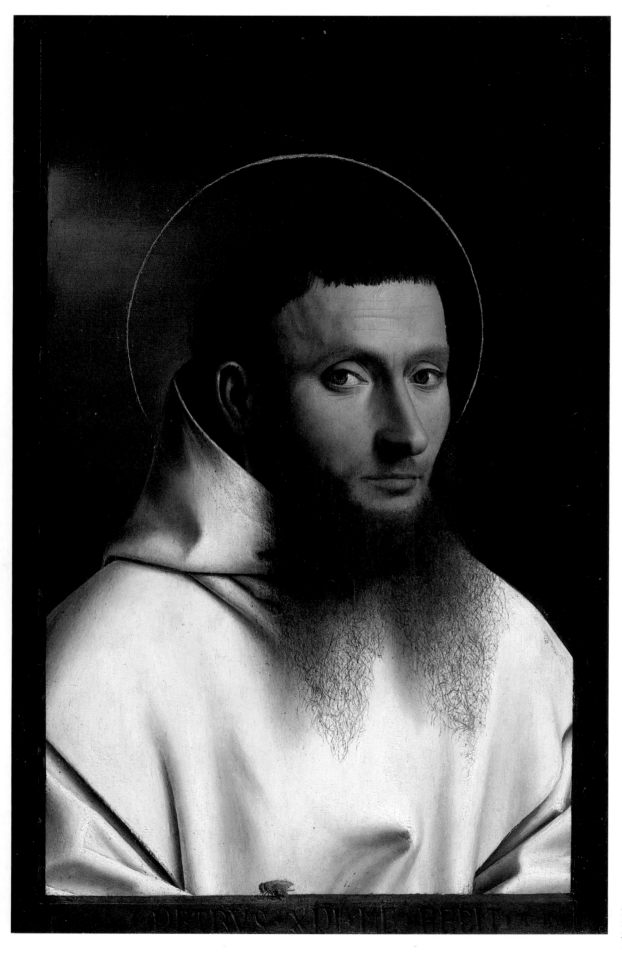

5 *Portrait of a Carthusian*, 1446
Petrus Christus
Flemish, act. by 1444–d. 1472/73
Tempera and oil on wood;
11½ x 8 in. (29.2 x 20.3 cm.)
The Jules Bache Collection, 1949
(49.7.19)

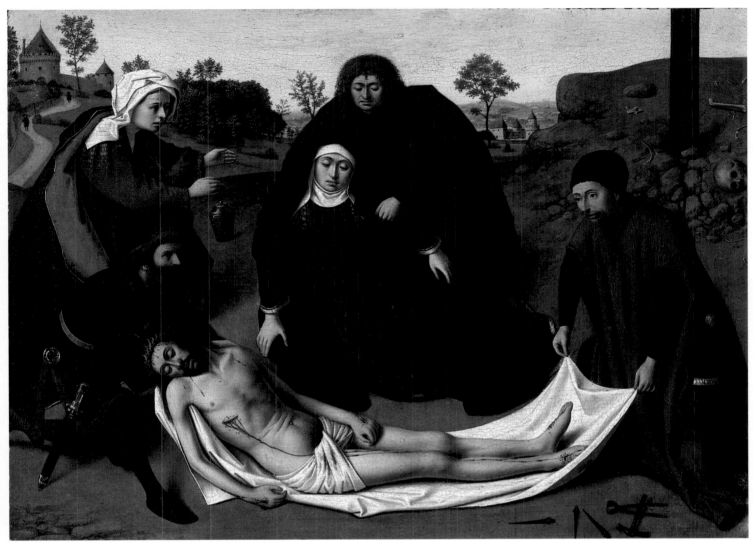

6 *The Lamentation*, probably 1450s
Petrus Christus
Flemish, act. by 1444–d. 1472/73
Tempera and oil on wood;
10¼ x 14⅛ in. (26.1 x 35.9 cm.)
Marquand Collection, Gift of
Henry G. Marquand, 1890 (91.26.12)

PETRUS CHRISTUS
Portrait of a Carthusian

Much of the strength of this portrait lies in its naturalistic effect. The sitter's features are vividly described and his physical presence is powerfully projected: We know the texture of his beard, the weight of the folds of his robe. The naturalism of the work surpasses even the masterly portraits by Christus's teacher, Jan van Eyck (see Plates 1, 2). On the sill of the simulated frame, where the artist put the date (1446) and his signature (*XPI* is an abbreviation of the Greek form of Christus), Petrus has painted an astonishingly lifelike fly, a tour de force of illusionism.

This is one of the earliest signed and dated paintings by Petrus Christus. While the sitter has not been identified, his hair and beard are cut in the manner of a converse, or lay brother.

PETRUS CHRISTUS
The Lamentation

Despite its small size, Petrus Christus's representation of the Lamentation—the mourning over Christ's dead body—is one of the artist's most monumental compositions. The body of Christ lies on a shroud held aloft by Joseph of Arimathea at his head and Nicodemus at his feet. Behind Joseph of Arimathea is Mary Magdalen, and at the center the Virgin Mary collapses in the arms of John the Evangelist. The centripetal composition is tightly structured by the sweeping curves formed by the body of Christ and the figures flanking him and by the Virgin and Saint John.

On the right, at the foot of the cross on which Christ was crucified, is the skull of Adam, here included since through the sacrifice of Christ, the "new Adam," mankind was redeemed from original sin.

This panel probably dates from the 1450s. A larger version of the Lamentation in the Musées Royaux des Beaux-Arts in Brussels was most likely painted a few years earlier.

27

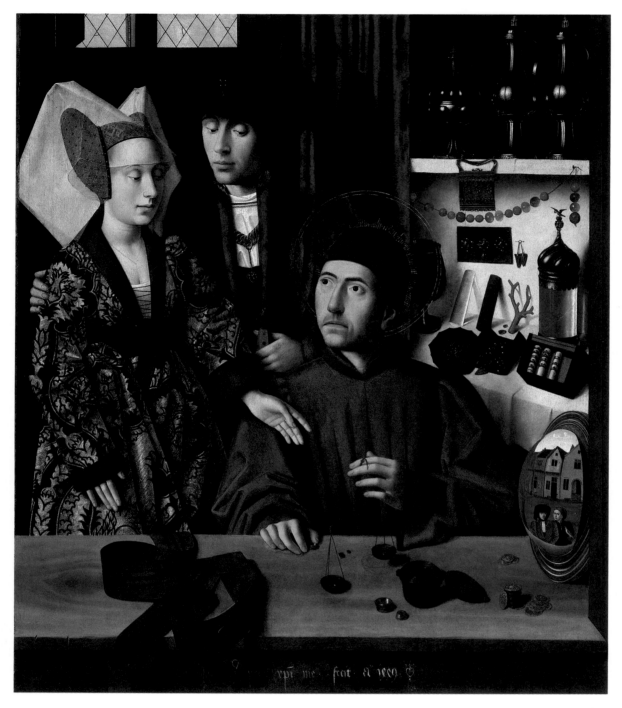

7 *Saint Eligius*, 1449
Petrus Christus
Flemish, act. by 1444–d. 1472/73
Oil on panel;
39 x 33⁷⁄₁₆ in. (99 x 85 cm.)
Robert Lehman Collection, 1975
(1975.1.110)

Opposite: detail

PETRUS CHRISTUS
Saint Eligius

Tradition holds that this painting was commissioned by a goldsmiths' guild to promote their trade under the protection of Eligius, the patron saint of their craft. Unusually large for a Flemish painting, the picture is dominated by three almost life-size figures. Saint Eligius, a metalworker and bishop who died in 660, is represented as a goldsmith in his workshop. Dressed in the clothes of a common craftsman but distinguished by a halo, he is seated before a window on the ledge of which he displays his wares. Behind

him stand an elegantly dressed man and woman. The man tenderly holds his arm around the woman; displayed before her is a bridal girdle. The young couple are to be wed and have apparently come to buy a wedding ring.

Christus has included in this work more than thirty depictions of jewels and other precious objects, and the painting is one of our most important sources of knowledge of fifteenth-century goldsmiths' work. *Saint Eligius* has been called the first genre painting.

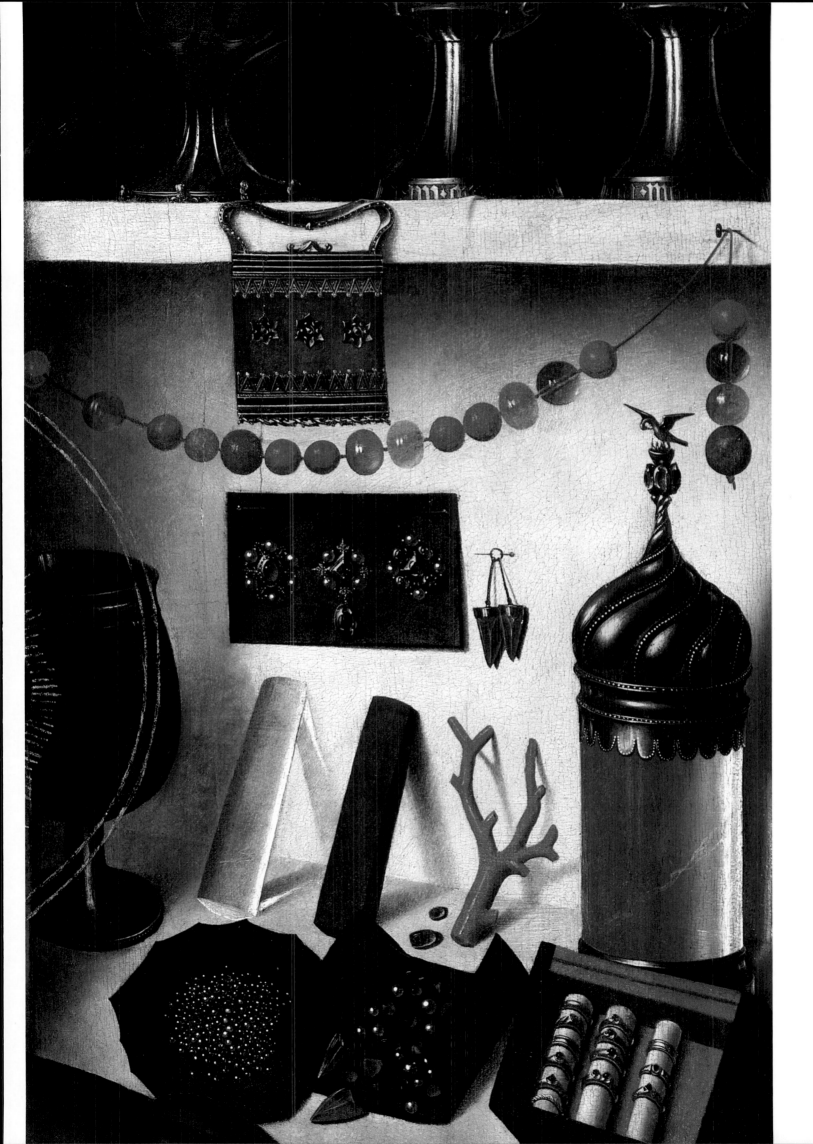

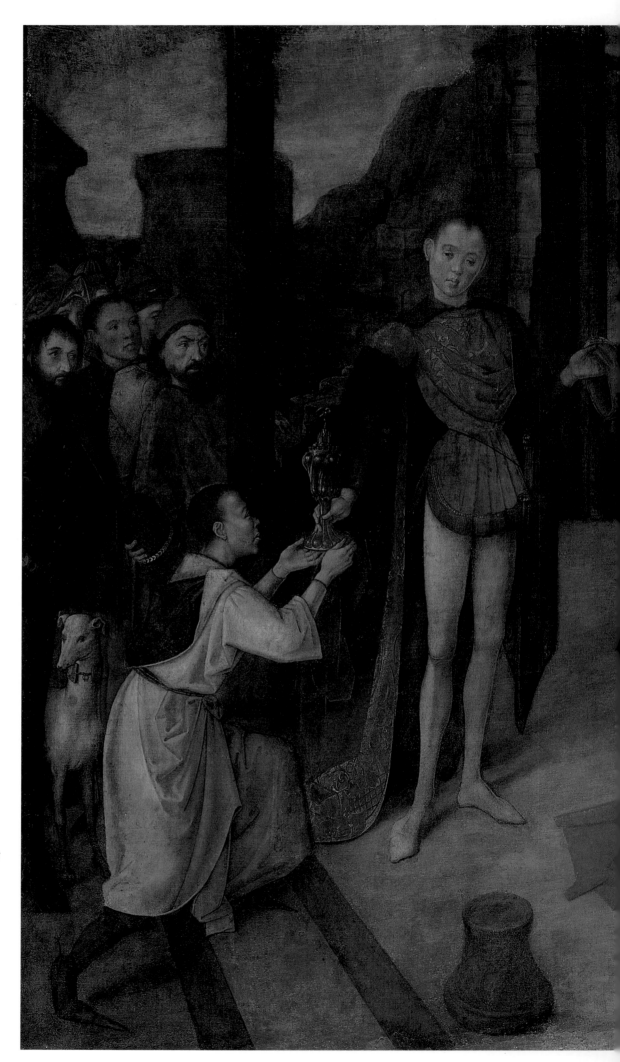

8 The Adoration of the Magi, ca. 1467
Joos van Ghent
Flemish, act. ca. 1460–d. ca. 1480
Tempera on linen;
43 x 63 in. (109.2 x 160 cm.)
Bequest of George Blumenthal,
1941 (41.190.25)

Page 32: text

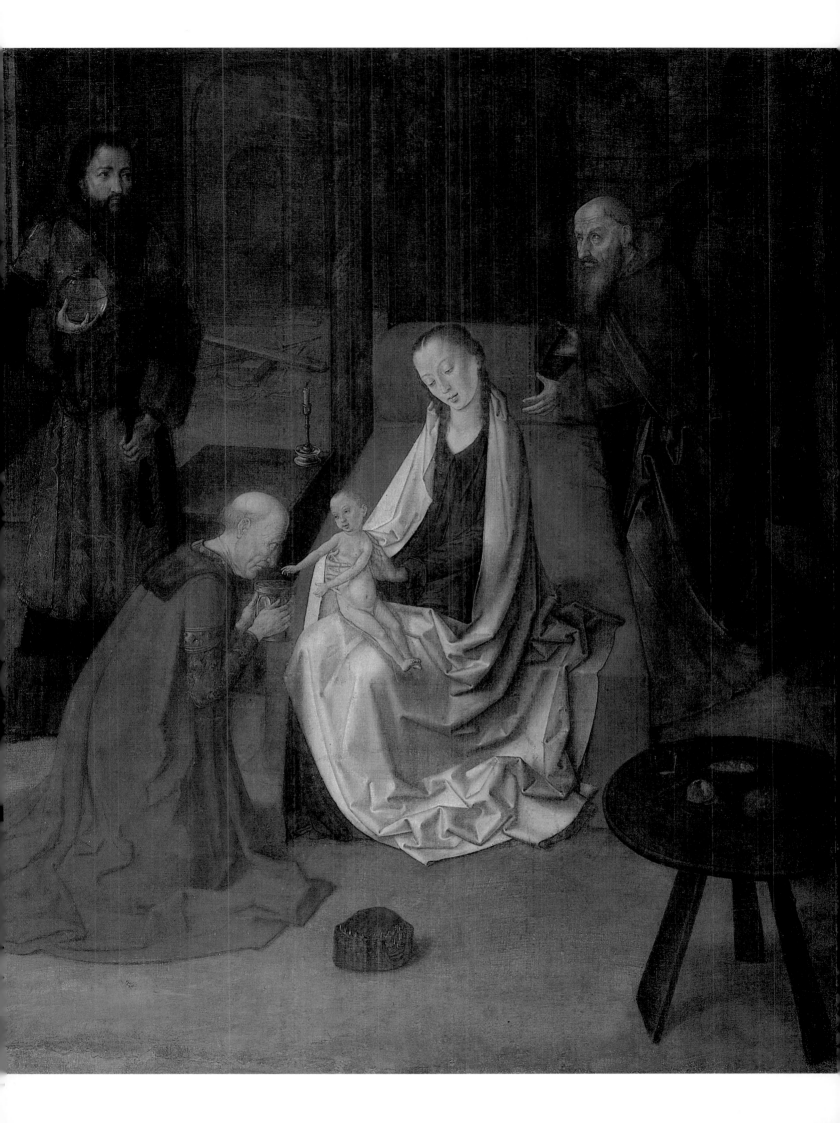

JOOS VAN GHENT (Pages 30–31)
The Adoration of the Magi

This gentle and reverent Adoration of the Magi was painted in the mid-1460s by Joos van Wassenhove, known more generally as Joos van Ghent because he registered in Ghent as a free master in 1464. Joos was inscribed as a free master in the Antwerp painters' guild in 1460, but at the end of the decade he moved to Italy—one of the first major artists from the Netherlands to do so—and worked for Fe lerigo da Montefeltro, duke of Urbino. He remained in Italy for the rest of his life.

The softened contours and muted colors of this work are the result of its medium and support: tempera (a thin glue medium) on linen, which has absorbed much of the pigment over the years, producing the faded effect so striking in contrast to the more familiar effect of oil on wood. The composition owes much to Dieric Bouts, especially the elongated forms of the figures and the capacious spatial arrangement with the figures set back in depth.

HUGO VAN DER GOES
Portrait of a Man

Self-doubting yet ambitious, Hugo van der Goes was haunted by an overwhelming sense of man's sinfulness and of the potential for tragedy in life. In his later years he retired to a monastery near Brussels in an attempt to find the peace of mind that had hitherto eluded him. There he apparently suffered a total nervous breakdown.

This sensibility can be detected in many of his paintings. Hugo was adept at vivid psychological characterization. His portraits do not display the immobile faces found in works by Jan van Eyck and Rogier van der Weyden but depict individuals who seem to respond to the fleeting moment. Hands are especially expressive in Hugo's works and often

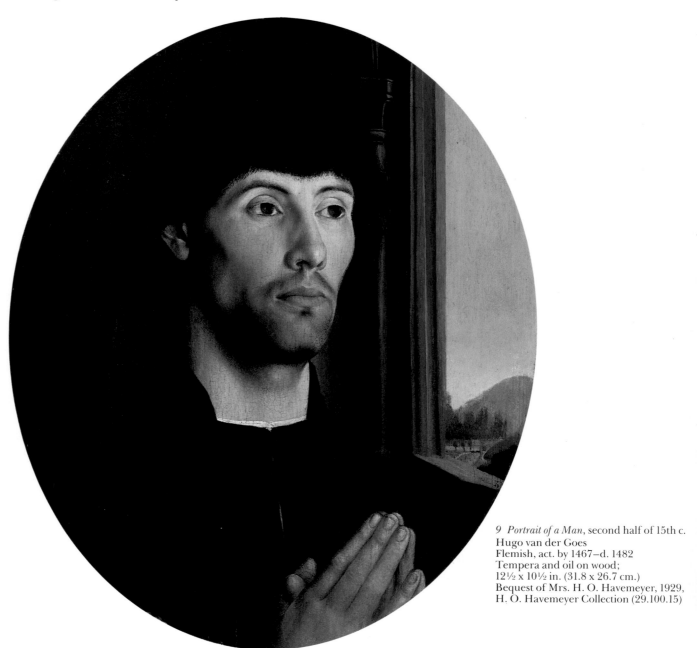

9 *Portrait of a Man*, second half of 15th c.
Hugo van der Goes
Flemish, act. by 1467–d. 1482
Tempera and oil on wood;
12½ x 10½ in. (31.8 x 26.7 cm.)
Bequest of Mrs. H. O. Havemeyer, 1929,
H. O. Havemeyer Collection (29.100.15)

HANS MEMLING
Portrait of a Young Man

serve to charge the composition with a nervous intensity.

The *Portrait of a Man* survives in fragmentary form. Its oval shape is not original: It has been cut down from what was presumably a rectilinear format and was probably the left half of a diptych, or possibly part of a larger panel from an altarpiece. A section of the window frame and most of the sky in the view at the right have been repainted where a piece of the panel has been replaced with a wedge inserted at a later date. The presentation of the head with its powerfully modeled features viewed from below relates it to the portraits in Hugo's Portinari altarpiece, now in the Uffizi, Florence, which was painted about 1475/76.

At the death of Hans Memling, a contemporary wrote, "Johannes Memlinc was the most accomplished and excellent painter in the entire Christian world." He is still greatly admired for the mastery of his technique and the tranquil atmosphere in his works. There is a kinship to the placidity of Raphael: However dramatic the subject (the horror of the beheading of John the Baptist or the rapture of the mystical marriage of Saint Catherine of Alexandria), the participants and onlookers retain their stillness.

Memling was an excellent portraitist, following the lead of Jan van Eyck and Petrus Christus. This picture of an unknown sitter—his physiognomy and dress indicate that he was one of the many Italians living prosperously in Bruges—was painted in the early 1470s and is considered one of Memling's best portraits.

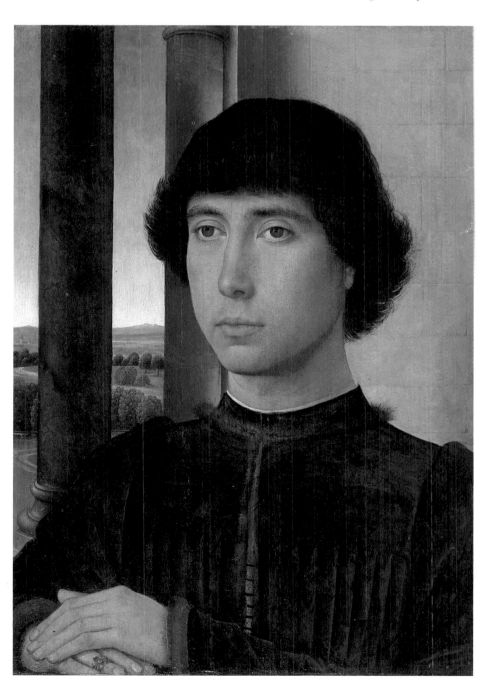

10 Portrait of a Young Man, ca. 1470–75
Hans Memling
Flemish, act. by 1465–d. 1494
Oil on wood; 15¼ x 11⅛ in.
(38.8 x 28.3 cm.)
Robert Lehman Collection, 1975
(1975.1.112)

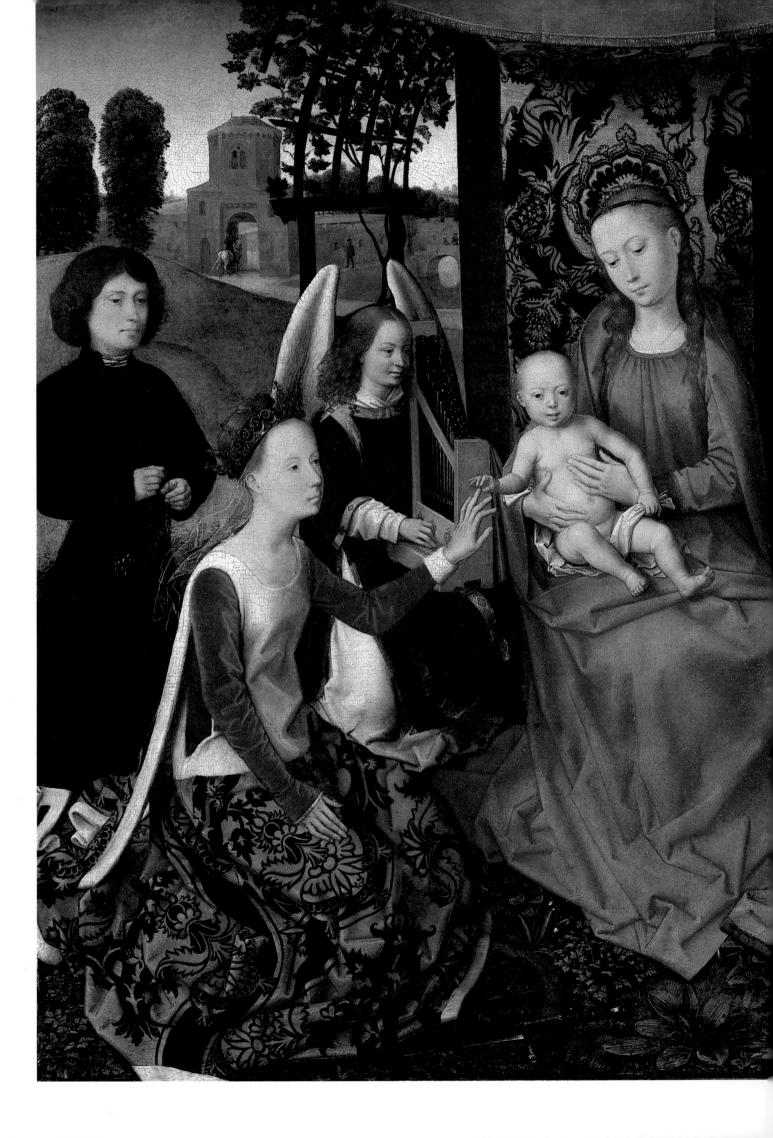

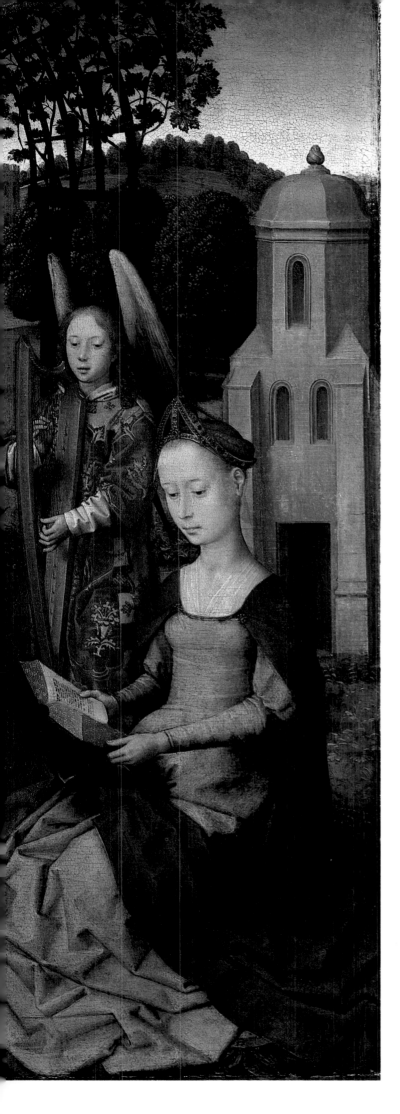

11 *The Marriage of Saint Catherine*,
second half of 15th c.
Hans Memling
Flemish, act. by 1465–d. 1494
Tempera and oil on wood;
27 x 28⅞ in. (68.6 x 73.3 cm.)
Bequest of Benjamin Altman, 1913
(14.40.634)

HANS MEMLING
The Marriage of Saint Catherine

This work depicts the mystical marriage of Saint Catherine of Alexandria, whose popularity in the Middle Ages was second only to that of Mary Magdalen. The subject is drawn from the legend wherein the saint dreams that she is marrying the Christ Child and awakens to find a ring on her finger. As in other paintings by Memling, the drama of the moment is in no way reflected by the expressions on the faces of the participants.

In addition to the central action, Memling has identified the saint by including in the foreground the sword and wheel that were the instruments of her martyrdom. The canopied throne of the Virgin is flanked by music-making angels and, on the left, a male donor. The grape arbor may have been a later addition, since it appears to have been painted over the sky and the landscape background. Saint Barbara, also a mystical bride of Christ, is shown kneeling at the right in front of the tower in which she was imprisoned by her jealous father and that was the location of her surreptitious conversion to Christianity.

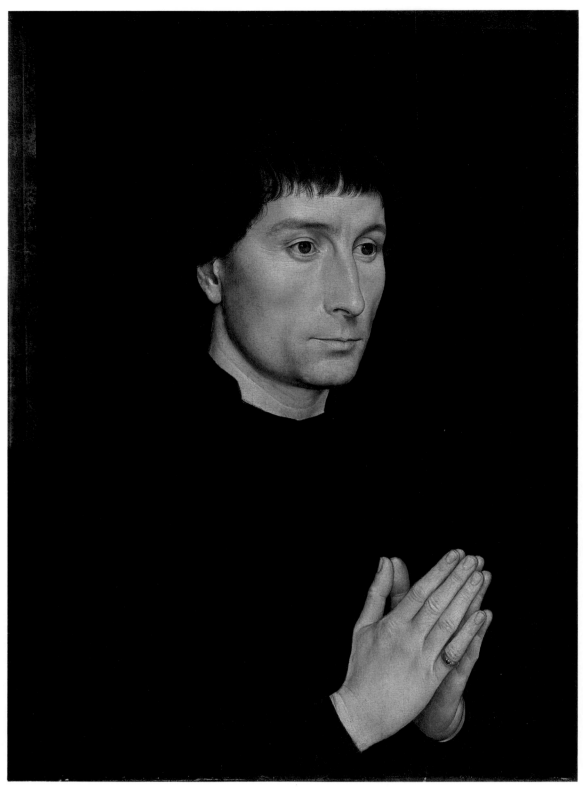

12 *Tommaso Portinari*, ca. 1470
Hans Memling
Flemish, act. by 1465–d. 1494
Tempera and oil on wood;
17⅜ x 13¼ in. (44.1 x 33.7 cm.)
Bequest of Benjamin Altman,
1913 (14.40.626)

HANS MEMLING
Tommaso Portinari and *Maria Baroncelli*

Although born in Germany, Hans Memling is considered to be a Flemish painter because he spent most of his life in Bruges. His work was highly popular, particularly with the large, affluent Italian community residing there.

Tommaso Portinari may have commissioned these portraits to commemorate his marriage to Maria Maddalena Baroncelli in 1470. The pose of the sitters indicates that the panels were the wings of a triptych that probably had as its center panel a half-length Virgin and Child.

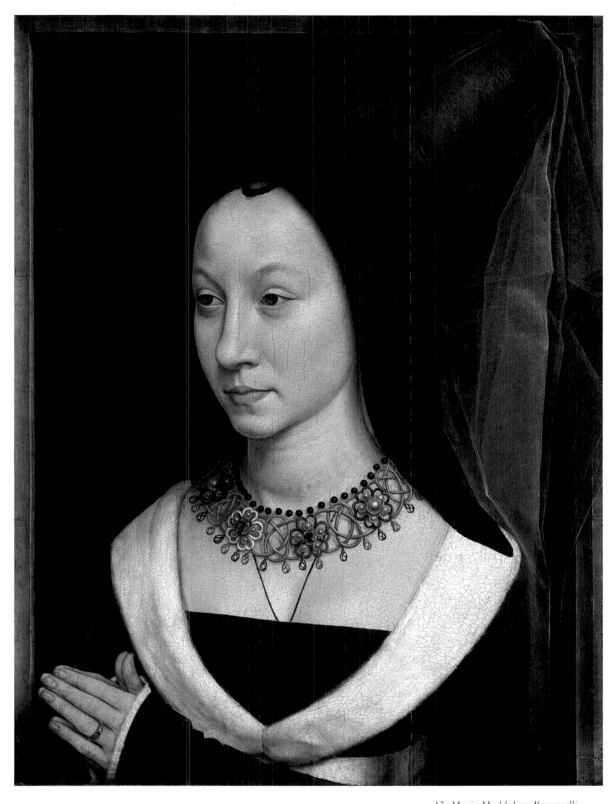

13 *Maria Maddalena Baroncelli,*
Wife of Tommaso Portinari, ca. 1470
Hans Memling
Flemish, act. by 1465–d. 1494
Tempera and oil on wood;
17⅜ x 13⅜ in. (44.1 x 34 cm.)
Bequest of Benjamin Altman, 1913
(14.40.627)

Portinari was a Florentine merchant banker who repre-
sented the Medici interests in Bruges. He was thirty-eight
years old and a man of standing and culture when he mar-
ried the fourteen-year-old Maria Baroncelli. He loved Flemish
art and commissioned other works by Flemish artists, in-
cluding the Portinari altarpiece by Hugo van der Goes, now
in the Uffizi, Florence, in which Tommaso and Maria
Portinari are also portrayed. Indeed, Maria wears the same
necklace in both works.

HANS MEMLING
Annunciation

One of the most engaging aspects of Flemish religious art is its use of contemporary genre backgrounds for momentous biblical events. Memling's *Annunciation* is set in the ordinary, if comfortably bourgeois, home of a Bruges merchant, stocked with the artifacts of everyday life. The selection of items, however, was not artless: These household objects double as religious symbols. The brass candlestick and the half-filled glass bottle represent the glory and clarity of the Virgin; the lilies in the foreground are the flowers of her purity—symbolic references that Memling learned from Jan van Eyck and Robert Campin, two earlier Flemish painters. The serenity and the cool, limpid colors resemble those of Rogier van der Weyden, a Flemish artist who preceded Memling by about thirty years.

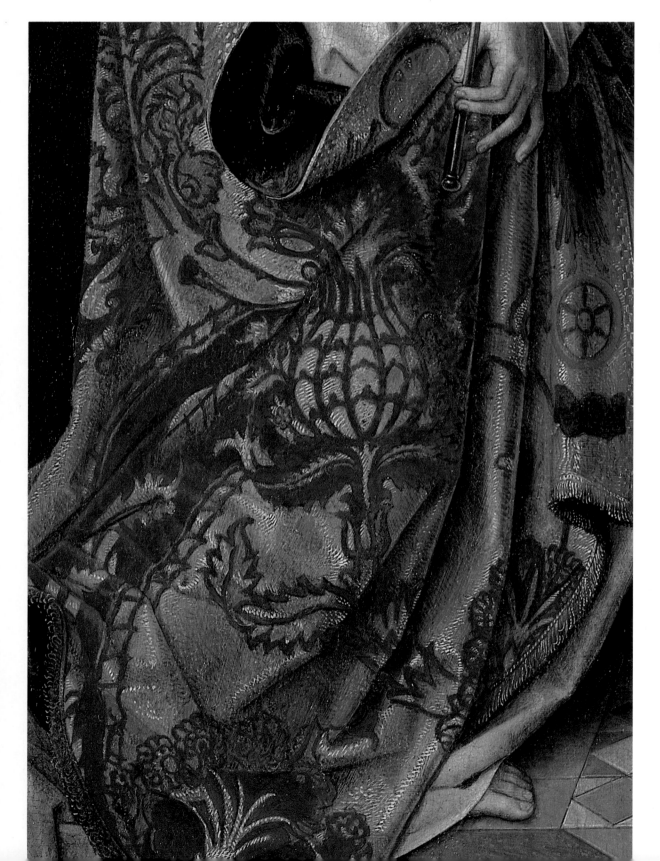

14 Annunciation, 1482
Hans Memling
Flemish, act. by 1465–d. 1494
Oil on wood;
32 x 21⅝ in. (81.3 x 54.9 cm.)
Robert Lehman Collection,
1975 (1975.1.113)

Left: detail

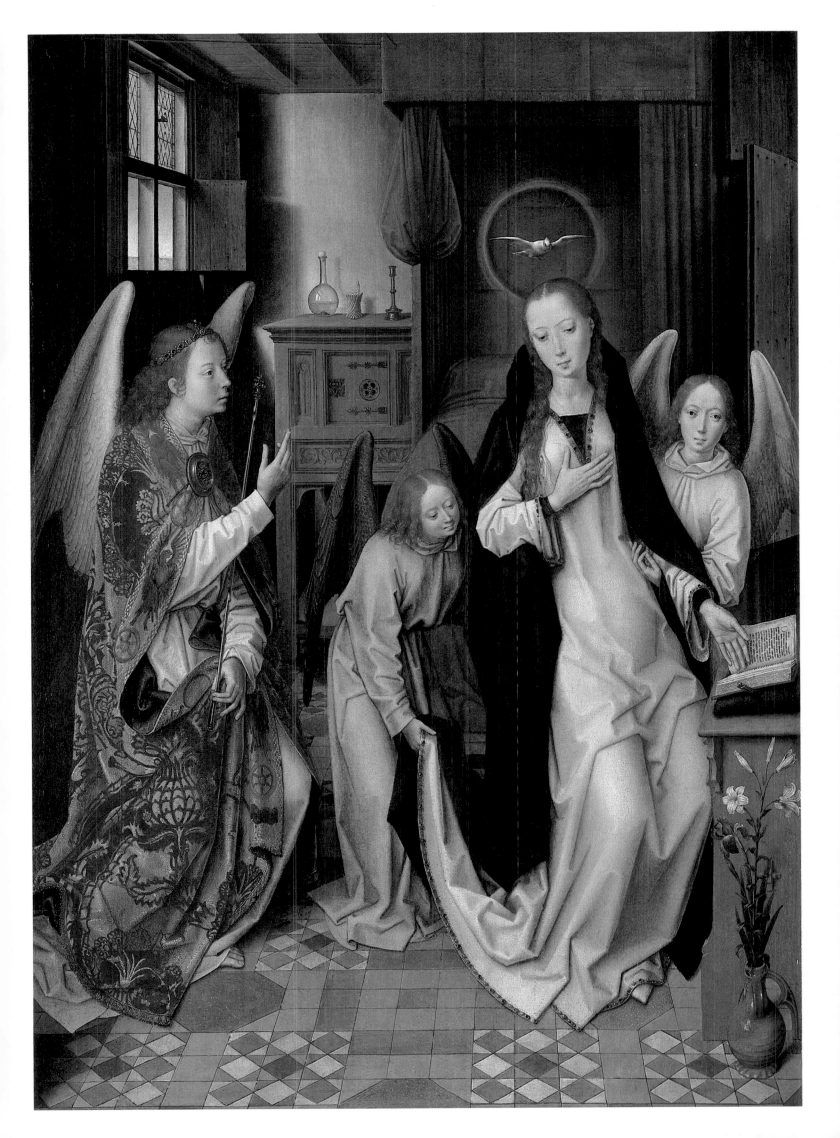

MASTER F.V.B.

Saint Barbara

The man known as Master F.V.B. (the "V.B." may stand for "van Brugge"—"of Bruges") was one of the very finest early Flemish engravers, and one of the few early non-Italian engravers to copy paintings.

Saint Barbara was the daughter of a heathen nobleman, who had a tower built in which to lock his daughter to keep her from suitors. The tower was to have only two windows, but in her father's absence Saint Barbara persuaded the workmen to add a third, so that the windows would stand for the Trinity. She managed as well to let a priest into the tower to baptize her. When her father returned, he was enraged and turned her over to the Romans. She refused to reject Christianity and was beheaded by her father.

Here the saint, patroness of armorers and firearms, stands in front of the tower, her most common attribute. The feather Saint Barbara holds may be a peacock feather, a symbol of immortality.

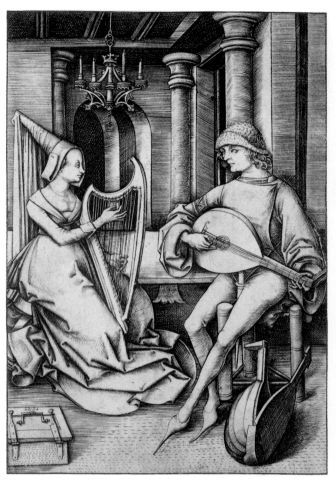

16 *Lute and Harp Duet*, 1490s
Israhel van Meckenem
German, before 1450–d. 1503
Engraving;
6¼ x 4¼ in. (16 x 10.8 cm.)
Harris Brisbane Dick Fund,
1927 (27.5.2)

15 *Saint Barbara*, 1475–1500
Master F. V. B.
Dutch
Engraving;
6⁹⁄₁₆ x 3¹¹⁄₁₆ in. (16.6 x 9.2 cm.)
The Elisha Whittelsey Collection,
The Elisha Whittelsey Fund,
1955 (55.530)

ISRAHEL VAN MECKENEM

Lute and Harp Duet

Israhel van Meckenem, an extremely prolific engraver, provides us with an early example of the mass production of prints. He amassed more than six hundred copper plates, from which he made a huge number of impressions. He would repeatedly retouch worn areas of the plates in order to maintain this great output, although he made them last as long as possible by using a rather heavy hand to drive his graver.

Virtually all of Israhel's work was copied from the work of other men. He copied some 145 engravings by the Master E.S. (see Plate 58), and added "IM" or "Israhel" to forty-one more plates actually engraved by E.S. himself. In addition, he apparently engraved thirty lost drawings or drypoints by the Housebook Master. Among these were six engravings of couples dancing or playing music, including the example reproduced here, depicting a young couple playing a lute and a harp. The unidealized couple (note the lady's long nose and the man's pointed chin) and the rather simple, unadorned interior remind us that the realistic depiction of life on earth is an important characteristic of Northern Renaissance art, distinguishing it from the more thoroughly religious art of Italy.

FRENCH OR FLEMISH WORKSHOP
Playing at Quintain

Toward the close of the Middle Ages, silver-stained glass roundels were a popular form of decoration in Northern Europe. They were attractive to guilds as decorative illustrations, often depicting the patron saint of the organization. They were also considered suitable as donations and were set as highlights in windows of clear-glass diamond panes, where they attested to the solid prosperity of the burgher class. In private homes the subject of the roundel was usually drawn from the Bible or from the legend of a revered saint.

The roundel seen here is unusual in that its subject matter is purely genre. It illustrates the popular game of quintain, which developed from a rougher version used to train knights for the joust. It was taken up, in a modified version involving a three-legged stool or a bench instead of a horse, by the peasantry and was popular with young couples since it allowed for the physical horseplay that is so often part of courtship. The object of the game was for the standing player to topple the seated one, as the knight would tilt at his opponent.

The style of this piece is based on the designs of the Pigouchet workshop of Paris, whose printed books were widely influential and provided the prototype for many tapestries and stained-glass works.

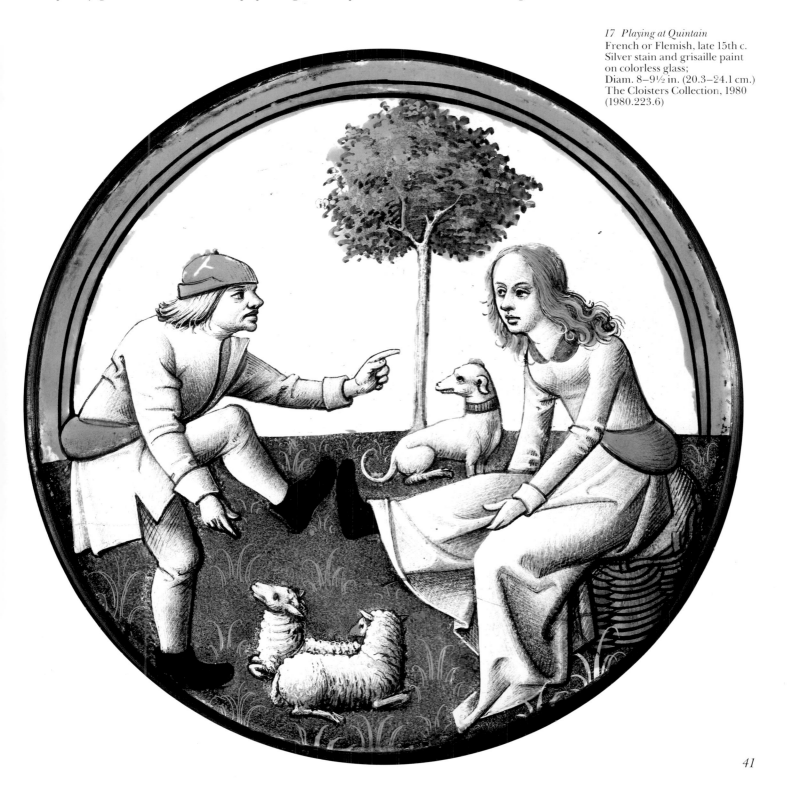

17 Playing at Quintain
French or Flemish, late 15th c.
Silver stain and grisaille paint
on colorless glass;
Diam. 8–9½ in. (20.3–24.1 cm.)
The Cloisters Collection, 1980
(1980.223.6)

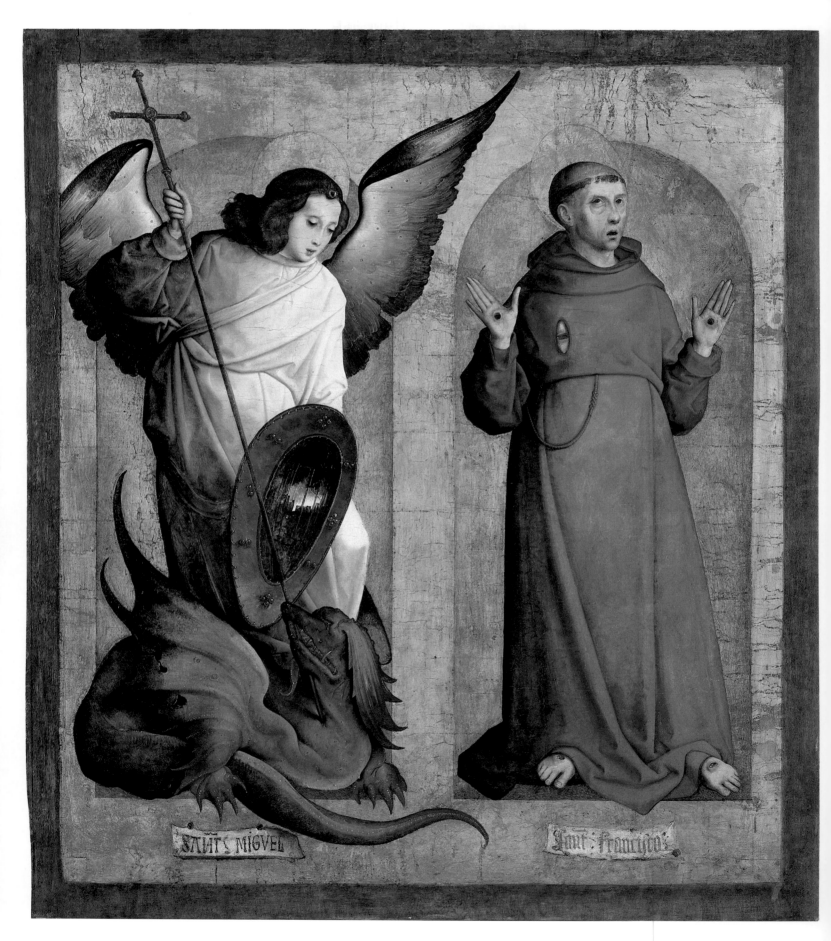

SANT MIGVEL Sant Francisco

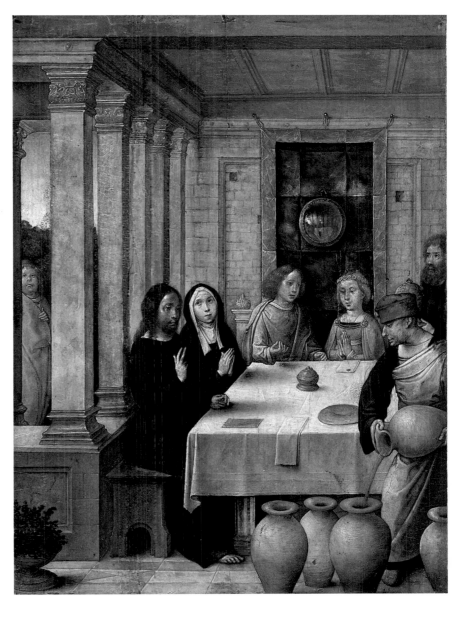

18 *Saints Michael and Francis*, 1505–09
Juan de Flandes
Flemish, act. in Spain by 1496–d. 1519
Tempera and oil on wood;
36⅞ x 32¾ in. (93.7 x 83.2 cm.)
Purchase, Bequest of Mary Wetmore
Shively, in memory of her husband,
Henry L. Shively, M.D., 1958 (58.132)

19 *The Marriage Feast at Cana*, ca. 1500
Juan de Flandes
Flemish, act. in Spain by 1496–d. 1519
Oil on wood; 8¼ x 6¼ in. (21 x 15.9 cm.)
The Jack and Belle Linsky Collection,
1982 (82.60.20)

JUAN DE FLANDES

Juan de Flandes probably trained as an artist in Bruges, or possibly in Ghent. However, all of his known works were created in Spain, where he worked for Isabella the Catholic, queen of Castile and León, who is best known to posterity for her sponsorship of the voyage on which Christopher Columbus discovered the New World.

The panel painting of Saints Michael and Francis is probably a fragment of the retable made for the chapel of the University of Salamanca, on which Juan de Flandes worked from 1505 until 1509. The saints are pictured with the symbols of their legends. Saint Michael, an archangel whose origins are ancient and who represents the church militant, is shown as described in the Book of Revelations, slaying a dragon that represents the forces of darkness. His wings distinguish him from the other great dragon slayer of Christian mythology, Saint George. Saint Francis of Assisi, the founder of the order of the Franciscan friars, died in 1226 and was a more recent and verifiable historical figure at the time of the work. He was widely revered, especially in Italy, and there were many legends attached to his life. He is seen here bearing the stigmata, or wounds, corresponding to those

inflicted upon Christ. According to Christian myth, they were a sign of exceptional religious devotion visited upon Saint Francis and Saint Catherine of Siena as testimony of their intense personal identification with Christ.

The Marriage Feast at Cana, a small, remarkably well-preserved panel painting, is one of forty-seven panels commissioned in about 1500 by Queen Isabella. They are presumed to have been intended as a portable altarpiece. Albrecht Dürer referred to them in 1521: "I saw about forty small panels painted in oil, the likes of which I have never seen for purity and quality." The subject of the Museum's panel is the first miracle performed by Christ, whereby he spared the host embarrassment at a wedding by changing water into wine after the supply of wine had been exhausted. In the Middle Ages, tradition held that the occasion was the wedding of John the Evangelist and Mary Magdalen; the apostlelike appearance of the bridegroom supports this interpretation. The man outside the loggia, glancing toward the viewer, is thought to be a self-portrait. The asymmetry and cropping suggest that the feast extended beyond the confines of the frame.

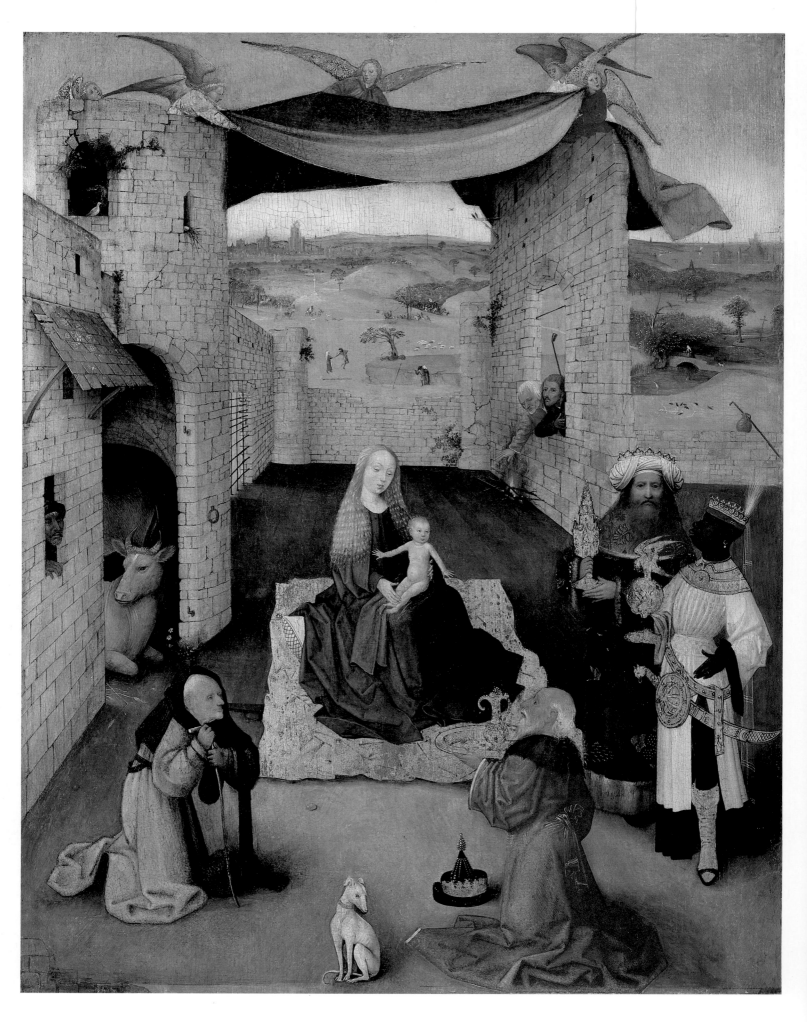

HIERONYMUS BOSCH
The Adoration of the Magi

Renowned for his phantasmagoric compositions, Hieronymus Bosch nonetheless remains an enigmatic figure about whose life little is known. He spent his entire career in 's Hertogenbosch, a Dutch town from which he took his name to avoid confusion with other members of his family who were painters; he was a religious man who belonged to one of the most respected and pious Catholic confraternities; and he married the daughter of an affluent pharmacist who probably imparted to him the knowledge of alchemy and science that he incorporated in some of his works. In the century after his death he became the favorite painter of Philip II of Spain, who collected his work avidly, thus assembling the unparalleled collection at the Prado, Madrid.

Bosch painted several versions of the Adoration of the Magi, perhaps because its exotic cast of characters appealed to his taste for the bizarre. The painting in the Museum's collection is considered to be one of the artist's earliest works, partly because the figures are still awkward. The landscape, however, is similar to the background in the larger and probably later version in the central panel of his Epiphany altarpiece in the Prado.

20 The Adoration of the Magi
Hieronymus Bosch
Flemish, act. by 1480–d. 1516
Tempera and oil on wood;
28 x 22¼ in. (71.1 x 56.5 cm.)
John Stewart Kennedy Fund,
1912 (13.26)

Right: detail

GERARD DAVID
The Rest on the Flight into Egypt

The influence of Italian Renaissance art can be more clearly seen in the works of Gerard David than in those of his predecessor in Bruges, Hans Memling. David was a respected and industrious painter whose popularity spread as far south as Italy, where he painted several important works for Genoese patrons. After his death David's reputation declined, and for more than three centuries he was forgotten. Only in the nineteenth century did his reputation come to the fore once again.

Born in Oudewater, near Gouda in southern Holland, during the second half of the fifteenth century, David became a member of the Bruges painters' guild in 1484. He succeeded Memling as the leading painter in the city, was elected to the guild leadership four times, and ran a large and prosperous workshop.

The Rest on the Flight into Egypt refers to the story in the Gospel According to Matthew in which Joseph, who had been forewarned in a dream, took his family beyond the reach of the jealous King Herod. It became a popular and widely depicted subject in the late fifteenth and early sixteenth centuries and was painted by David several times. This version is one of his most popular treatments. The Virgin is seen resting in the foreground, and the scene in the background depicts the journey. The extensive landscape setting attests to David's role in the introduction of that genre in Northern European painting.

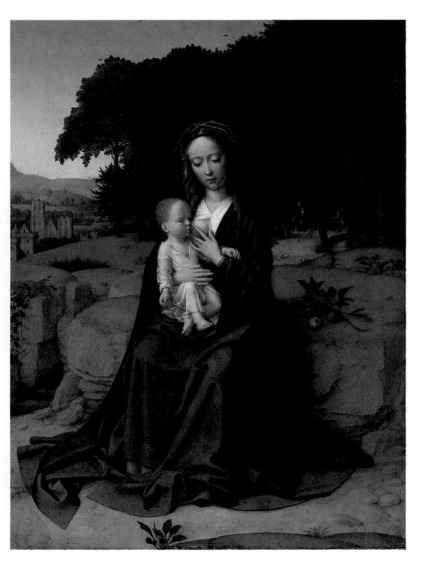

GERARD DAVID
The Annunciation

The pair of paintings seen here originally formed the outer wings of an altarpiece by Gerard David. They recount the New Testament story of the Annunciation, in which the archangel Gabriel, on the left, appears before the Virgin to tell her that she will be the mother of Christ. The style of the works indicates that they were painted in about 1500. The inner panels of the altar, which are also in the Robert Lehman Collection of the Metropolitan, depict Christ bearing the cross, the Crucifixion, and the Resurrection. It has been suggested that the scene in the center may have been the Pietà now in the Philadelphia Museum of Art, in which case the entire altar, when open, would have depicted scenes from the Passion. When the altar was closed during Lent, *The Annunciation*, with its grisaille tones, would have presented the appropriate aspect of mourning, although the gray has been lightened with touches of pale flesh tones as if to infuse hope and remind the viewer of the possibility of salvation. Though sober in color, these panels are not somber.

The outer and inner wings were separated early in the nineteenth century, but it is not known when they were detached from the central panel. The four paintings in the Metropolitan are all in excellent condition and reveal the fine details and careful brushstrokes of David's work.

21 The Rest on the Flight into Egypt
Gerard David
Flemish, act. by 1484–d. 1523
Tempera and oil on wood;
20 x 17 in. (50.8 x 43.2 cm.)
The Jules Bache Collection, 1949
(49.7.21)

22 The Annunciation, ca. 1500
Gerard David
Flemish, act. by 1484–d. 1523
Oil on canvas;
each 34 x 11 in. (86.4 x 28 cm.)
Robert Lehman Collection, 1975
(1975.1.120)

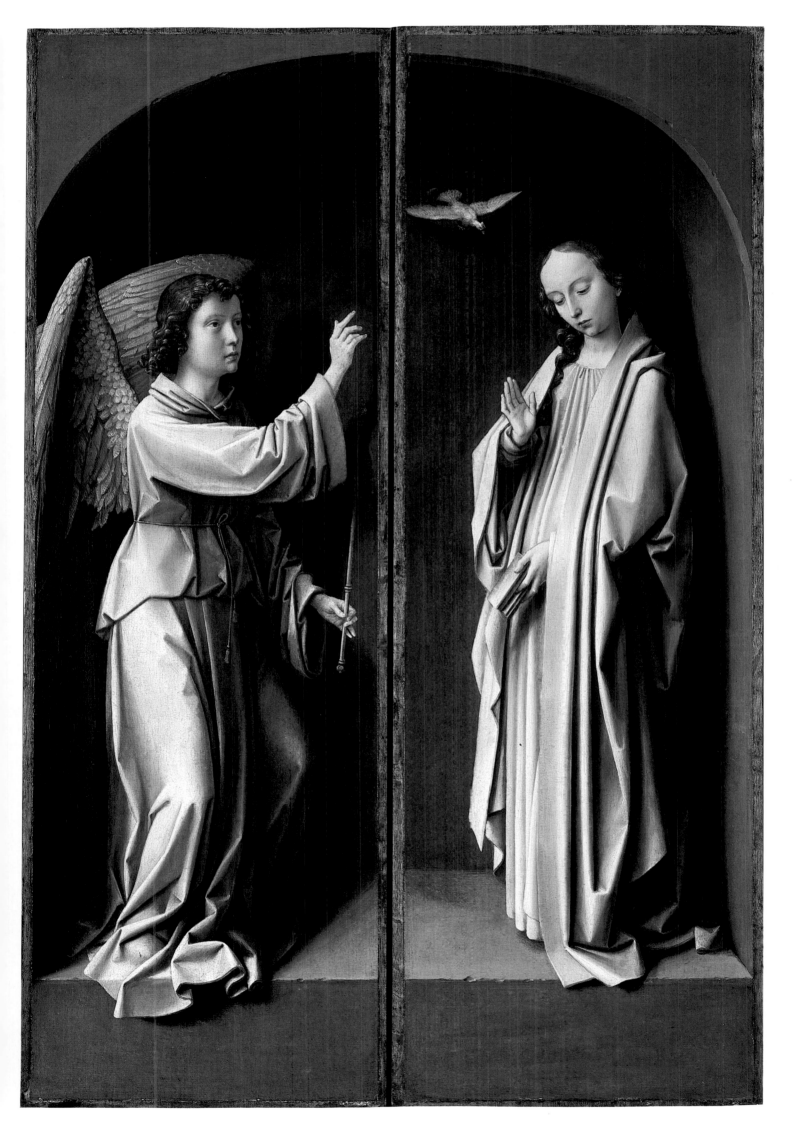

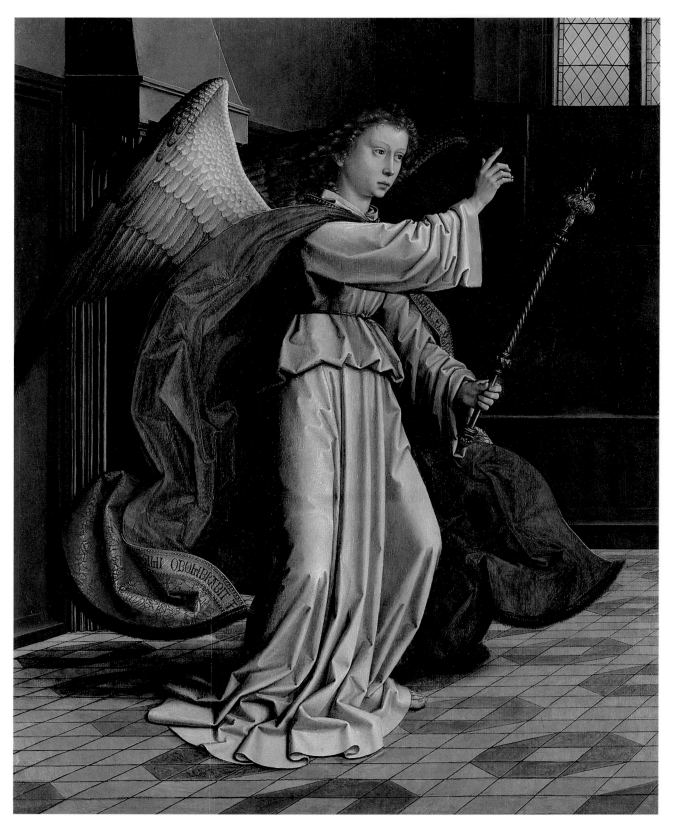

23, 24 The Annunciation, 1506
Gerard David
Flemish, act. by 1484–d. 1523
Tempera and oil on wood;
each panel 30 x 24 in.
(76.2 x 61 cm.) Bequest of
Mary Stillman Harkness, 1950
(50.145.9ab)

GERARD DAVID
The Annunciation

Part of a polyptych, these panels were painted by Gerard David in 1506 for the abbey church of San Girolamo della Cervara, near Genoa. In his own city of Bruges, David was enormously successful, and his fame had spread southward to Italy, where his tranquil Virgins and the subtlety of his colors were evidently appealing. The main panels of this

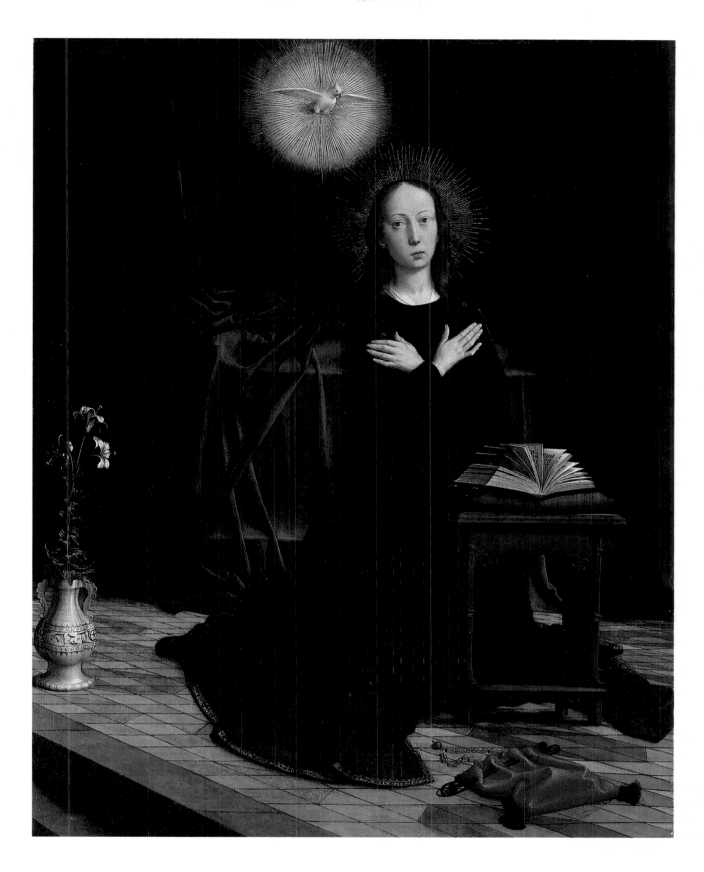

altarpiece depict Saints Jerome and Benedict, and the Virgin and Child. They are now in Genoa. A lunette showing God between two angels is in the Louvre.

The Metropolitan Museum's panels depict the Annunciation. The contrast between the stillness of the Virgin's pose, eyes raised and hands crossed on her breast, and the action of Gabriel. who appears to have just alighted, right hand raised in greeting and muscles still tensed, enlivens the composition. In the cool, neutral tones of the background, the shades of blue and blue-green of the clothing and the shot green and pink that line Gabriel's cloak are characteristic of David's refined color sense.

25 *The Brindle Cat*, 1546
Jan Vermeyen
Dutch, 1500–59
Drypoint; 8¾ x 5⅞ in.
(22.2 x 14.9 cm.)
Harris Brisbane Dick
Fund, 1933 (33.52.74)

JAN VERMEYEN
The Brindle Cat

Engraving is a technique in which the surface of a metal plate, usually copper, is gouged with a graver to create an intaglio design. The plate is then inked, the excess ink is wiped away, and with tremendous force the plate is pressed against dampened paper on which the ink-filled cavities leave their image. In drypoint, which is a variation of the engraving process, a needlelike instrument is used instead of a graver to produce lines with a ragged or blurred edge. Ink bleeds into the tiny veins of the ragging and softens the effect of the printed line.

Drypoint was used by the Dutch artist Jan Vermeyen to produce this image of a woman holding a brindle cat. Vermeyen was a Dutch painter and tapestry designer who became court painter to Margaret of Austria (see Plate 98), regent of the Netherlands, in 1525. An adventurer who traveled to Spain and North Africa, Vermeyen was an individualist who managed to maintain a Dutch style in spite of the dissemination of prints and of Italian taste across Europe.

In this work, a distinctly Northern maiden with upright posture, almond eyes, and full lips and chin gazes stoically before her while a cat perches somewhat uncomfortably on her crossed arms.

LUCAS VAN LEYDEN
The Milkmaid

Lucas van Leyden was a child prodigy who produced his first engraving at fourteen. He became one of the greatest followers of Albrecht Dürer, concentrating on genre subjects and, in the characteristic Northern manner, adapting religious themes to everyday people and settings.

This engraving of a milkmaid, a farmhand, a cow, and a bull, set in a farm landscape, is often referred to as the first truly bucolic scene in Dutch art. With the meticulous attention typical of Dürer, Lucas shows the flesh sagging from the bony spine of the cow, the cleft hooves of the animals, and the ample bosom of the milkmaid. James Snyder points out that the male of both species eyes the female with a markedly similar interest and intention and suggests that the scene may be an illustration of a double entendre in Dutch—the verb *melken*, "to milk," can also mean "to entice."

26 *The Milkmaid*, 1510
Lucas van Leyden
Dutch, 1494–1533
Engraving; 4⁹⁄₁₆ x 6⅛ in.
(11.7 x 15.6 cm.)
Harris Brisbane Dick Fund,
1926 (26.64.4)

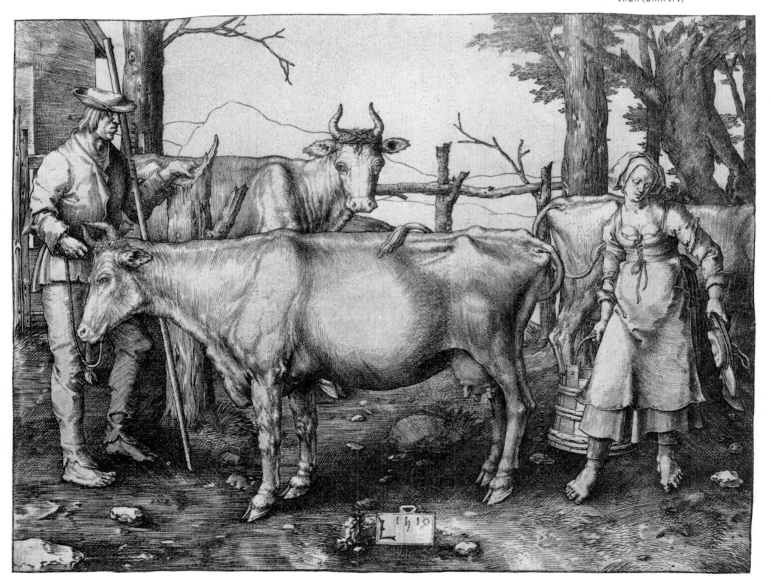

27 *The Annunciation*
Joos van Cleve
Flemish, act. by 1507–d. 1540/41
Tempera and oil on wood;
34 x 31½ in. (86.4 x 80 cm.)
The Friedsam Collection, Bequest of
Michael Friedsam, 1931 (32.100.60)

JOOS VAN CLEVE
The Annunciation

In the early years of the sixteenth century, a Mannerist style of painting flourished in the prosperous bourgeois city of Antwerp, where the paintings of Joos van Cleve were highly popular. This depiction of the Annunciation, full of genrelike detail, provides an image of an affluent domestic interior of the artist's day. The comfortable bedroom is furnished with a canopied bed, a bull's-eye mirror, a small folding triptych on an oak cabinet that suggests an altar for private devotions, an elaborate chair of wrought iron and brass, an oak bench, a prie-dieu, and a brass chandelier. An attractively tiled floor is featured, as are shuttered and stained-glass windows and a large fireplace above which burns a single candle against a brass charger.

There is concealed religious content in much of the seemingly merely domestic detail: The burning candle represents the presence of the Holy Spirit, the lily stalk in the vase stands for the purity of the Virgin, and the subject of the triptych, the meeting of Abraham and Melchizedek, was understood in the sixteenth century to be an Old Testament prefiguration of the Last Supper, and thus of Christ's sacrifice for man's salvation. The hand-colored woodblock print tacked to the wall depicts the archetypal Old Testament subject: Moses bearing the Tablets of the Law. Just as Moses receiving the commandments was the pivotal event marking the transition from the era before law (*ante legem*) to that under law (*sub lege*), the Incarnation of Christ marked the transition from the era *sub lege* to that *sub gratia* (under grace).

28 *Virgin and Child with Saint Joseph,*
ca. 1513
Joos van Cleve
Flemish, act. by 1507–d. 1540/41
Tempera and oil on wood;
16¾ x 12½ in. (42.5 x 31.8 cm.)
The Friedsam Collection, Bequest of
Michael Friedsam, 1931 (32.100.57)

JOOS VAN CLEVE
Virgin and Child with Saint Joseph

The Holy Family became a popular subject with painters in fifteenth-century Flanders as a result of the increasing importance of the cult of Saint Joseph. Joos van Cleve evidently found a ready market for his paintings of the Holy Family, for they were produced repeatedly in his workshop. The version seen here is one of his earliest, probably made around 1513. Both the positioning and the physiognomies of the Virgin and Child can be directly traced to Jan van Eyck's *Lucca Madonna*, now in the Städelsches Kunstinstitut, Frankfurt. The Virgin is seated behind a parapet on which is laid a variety of still-life elements that may simply be genrelike embellishments or may be loaded with symbolic religious content. The Virgin and Saint Joseph gaze with intense devotion at the Christ Child, who clutches an apple, symbol of original sin and an allusion to his role as the "new Adam," redeemer of mankind. The popularity of this composition is attested to by the numerous versions of it that survive.

29 *The Penitence of Saint Jerome,*
after 1515
Joachim Patinir
Flemish, act. by 1515–d. 1524
Tempera and oil on wood;
central panel 46¼ x 32 in.
(117.5 x 81.3 cm.),
each wing 47½ x 14 in.
(120.7 x 35.6 cm.)
Fletcher Fund, 1936 (36.14a–c)

Pages 56–57: text and details

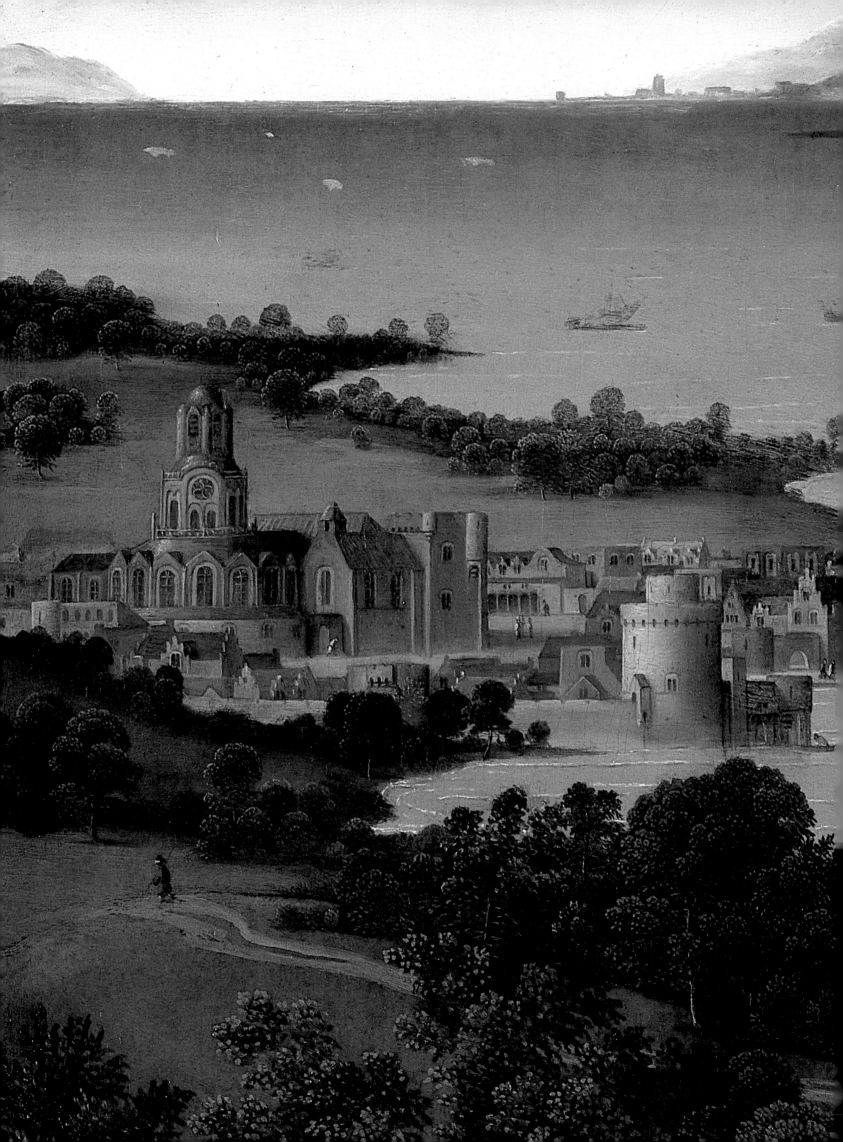

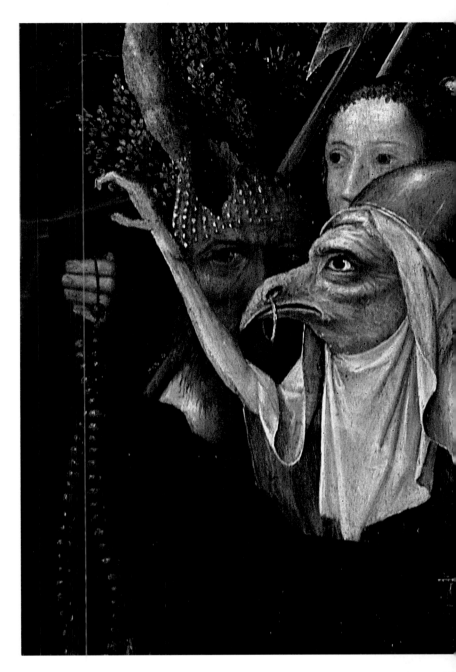

JOACHIM PATINIR (Pages 54–55)

The Penitence of Saint Jerome

Patinir came from either Dinant or Bouvignes and became
a master in Antwerp in 1515 at about the age of thirty-five.
Although he made no pure landscapes, his emphasis on the
natural setting over the narrative content of his paintings,
as well as the probably true report that he furnished land-
scape backgrounds for pictures by other artists, has caused
him to be regarded as the first landscape painter.

The center panel of this triptych depicts the penitence of
Saint Jerome, the baptism of Christ and the temptation of
Saint Anthony are shown on the interior wings. On the ex-
terior wings are Saint Anne with the Virgin and Child, and
Saint Sebald.

In this panoramic view, so vast that we seem to see the
curve of the earth, three saints are integrated in a setting
that includes harbors, towns, a monastery, and wilderness.

Details of *The Penitence of Saint Jerome* (Plate 29) 57

STAINED-GLASS PANELS

These panels are from a series of twelve depicting scenes from the life of Christ, originally in the great cloister of the Carthusian monastery in Louvain. Plate 30 shows a scene from the Parable of the Laborers in the Vineyard, in which the laborers arriving late are being paid as much as those who have worked all day. The panel in Plate 31 shows a scene from the Healing of the Paralytic at Capernaum: Christ was preaching in a house in Capernaum and a paralytic brought to him to be cured had to be lowered, while lying in his bed, through a hole in the roof because the crowds were too great for him to enter any other way. The panel in Plate 32 shows the Crucifixion, and that in Plate 33 illustrates a scene recounted by Matthew, Mark, and Luke in which Jesus quells a storm on the Sea of Galilee. Mark (4:35–41) tells that Jesus "rebuked the wind and said unto the sea, 'Peace! Be still!'"

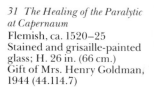

31 The Healing of the Paralytic at Capernaum
Flemish, ca. 1520–25
Stained and grisaille-painted glass; H. 26 in. (66 cm.)
Gift of Mrs. Henry Goldman, 1944 (44.114.7)

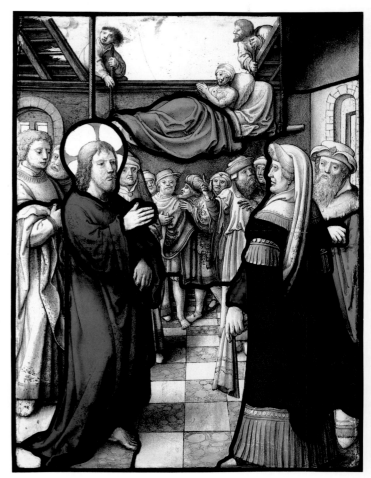

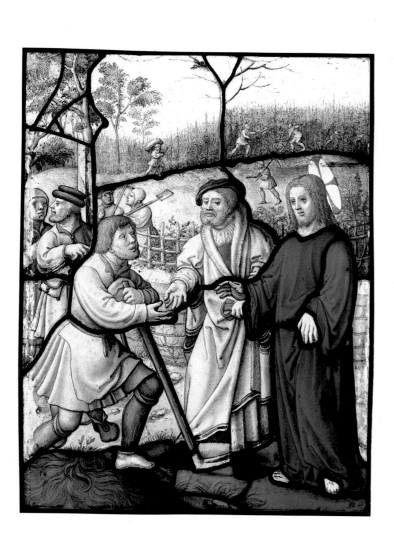

30 The Parable of the Vineyard
Flemish, ca.1520–25
Stained and grisaille-painted glass; H. 26 in. (66 cm.)
Gift of Mrs. Henry Goldman, 1944 (44.114.3)

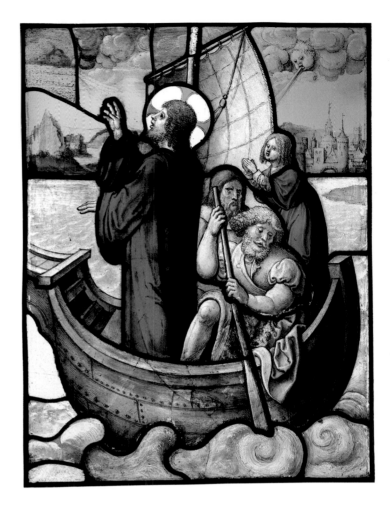

33 *Christ Rebukes the Storm*
Flemish, ca. 1520–25
Stained and grisaille-painted
glass; H. 20 in. (50.8 cm.)
Gift of Mrs. Henry Goldman,
1944 (44.114.1)

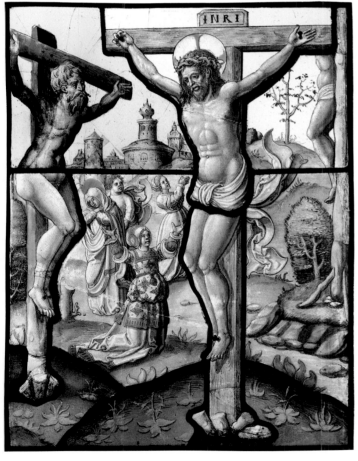

32 *The Crucifixion*
Flemish, ca. 1520–25
Stained and grisaille-painted
glass; H. 26 in. (66 cm.)
Gift of Mrs. Henry Goldman,
1944 (44.114.2)

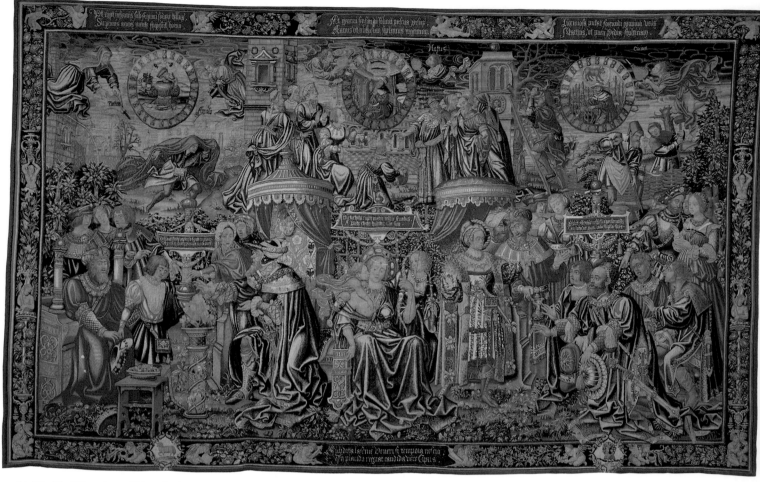

34 The First Three Ages of Man: Spring
Brussels, ca. 1520–25
Wool and silk, 14 ft. 7 in. x 23 ft. 8 in.
(4.45 x 7.28 m.) Gift of The Hearst Foundation,
in memory of William Randolph Hearst,1953
(53.221.1)

FLEMISH WORKSHOP
The Twelve Ages of Man

The theme of the ages of man, well known in the history of art, signifies the inevitable end of youth and beauty and the transience of mortal life. When the ages of man are depicted as twelve, each age comprises six years and corresponds to a particular month. Each of the tapestries reproduced here depicts three of the twelve ages.

Plate 37, for example, reproduces the tapestry showing the autumn of life, or ages thirty-six through fifty-four. Here Bacchus, the god of wine, presides. July, in which the grass dries up as the body's strength declines, is illustrated by a scene of the centaur Chiron instructing young Aesculapius in medicine. For August, in which the harvest is gathered as man should gather his wealth, Joseph is seen ordering the harvest to be cut and stored against the lean years ahead. September is the month of the vintage: Here, Hercules slays the dragon that defended the garden of the Hesperides and plucks the golden apples.

While today the average person might be less adept at deciphering the iconographic program than were the sixteenth-century patrons for whom the tapestries were made, we can still delight in the tapestries' rich colors and design and in the many charming details, such as the border figures and the landscapes, which are reminiscent of manuscript illumination.

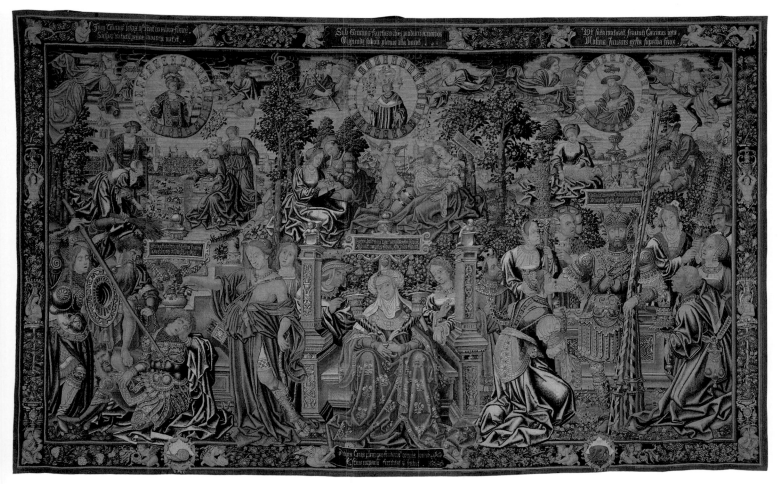

35 *The Second Three Ages of Man: Summer*
Brussels, ca. 1520–25
Wool and silk, 14 ft. 6¼ in. x 24 ft. 1 in.
(4.42 x 7.32 m.) Gift of The Hearst Foundation,
in memory of William Randolph Hearst, 1953
(53.221.2)

36 *The Fourth Three Ages of Man: Winter*
Brussels, ca. 1520–25
Wool and silk, 14 ft. 7 in. x 23 ft. 6 in.
(4.45 x 7.23 m.)
Gift of The Hearst Foundation, in memory
of William Randolph Hearst, 1953 (53.221.4)

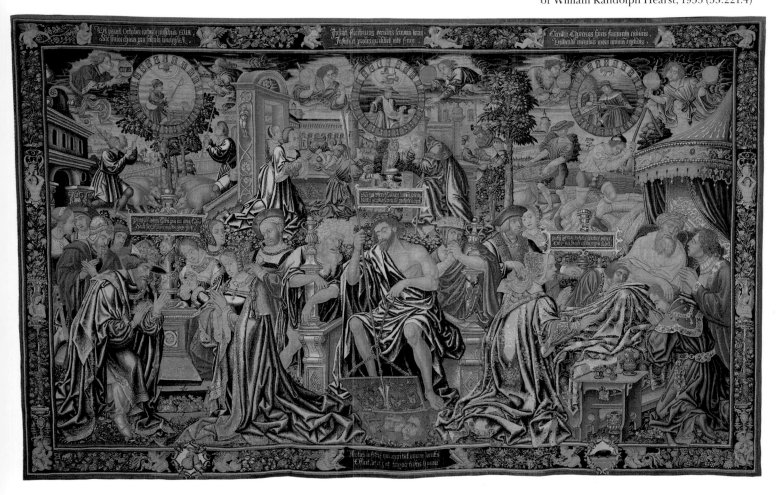

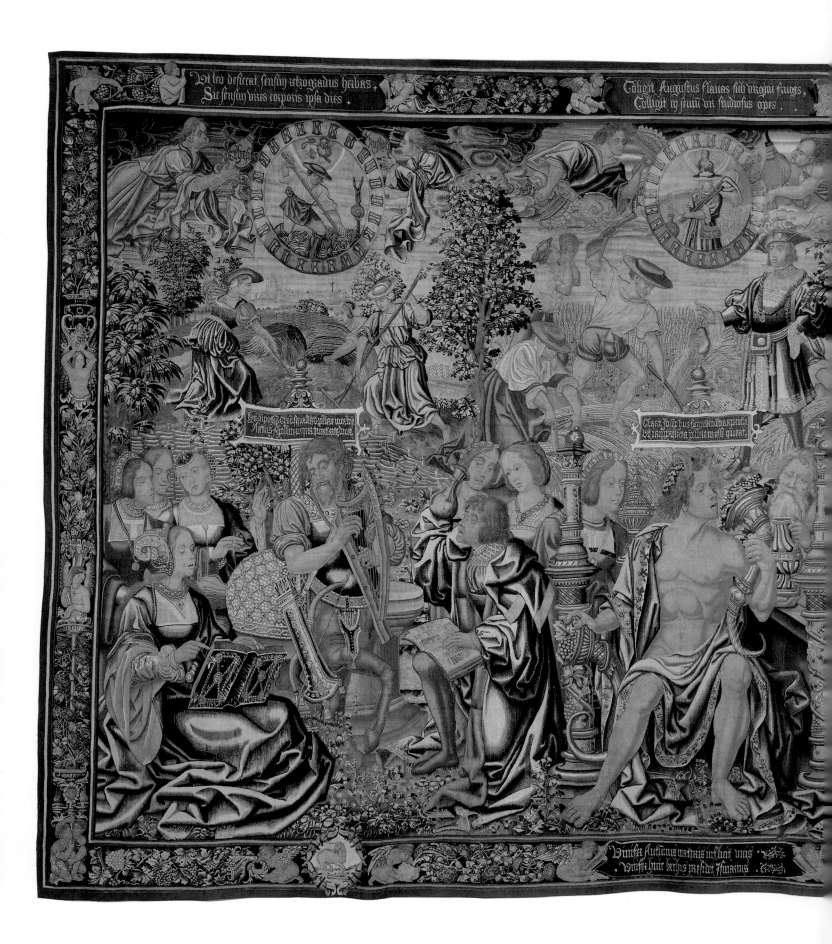

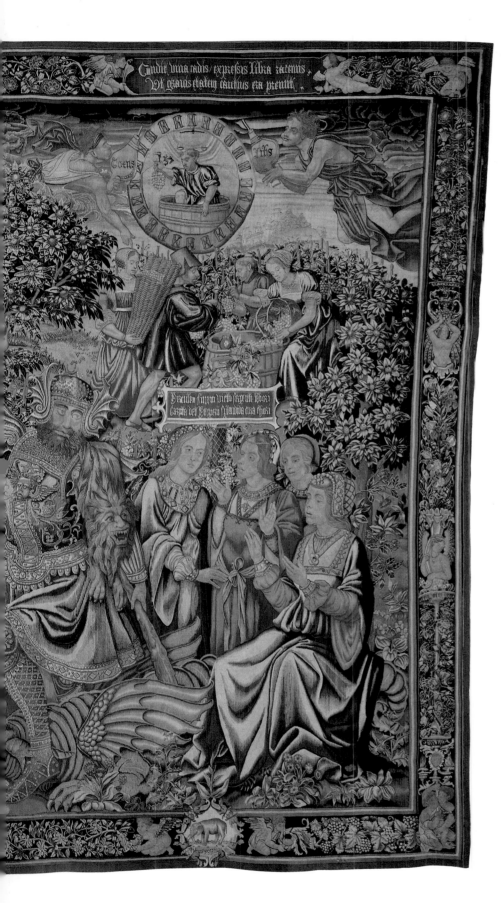

37 *The Third Three Ages of Man: Autumn*
Brussels, ca. 1520–25
Wool and silk, 14 ft. 11½ in. x 24 ft.
(4.56 x 7.32 m.)
Gift of The Hearst Foundation,
in memory of William Randolph Hearst,
1953 (53.221.3)

Page 60: text

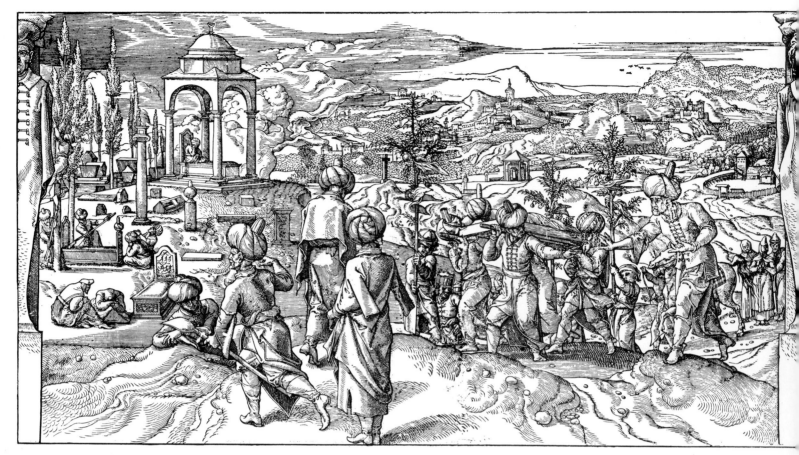

*38 Ces Moeurs et Fachons de faire des Turcz
(Manners and Customs of the Turks)*
After Pieter Coeck
Flemish, 1502–1550
Woodblock print; 11⅝ x 21¼ in.
(29.5 x 54 cm.) Harris Brisbane Dick
Fund, 1928 (28.85.5)

AFTER PIETER COECK
Manners and Customs of the Turks

Pieter Coeck, a native of Aelst, shared the fascination for exotic lands felt by most Europeans during the Renaissance. The savage inhabitants of the Americas were of primary interest, but with the siege of Vienna by the Turks (which lasted intermittently from 1529 until 1683) the focus shifted to Turkey.

In 1533 Coeck traveled to Constantinople and made a series of drawings that were made into woodcuts after his death. As a printed strip, the woodcuts constitute a sixteen-foot mural illustrating Coeck's journey with scenes of the exotic customs and architecture of the Turks. The drawings were conceived in the manner of a tapestry series whose vistas are divided by atlantes and caryatids. The first scenes are set in the chaos of a military camp somewhere in the Balkan Peninsula, and the last illustrate the domes and minarets of Constantinople.

The section seen here depicts the burial of a high military official in a cemetery not far from Adrianople. The graveyard shows a domed edifice surmounted by a crescent moon, symbol of Turkey, and tombstones topped with turbans and engraved with elaborate Cyrillic script. Four military men bear the deceased on a stretcher; a veiled wife follows.

QUENTIN MASSYS
The Adoration of the Magi

Quentin Massys was born in Louvain, where he remained until his marriage in 1486. He is listed as an independent master of the Antwerp guild in 1491. The grotesque physiognomies, elaborate costumes, and ornate architecture of his *Adoration of the Magi* are characteristic of the Antwerp school in the second decade of the sixteenth century, when Massys was the leading innovator. The influence of Italian art is evident in the background architecture. The pilaster behind the head of the Virgin bears the number 26, probably referring to the year the picture was painted: 1526.

39 The Adoration of the Magi, 1526
Quentin Massys
Flemish, 1465/66–1530
Tempera and oil on wood;
40½ x 31½ in. (102.9 x 80 cm.)
John Stewart Kennedy Fund, 1911
(11.143)

64

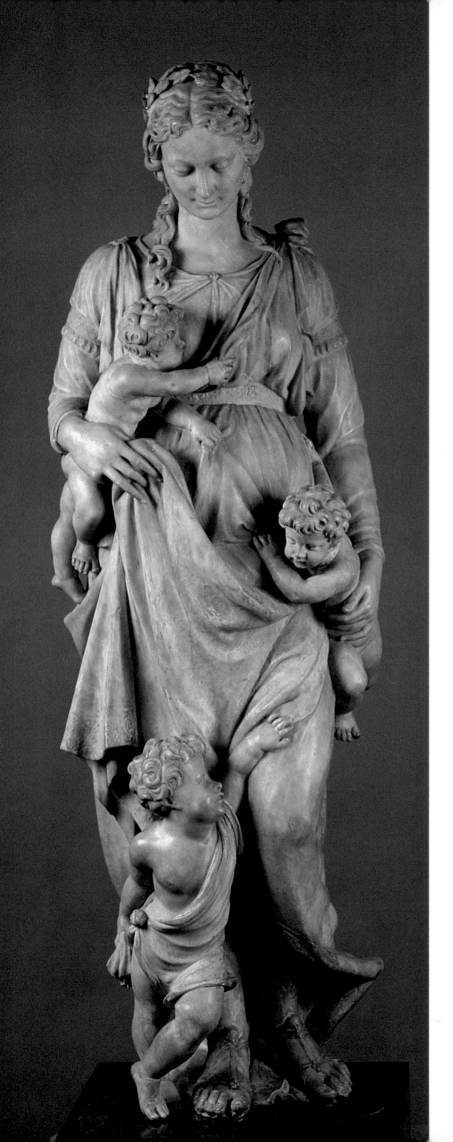

FRANCO-FLEMISH SCULPTOR
Charity

This nearly life-size statue represents the theological virtue of love in its most familiar guise, as Charity with her children. It was long attributed to the French sculptor Germain Pilon but does not have the rigorous linearity of the French school and is more likely to be Flemish. Alabaster was greatly favored as a medium in the Low Countries, where Mannerist sculptors must surely have relished the stone's contribution to their softly rounded, mellow characterizations, whether in large- or small-scale compositions. An architectural setting for the sculpture may be inferred from the flattened back.

40 Charity
Franco-Flemish, second half of 16th c.
Alabaster; H. 54½ in. (138.4 cm.)
Purchase, Josephine Bay Paul and
C. Michael Paul Foundation, Inc. Gift
and Charles Ulrick and Josephine Bay
Foundation, Inc. Gift, 1965 (65.110)

Right: detail

OVERLEAF:

WILLEM DE PANNEMAKER *(Pages 68–69)*
The Bridal Chamber of Herse

When the god Mercury spied the three daughters of Cecrops, king of Athens, returning from the festival of Minerva, he immediately fell in love with Herse, the most beautiful. This tapestry is one of a set of eight recounting the story of their love affair. Mercury enters Herse's bedroom so eagerly that his winged sandals fall from his feet. His golden staff, or caduceus, rests on a table. (Herse's jealous sister, Aglauros, had tried to prevent Mercury from entering the chamber, and he had turned her into stone with a touch of his staff.) Several cupids attend Mercury; one removes his hat, another takes off Herse's sandal. The splendid chamber is sumptuously decorated with elaborately carved furniture and with rich fabrics covering the walls and bed.

The figures in the tapestry borders represent Virtues and have no connection with the main scene; they were originally designed to frame tapestries after Raphael's cartoons—full-size colored models—for the Acts of the Apostles. Silver and silver-gilt threads are lavishly used throughout. In the lower borders, in gilt thread, are the letters "BB," for Brabant-Brussels, and the weaver's mark of Willem de Pannemaker (act. 1541–78).

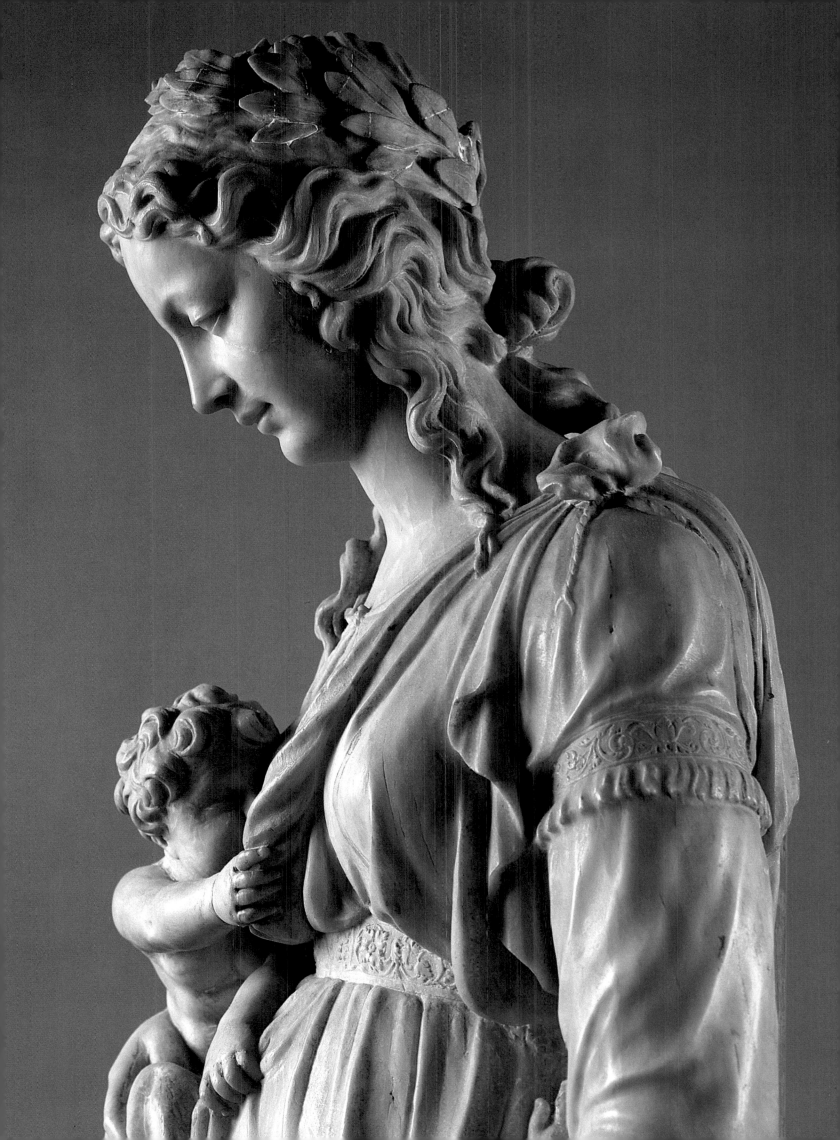

41 The Bridal Chamber of Herse, ca. 1550
Willem de Pannemaker
Flemish, act. 1541–78
Wool, silk, and metal threads;
14 ft. 5 in. x 17 ft. 8 in. (4.39 x 5.38 m.)
Bequest of George Blumenthal, 1941
(41.190.135)

Page 66: text

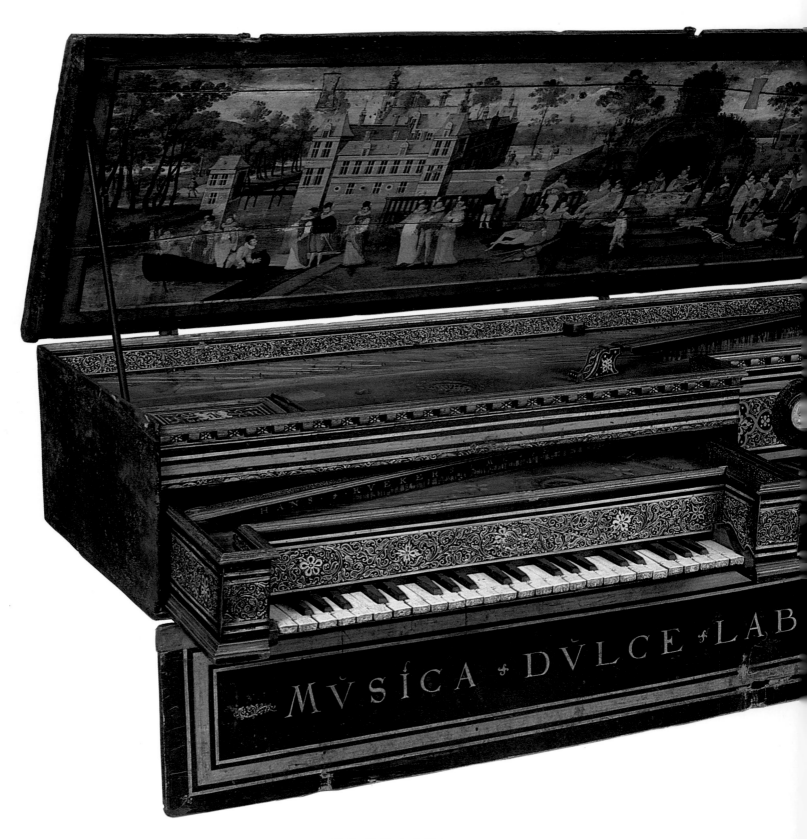

42 *Double Virginal*, 1581
Hans Ruckers the Elder
Flemish, ca. 1545–d. 1598
Wood and various other materials;
W. 74¾ in. (190 cm.)
Gift of B. H. Homan, 1929 (29.90)

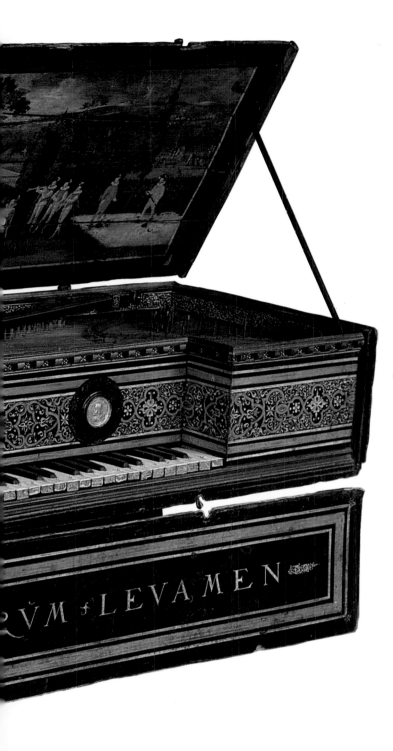

HANS RUCKERS THE ELDER
Double Virginal

This lavishly decorated virginal, made in Antwerp in 1581, is the oldest extant work by Hans Ruckers the Elder, head of a renowned family of Flemish harpsichord builders. The virginal actually consists of two instruments. The smaller one is an octave higher in pitch and lighter in tone and timbre than the larger one. When this "child" at the left is placed above its "mother," both can be played by one person.

On the underside of the lid is a painted scene of a garden fete. The panel below the keyboards bears a Latin motto that may be translated, "Sweet music is a balm for toil." Above the main keyboard are medallions of Philip II and his fourth wife, Anne of Austria, with inscriptions referring to Philip as king of Spain and the New World. Indeed, this virginal may have been a gift from the royal house to friends in South America. It was discovered around 1915 in a hacienda chapel near Cuzco, Peru.

OVERLEAF:

PIETER BRUEGEL THE ELDER *(Pages 72–73)*
The Harvesters

Although Pieter Bruegel the Elder journeyed to Italy in 1552–53, the trip had little effect on his art; instead of historical subjects, Bruegel depicted peasant life. In this picture of a wheat harvest, the simplified forms of the harvesters convincingly convey their weight and solidity, while their familiar activities—cutting bread, eating, drinking—endow them with an everyday reality. The contorted expressions on some of the faces, as well as the posture of the exhausted man lying against the tree and of the man trudging in from the fields at the left, suggest the hardships they endured. The figures occupy a relatively small portion of the panel in comparison with the vast landscape, reminding us that man remains subordinate to nature.

This painting is from a series depicting the labors of the months, of which the overriding concern is the powerful rhythms and cycles of nature. The original number of paintings in the series was either six, with two months represented in each picture, or twelve. *The Harvesters* probably represents either August or July and August.

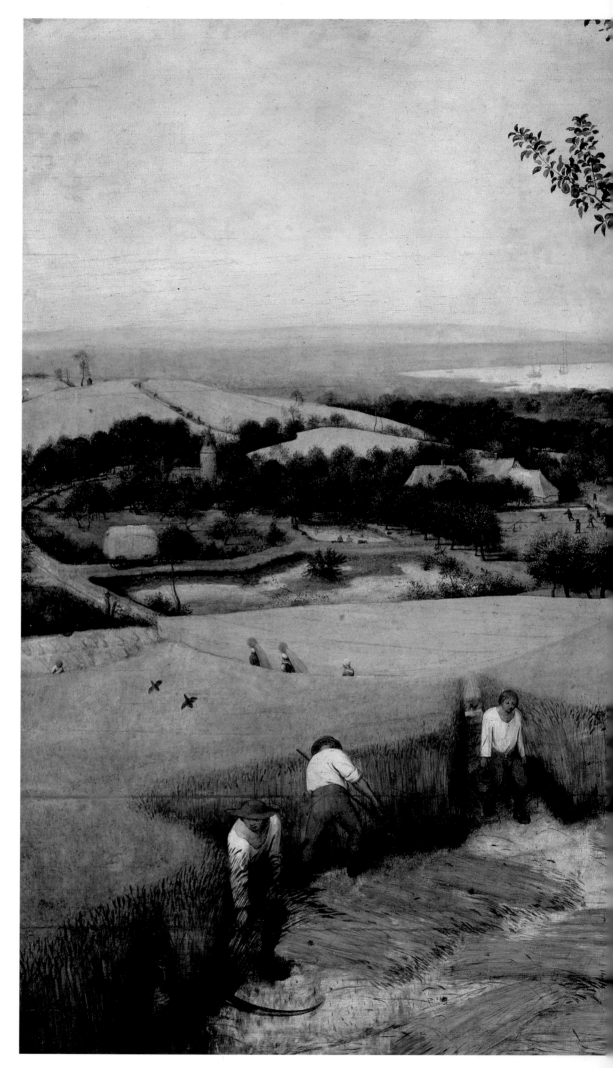

43 The Harvesters, 1565
Pieter Bruegel the Elder
Flemish, act. by 1551–d. 1569
Oil on wood;
46½ x 63¼ in. (118 x 160.7 cm.)
Rogers Fund, 1919 (19.164)

Pages 74–75: detail

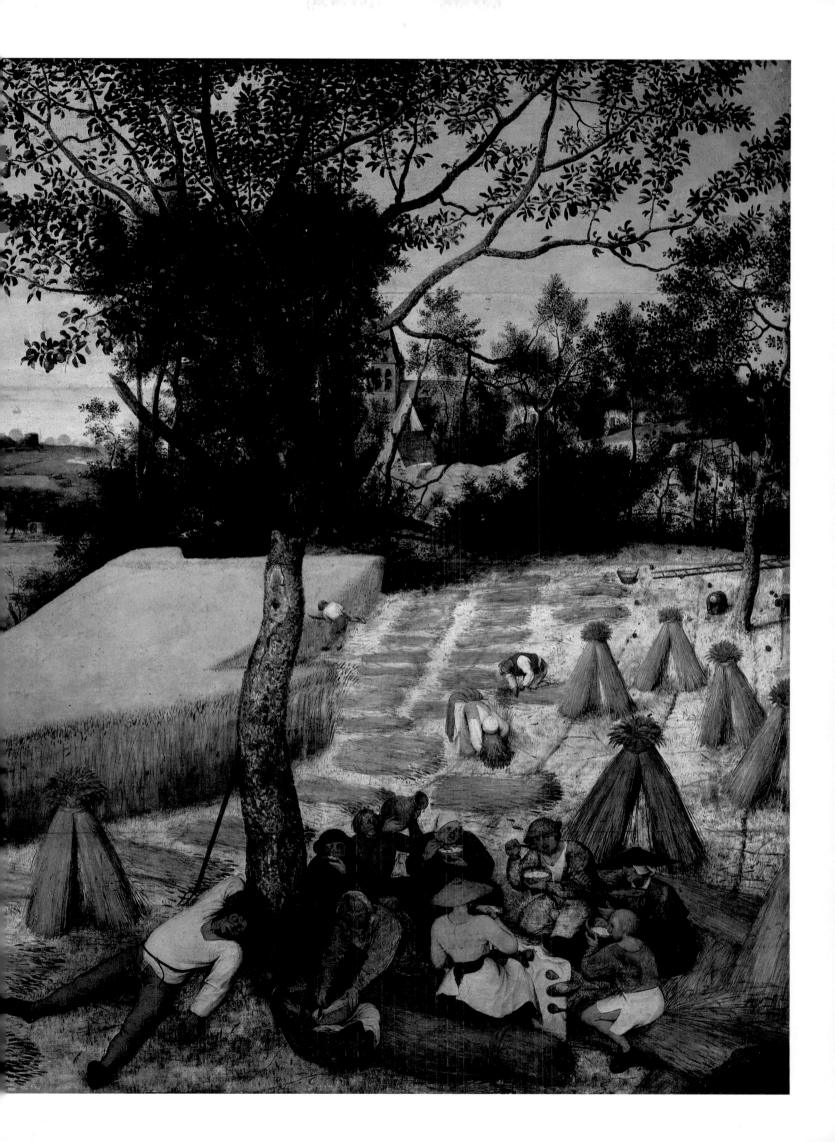

Marrius, Aprilis, Maius, funt tempora ueris · | VER Pueritię compar | Vere Venus gaudet florentibus aurea fertis ·

44 Spring, 16th c.
After Pieter Bruegel the Elder
Flemish, act. by 1551–d. 1569
Engraving; 9 x 11¾ in.
(22.9 x 29.8 cm.)
Harris Brisbane Dick Fund,
1926 (26.72.57)

AFTER PIETER BRUEGEL THE ELDER
Spring and *Summer*

Although Pieter Bruegel the Elder was the most famous Northern printmaker of this period, he is rarely mentioned in the history of engraving because he did not actually perform the process himself but made drawings for other men to copy in etchings and engravings.

This pair of prints is part of a series Bruegel made to illustrate the activities appropriate to the seasons. The prints show his preoccupation with the lives of the peasants and the subordination of those lives to landscape and season.

In *Spring,* illustrated on the left, Bruegel displays a medley of activity from sowing seeds to shearing sheep, from

Iulius, Augustus, nec non et Iunius Aestas · AESTAS Adoles ... centiæ imago Frugiferas aruis fert Aestas torrida meßeis ·

45 *Summer*, 16th c.
After Pieter Bruegel the Elder
Flemish, act. by 1551–d. 1569
Engraving; 8¹⁵/₁₆ x 11⁵/₁₆ in.
(22.5 x 28.9 cm.)
Harris Brisbane Dick Fund,
1926 (26.72.23)

shoveling earth to training vines over a pergola, and even includes such seasonal pleasantries as lovemaking with musical accompaniment beside a stream.

In *Summer*, shown on the right, the artist's interest is evident in the anonymous faces of the workers in the foreground and in the scenes of toil that extend to the horizon and stand out in silhouette on the crest of every hill.

Clearly, in Bruegel's view, the tasks and recreations of these simple people—in fact, every detail of their behavior and responses—are determined by the relentless cycle of the four seasons.

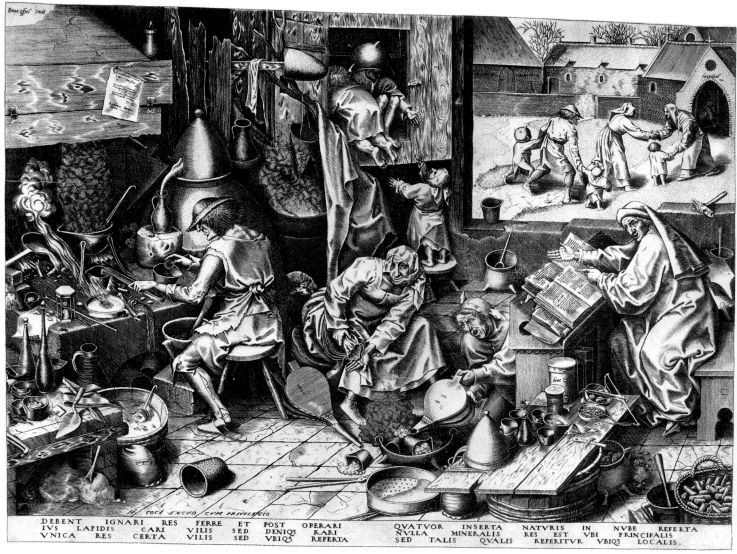

DEBENT IGNARI RES FERRE ET POST OPERARI QVATVOR INSERTA NATVRIS IN NVBE REFERTA
IVS LAPIDIS CARI VILIS SED DENIQ5 RARI NVLLA MINERALIS RES EST VBI PRINCIPALIS
VNICA RES CERTA VILIS SED VBIQ5 REPERTA SED TALIS QVALIS REPERITVR VBIQ5 LOCALIS.

46 The Alchemist
After Pieter Bruegel the Elder
Flemish, act. by 1551–d. 1569
Engraving;
13³⁄₁₆ x 17¹¹⁄₁₆ in.
(33.3 x 44.8 cm.)
Harris Brisbane Dick Fund,
1926 (26.72.29)

47 Distillation
Jan van der Straet
Flemish, 1523–1605
Engraving; 8 x 10½ in.
(20.3 x 26.7 cm.)
Harris Brisbane Dick
Fund, 1934 (34.30.8)

DISTILLATIO.
In igne fuccus omnium, arte, corporum Vigens fit vnda, limpida et potiſſima.

AFTER PIETER BRUEGEL THE ELDER
The Alchemist

The science of alchemy—the attempt to transform ordinary metals into precious ones, to find a universal cure for disease, and to prolong life indefinitely—was practiced from antiquity through the seventeenth century, when it began to be discredited by modern science. In the fifteenth and sixteenth centuries the craft began attracting charlatans, and by the seventeenth, it was an object of scorn.

This seventeenth-century print, after a drawing by Pieter Bruegel the Elder, gives a satirical portrait of the alchemist at work. The iconography of the portrait is detailed and makes specific reference to contemporary symbols of derision. In his makeshift laboratory, the main room of his house, the alchemist's entire family is assembled—including three incarnations of the magician himself. As philosopher, he sits in robes before a pile of scholarly volumes, indicating a passage or a formula and discoursing with the air. In the guise of an idiot, the alchemist kneels beside a caldron filled with flasks and crucibles, fruitlessly pumping a bellows—an allusion to his nickname, *souffleur*, or puffer. Above the hearth another version of the alchemist hunches in concentration, about to melt the family's last gold coin, which alludes to the fact that alchemical transformations always require a little real gold as a starter. His ragged wife shakes an empty purse, his children frolic without discipline, plaster chips away, containers spill their contents, and potions smoke unattended amid general chaos. In place of the landscape that might relieve this scene, Bruegel shows the family seeking refuge in the local hospital.

JAN VAN DER STRAET
Gunpowder and *Distillation*

Jan van der Straet, a painter, tapestry designer, and draftsman, who latinized his name to Johannes Stradanus early in his career, was born in Bruges in 1523. He left Bruges at the age of twenty-two and traveled extensively before settling in Florence, where he helped to decorate the palace of Grand Duke Cosimo de' Medici.

This pair of prints is from a series of twenty known as *Nova Reperta*, or "New Discoveries." They document the achievements of the Renaissance from the printing press, the manufacture of silk, and the mechanical clock to the discovery of the New World. The two prints reproduced here show the production of cannons and the process of distillation. *Gunpowder* shows the interior of a foundry in which a furnace, fed with scrap metal, is pouring forth molten metal to be fashioned into cannons. A man at the left walks a wheel to spin a cannon for boring, and outside the window to the right, a turret topples from the impact of this weapon. Beneath the print is an inscription in Latin that translates: "Thunder and lightning made by hand. It seems to be a gift from the jealous underworld."

Distillation shows a central still, billowing with steam, from which tear-shaped alembics nurse. A boy crushes herbs with a countersprung pestle, a man presses liquid with a screw-turned vise, and a philosopher sits in the foreground poring over recipes with the aid of yet another new invention, spectacles. The Latin inscription beneath this print translates: "In the fire, the juice of all bodies is turned by art into a mighty billow, clear and most potent."

48 *Gunpowder*
Jan van der Straet
Flemish, 1523–1605
Engraving; 8 x 10⁷⁄₁₆ in.
(20.3 x 26.4 cm.)
Harris Brisbane Dick
Fund 1953 (53.600.1819)

CHASUBLE AND DALMATIC

During the Renaissance, members of the Church held an important place in the hierarchy of political power, and the liturgical vestments in which they appeared were a statement of their position.

Because of the idiosyncratic details of their iconography, the dalmatic and chasuble pictured here are thought to have been made for use in a private family chapel. As the basis of their design the garments have an elaborate version of the Italian pomegranate pattern into which panels of decoration have been woven. Both dalmatic and chasuble include shields, one of which has been identified with a family from Utrecht, the other with a family from the Utrecht area. The faceted shield of azure and gold on the left belongs to the Van der Geer family. The more elaborate shield on the right represents the arms of the bastards of the lords of Culenborch, a village ten miles southeast of Utrecht, their bastardy denoted by the wavy or engrailed border that surrounds the shield. These vestments are unusual in that they have been woven in a tapestry technique.

Pictured on the front of the dalmatic is the veil of Saint Veronica, who wiped the sweat from Christ's brow on his way to Calvary. On the back of the chasuble is a medallion showing the Israelites camped in the desert. They are seated before their tents. Aaron, holding a green rod, is lounging beside a woman and child, while Moses kneels behind them, horns emerging from his gray hair. The Israelites are gathering manna, which is falling from the blue background above them.

Most striking are the many panels that show brown-topped bulrushes bobbing above blue-and-white waves, surmounted by curling scrolls that bear the Latin inscription *Flectimur non frangimur undis*, "We are bent, not broken, by the waves." Bulrushes are often included in scenes of Christ's Passion and are symbolic of his meekness. This combination of phrase and illustration forms an impresa, or personal device; these were extremely popular in the sixteenth and seventeenth centuries. We do not know who the Van der Geer family was nor why this stoic motto was appropriate to them.

49 Chasuble
Dutch, 1570
Wool and silk;
44 x 27½ in. (111.8 x 69.9 cm.)
Rogers Fund, 1954 (54.76.2)

Front and back views

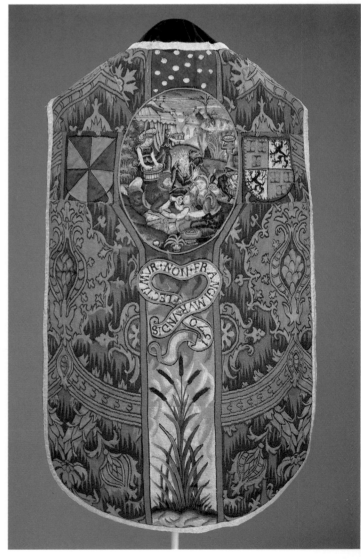

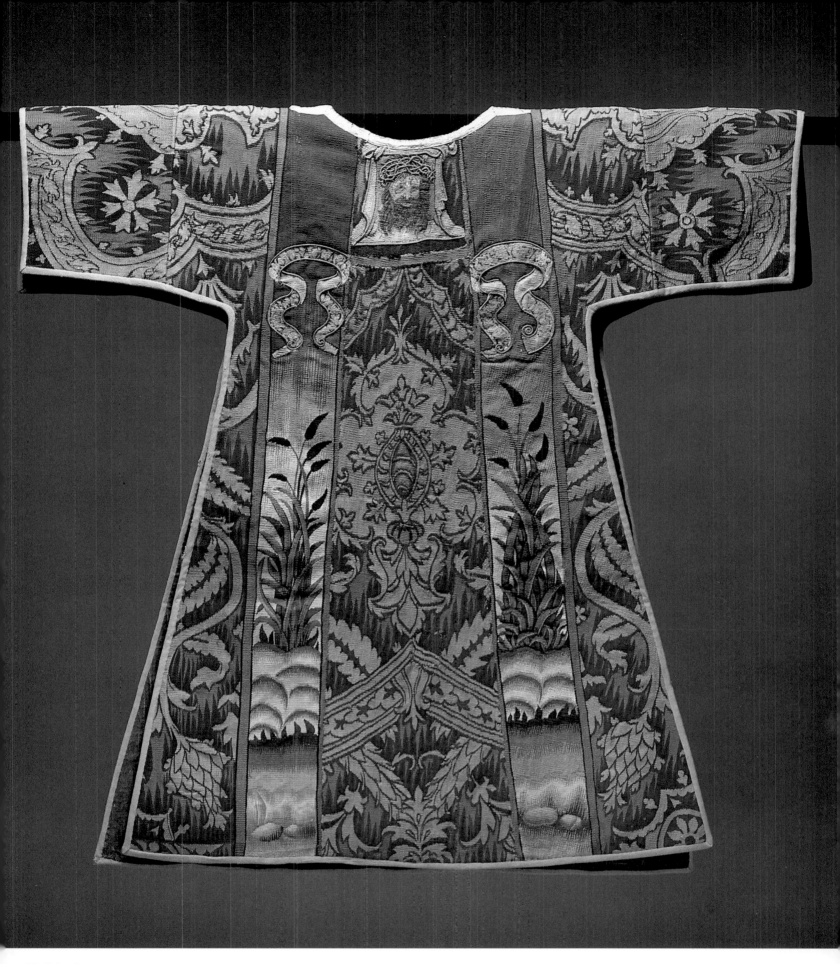

50 *Dalmatic*
Dutch, 1570
Wool and silk; H. 44 in. (111.8 cm.),
W. with sleeves 45 in. (114.3 cm.)
Rogers Fund, 1954 (54.76.1)

HENDRICK GOLTZIUS
Spring and *Autumn*

Hendrick Goltzius was one of the leading Mannerist engravers of late-sixteenth-century Haarlem. As the result of a childhood accident, Goltzius's right hand was clamped permanently shut, which forced him to use the muscles of his arm and shoulder to propel the pen.

The drawings pictured here, once part of a series representing the seasons, depict spring and autumn. Though engravings of all four seasons are extant, only these two drawings survive.

Goltzius illustrates spring with couples trysting in a gar-

den. In the foreground a lover plucks a lute while his beloved reads him poetry. Behind foliage on the right a couple embrace, and in the background several couples wander among parterres. Cupid floats above the scene.

Goltzius suggests the mood of autumn by representing a prudent housewife gathering food for winter storage. A youth, crowned with grapes like Bacchus, is about to taste the year's new wine but is interrupted by a sinister gentleman who may symbolize the yearly death that winter brings. In the sky are birds flying away to the south.

51 *Spring,* ca. 1597
Hendrick Goltzius
Dutch, 1558–1617
Pen and brown ink, red-brown
wash, over black chalk, heightened
with a little white gouache;
7⅝ x 5¹¹⁄₁₆ in. (19.4 x 14.5 cm.)
Rogers Fund, 1961 (61.25.1)

52 *Autumn,* ca. 1597
Hendrick Goltzius
Dutch, 1558–1617
Pen and brown ink, red-brown
wash, over black chalk, heightened
with a little white gouache;
7⅝ x 5¹¹⁄₁₆ in. (19.4 x 14.5 cm.)
Rogers Fund, 1961 (61.25.2)

53 Neptune, last quarter 16th c.
Attributed to Johann Gregor
van der Schardt
Dutch, ca. 1530–after 1581
Bronze; H. 18⅞ in. (47.9 cm.)
Gift of Ogden Mills, 1924
(24.212.10)

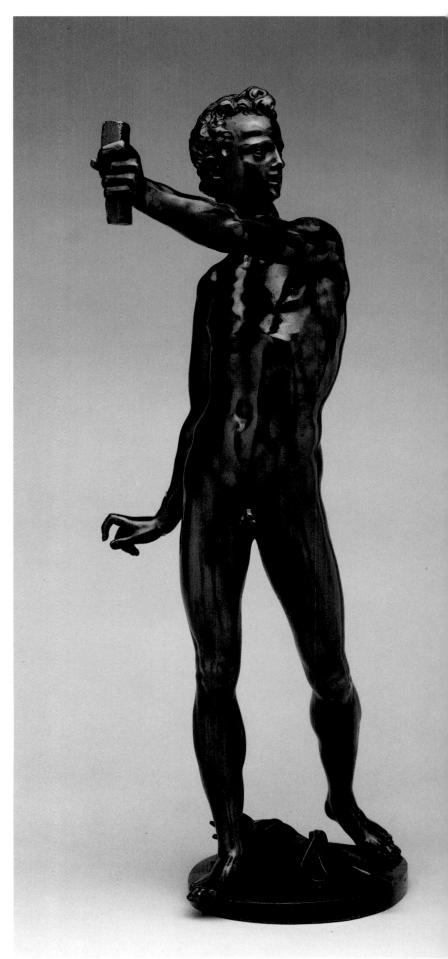

54 *Apollo*, ca. 1600
Adriaen de Fries
Dutch, 1545–1626
Bronze; H. 18⅝ in. (47.3 cm.)
Bequest of George Blumenthal,
1941 (41.190.534)

ATTRIBUTED TO JOHANN GREGOR VAN DER SCHARDT
Neptune

Johann Gregor van der Schardt, born in Nijmegen in the Netherlands, worked in various parts of Europe, including Italy, before settling in Nuremberg. His experience of Italian Mannerist sculpture contributed greatly to the style of his energetic figures. This sophisticated statuette of Neptune, balanced on one leg and holding his (missing) trident, is attributed only provisionally to Van der Schardt, whose works survive in very small quantity. An Italian sculptor is not to be ruled out.

ADRIAEN DE FRIES
Apollo

Adriaen de Fries was born in The Hague, studied in Italy, and from 1593, worked for the Emperor Rudolph II in Prague. He was the greatest Mannerist sculptor of his generation north of the Alps, and made many highly charged nudes such as the fountain figures now at Drottningholm in Sweden. De Fries was also the greatest proponent of the bronze statuette in Northern Europe. The *Apollo*, at once elegant and earthy, is a brilliant illustration of de Fries's vigor and of his assimilation of sources: In this case, the serpentine effects of Giovanni Bologna and Florentine Mannerism are wedded to the positive sideward movement of the ancient marble *Apollo Belvedere* in the Vatican. The statuette, originally furnished with bow and arrows, represents the Sun God as slayer of the serpent Python.

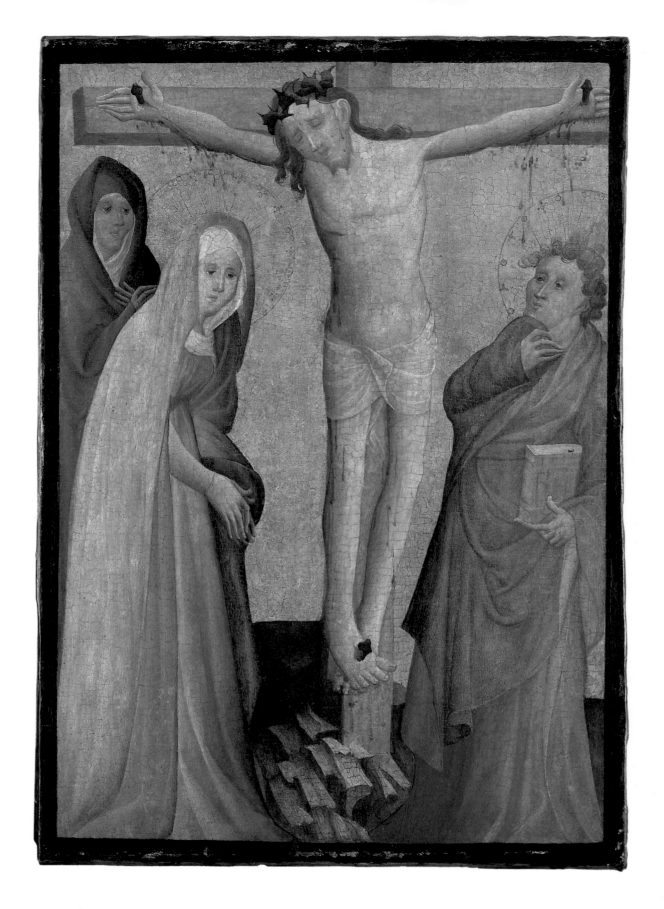

MASTER OF THE BERSWORDT ALTAR
The Crucifixion

This panel is part of an altarpiece from the Neustädter Marienkirche in Bielefeld, Westphalia, where the central section with *The Glorification of the Virgin* remains to this day. *The Crucifixion* was one of thirty scenes proceeding from *The Fall of Man* to *The Last Judgment* and forming an unusually extensive narrative cycle on the interior of the altarpiece.

The date 1400 is said to have been inscribed on the original frame.

The artist takes his name from an altarpiece in Dortmund that bears the arms of the Berswordt family. He was one of the foremost painters of the International Style in northwest Germany.

86

55 *The Crucifixion*, ca. 1400
Master of the Berswordt Altar
German
Tempera and gold transferred
to canvas, laid down on wood;
23½ x 17 in. (59.7 x 43.2 cm.)
Rogers Fund, 1943 (43.161)

56 *Madonna and Child with a Donor
Presented by Saint Jerome*, ca. 1450
German Master, mid-15th c.
Panel; 25 x 19 in. (63.5 x 48.3 cm.)
Robert Lehman Collection, 1975
(1975.1.133)

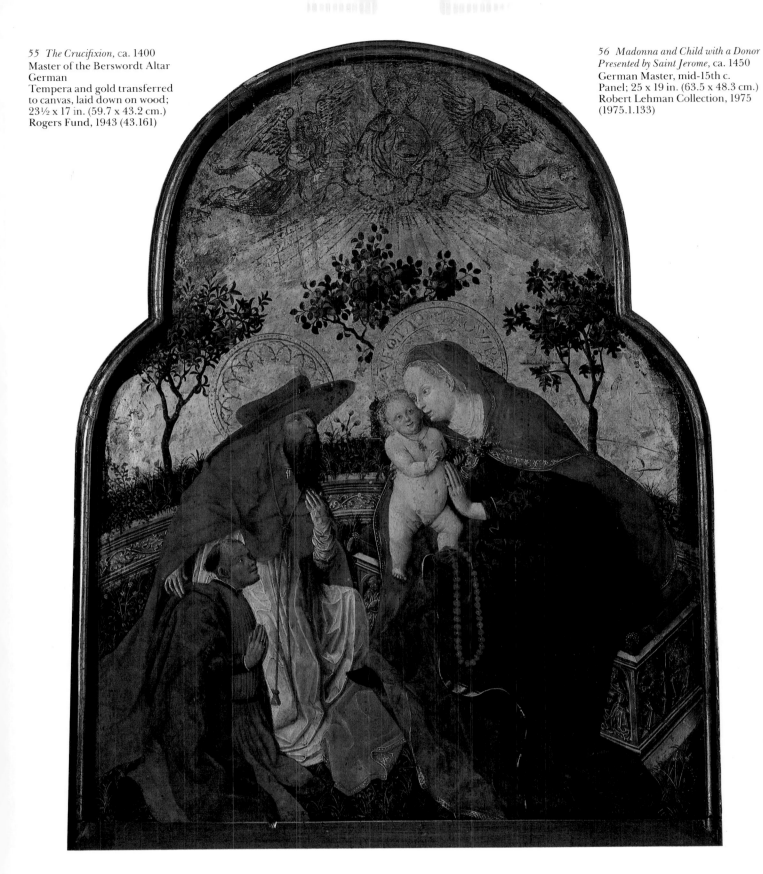

GERMAN MASTER

*Madonna and Child with a Donor Presented by
Saint Jerome*

This panel is a masterwork about which very little is known. It may be dated by its style and the details of the costumes to around 1450, and the facial types and the linearity of the design point toward a region including southern Germany and Switzerland. But the sculptured bench shows the influence of Flemish painters, and the prophets on the side of the bench show some similarities to Burgundian sculpture from about 1440. The delicate figures of God and the two angels are direct borrowings from Flemish and Burgundian goldsmiths' work of the early fifteenth century. The trees on the grassy bank strongly resemble those in Giovanni di Paolo's *Expulsion from Paradise*. Although the painter has not been identified, he was probably a south German artist who traveled in Flanders and Italy.

57 *The Martyrdom of Saint Sebastian*
Master of the Playing Cards
German, act. ca. 1435–55
Engraving;
5⁹⁄₁₆ x 8¼ in. (14 x 21 cm.)
Harris Brisbane Dick Fund, 1934
(34.38.1)

EARLY ENGRAVINGS

In the same period when woodcuts were sweeping Europe in the form of illustrations for stories, sermons, and moralizing pamphlets, engravings made their first appearance. This new technique enabled the artist to create fine gradations of light and shade, and to imitate textures by controlling the strength, length, and complexity of his lines. Engravings are rarer than woodcuts because, whereas one woodblock can create thousands of copies of an image, the softness of the copper plate, combined with the pressure exerted in the printing process, causes the engraved image to become vaguer and less detailed with each impression. The rarity of engravings made them highly prized, and this contributed to their survival in greater numbers than woodcuts, which were used and discarded.

The fifteenth-century German artist known, for his most famous work, as the Master of the Playing Cards is the first engraver to rise above the more primitive technique of the silversmith and to be identified with a surviving oeuvre, most

58 *Lovers on a Grassy Bank*
Master E. S.
German, act. ca. 1460
Engraving;
5¼ x 6½ in. (13.3 x 16.5 cm.)
Harris Brisbane Dick Fund,
1922 (22.83.14)

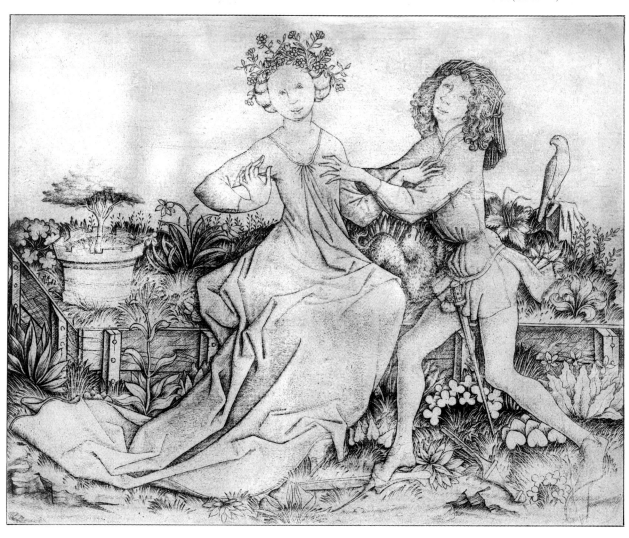

of which can be seen today in Dresden and Paris. It is generally believed, from clues given by his style of work and from the costumes and flora he depicted, that he lived in the Upper Rhineland. It was at one time thought that he was responsible for inventing the engraving process, but later opinion holds that his works were so sure and sophisticated that they could not have been the result of experimentation.

In *The Martyrdom of Saint Sebastian* (Plate 57), the emphatic contour strokes and delicately engraved interior modeling are typical of the first generation of German engravers. The legend of Saint Sebastian is not fully known. He is believed to have been a secret Christian who was sentenced to death when he declared his faith in order to help two fellow believers. He is typically portrayed tied to a tree or pillar and pierced by several arrows. He played a prominent role in the Middle Ages as the protector against plague.

Master E. S., another Upper Rhenish artist, dominated the second generation of German engravers and was one of

a new breed of artists who signed works of individual design, unlike the woodcutters, who worked within local traditions but were not concerned with personal style. Between 1461 and 1467, E. S. made a total of eighteen signed engravings, and, based on these, many others have been attributed to him. His subject matter was varied, from playing cards through pilgrim souvenirs, grotesque alphabets, and portrayals of the Madonna and Child, to the *Lovers on a Grassy Bank* (Plate 58).

Scenes such as this of knightly courtship were popular with the lesser nobility, and the work of E. S. was copied enthusiastically, as the concept of plagiarism did not exist at this time. His technique was much closer to that of a metalworker than to that of the painterly Master of the Playing Cards. He used tiny punches to decorate garments and introduced many novel strokes, such as curves, flicks, and dots. He began a technical revolution that was carried on by Martin Schongauer and Albrecht Dürer.

59 *The Annihilation of the Beast
and the Capture and Incarceration
of the Beast*
Folio 42 of the second edition
of the *Apocalypse* blockbook
Netherlandish, 1460–70
Woodcut, hand colored;
10⅝₁₆ x 7¹¹⁄₁₆ in. (26.4 x 19.7 cm.)
Gift of J. Pierpont Morgan,
1923 (23.73.3)

Woodblock Prints

A woodblock print is made by cutting wood away from a block to leave a raised image, inking the remaining surface with a leather ball, and then pressing the block against paper. The woodblock technique evolved from textile printing, which required simple designs easily reproduced in great quantity.

The transfer of the woodcut from cloth to paper began a visual revolution in fifteenth-century Europe. The most common early woodcuts were images developed for playing cards. Printed pictures of the Madonna, saints, and Bible stories were produced as cheap souvenirs for pilgrims and were collected by rich and poor alike. Where the metal engraving could produce only a few images, the woodblock was capable of thousands.

This image of Saint Florian was found in a bookbinding and is, consequently, well preserved. Typical of the wood-

60 *Saint Florian*
German, ca. 1460
Woodcut, hand colored;
10 x 6⁹⁄₁₆ in. (25.4 x 16.8 cm.)
Bequest of James Clark
McGuire, 1930 (31.54.111)

block technique are the simple lines that describe the saint and the broad areas of solid color, added by hand, that enliven the surface. Florian was a soldier in the Roman army in Austria who was martyred defending the faith against the purges of Diocletian. He was drowned in the river Enns with a millstone around his neck; a Benedictine abbey bearing his name commemorates the site. The cult of Saint Florian evolved only in the fourteenth century, when Florian be-

came known as a protector against fire, based on a legend that in his youth he had saved a burning house through prayer alone.

The other woodblock pictured here illustrates a scene from Revelations in which the Beast is captured, incarcerated, and annihilated. The scene formed part of the first blockbook—a book in which both text and illustration are cut from the same block—published in the Netherlands.

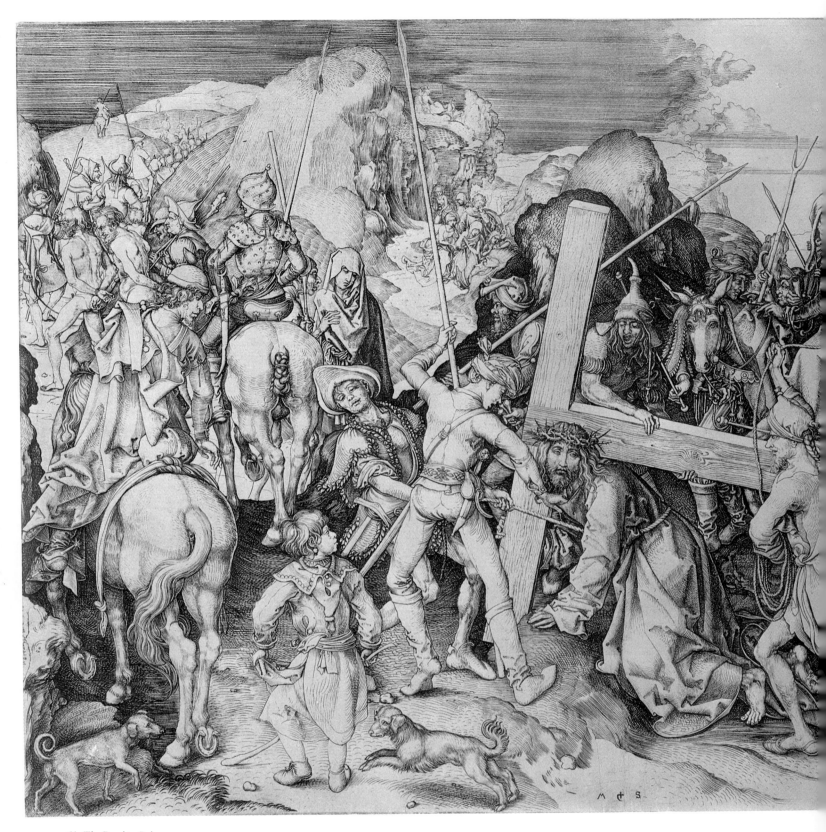

61 The Road to Calvary
Martin Schongauer
German, ca. 1445–91
Engraving; 11 x 16⅝ in.
(27.9 x 42.2 cm.)
Gift of Felix Warburg and
his family, 1941 (41.1.26)

MARTIN SCHONGAUER
The Road to Calvary

Before Martin Schongauer, engraving was still a craft, despite the giant strides taken by his immediate predecessor, the Master E. S., who had developed many new techniques that enabled engravers to enhance greatly the subtlety of their pictures. He certainly influenced Schongauer. But Schongauer carried the process much further into the realm of true art and became the most influential Northern European graphic artist of the period. He is the first German engraver whose personal history is known, and there is even a portrait of him dated 1483, in the Alte Pinakothek, Munich.

Schongauer was a painter before he turned to engraving. His father was a silversmith, but Martin served an apprenticeship to the painter Caspar Isenmann, who encouraged his interest in Flemish art. Schongauer's early work was profoundly influenced by Netherlandish panel paintings, and *The Road to Calvary* is an excellent example. The grandeur of presentation is so like that of a panel painting that it is entirely possible that the work was based on a missing Van Eyck. The complexity of design, the spatial depth, and the texture certainly all derive from Schongauer's early experience as a painter.

There are over fifty figures spread across this work. The tragic procession moves through the craggy landscape from left to right surrounded by anecdotal elements—children, dogs, and townsfolk, who are milling around as if it were a holiday fair. The strong vertical line of the cross draws the viewer's eye to the center of the work and also serves to isolate the figure of Christ from the multitude around him. Schongauer's subtle use of the burin enabled him to highlight the drama further by presenting it, allegorically, as a passage from bright sunlight to the gloom of an impending storm. This was the last work Schongauer made in his early, painterly style; thereafter he concentrated on exquisite figures in simple settings.

94

62 *Self-Portrait at Age Twenty-two,* 1493
Albrecht Dürer
German, 1471–1528
Pen and brown ink;
10⅞ x 8 in. (27.6 x 20.2 cm.)
Robert Lehman Collection, 1975
(1975.1.862)

Right: verso

ALBRECHT DÜRER

Self-Portrait at Age Twenty-two

Albrecht Dürer stands out among sixteenth-century artists as one of the most imaginative, inventive, and energetic men of his era. He was the very embodiment of the age of humanism: a good artist with a wide-ranging mind, open to the myriad new concepts developing around him in the arts and sciences. He was an observant man, hungry to learn and full of deep feeling, and these facets of his personality shine through in his self-portraits.

His first self-portrait, now in the Albertina, Vienna, shows him as an innocent, clear-eyed thirteen-year-old, but by the time he produced the second, in 1491, he was twenty and, judging by his worried expression, the complexities of life had begun to make themselves felt. The pen-and-ink drawing in the Museum's collection was made in 1493, after a year of travel, and some of the turbulence of expression in the work made two years earlier seems to have been stilled. The serious young man is still there, however, wary and enclosed and making nervous gestures with his hand. The beginnings of a beard and moustache make him look very young, despite the self-contained expression.

This may have been a study for the painted self-portrait in the Louvre, and, coming just a year before his wedding, it may also have been intended as a betrothal portrait. If so, it certainly seems to foretell the unhappiness that Dürer was about to endure in his marriage. The contrasting proportions of the hand indicate that it may have been a separate study, and the oddly situated pillow is related to a series on the back of the portrait.

63 Virgin and Child with Saint Anne, 1519
Albrecht Dürer
German, 1471–1528
Tempera and oil on canvas, transferred
from wood; 23⅜ x 19⅝ in. (60 x 49.9 cm.)
Bequest of Benjamin Altman, 1913
(14.40.633)

ALBRECHT DÜRER
Virgin and Child with Saint Anne

Saint Anne, the mother of the Virgin, was particularly re-
vered in Germany and was frequently depicted in Holy Fam-
ily groupings. The story of the birth of the Virgin echoes
those of Samuel and Isaac in the Old Testament and prefig-
ures that of Christ. Saint Anne and her husband, Saint
Joachim, were childless for twenty years when an angel in-
formed them that they would at last have a child, who would
in turn give birth to the Messiah.

The *Virgin and Child with Saint Anne,* charged with quiet
religious intensity, was painted in 1519, the year in which
Dürer became an ardent follower of Martin Luther. It owes
much to the artist's two visits to Venice, in his mid-twenties
and again in his mid-thirties, when he came under the in-
fluence of Italian art. In particular, Dürer was influenced
by Giovanni Bellini, and in this painting he emulated the
rounded monumentality of figures in Italian art. The life-
like baby is very different from the wizened creatures so
often found in Northern European paintings.

64 *The Holy Family in a Trellis,* 1512
Albrecht Dürer
German, 1471–1528
Pen and ink on paper;
10½ x 7⅞ in. (26.5 x 20 cm.)
Robert Lehman Collection, 1975
(1975.1.860)

ALBRECHT DÜRER
The Holy Family in a Trellis

Dürer never tired of creating new versions of the Holy Fam-
ily grouping: sometimes just the Virgin and Child; some-
times with the Virgin's mother, Saint Anne; and sometimes
accompanied by Saint Joseph. It was a theme that stimu-
lated his interest in iconography.

This drawing is prominently signed and dated 1512. The
work is one of Dürer's best drawings of the subject, swiftly
sketched with accomplished strokes, and shaded, in the style
of woodcuts and engravings, with widely spaced parallel lines
that create an almost spontaneous look of chiaroscuro. The
figures are modeled with a practiced hand; the swiftness of
execution, though evident, in no way detracts from the
accomplishment.

The Virgin is seated next to an earthen bank, and a pow-

erfully built Saint Joseph—in this picture far from the tra-
ditional weary old man—leans toward her, engrossed in a
book. Dürer's love of symbolism is evident here: The lightly
drawn trellis is an allusion to the enclosure mentioned in
the Song of Songs, which was familiar to artists in the late
Middle Ages as a metaphor for the Virgin's purity. And the
sketchy plant that winds around the trellis is a flowering
vine that seems to refer to the rose without thorns that was
also a symbol of the Virgin. The charm of the scene is en-
hanced by its relaxed quality. Saint Joseph reads his book;
the Virgin, one arm leaning on the bank beside her, seems
to be quietly resting rather than attending to her child; and
the infant Christ, curled forward in the soft-spined posture
of the newborn, looks very placid and genuinely babylike.

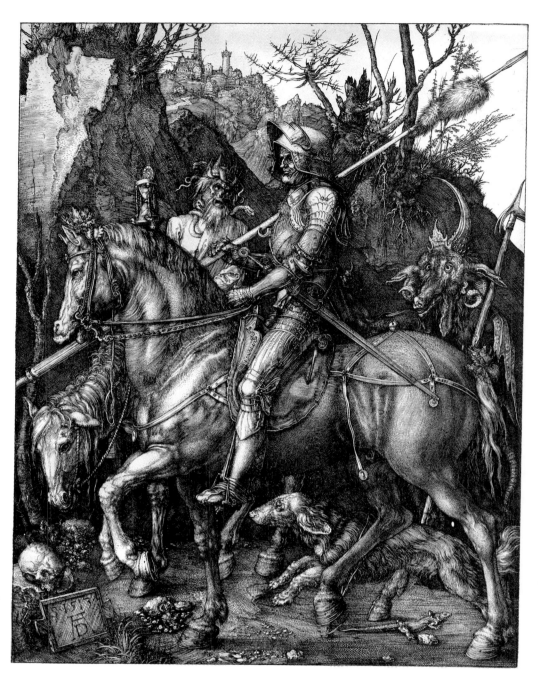

65 *The Four Horsemen of the Apocalypse*, 1498
Albrecht Dürer
German, 1471–1528
Woodcut;
15¼ x 11 in. (38.7 x 27.9 cm.)
Gift of Junius S. Morgan,
1919 (19.73.209)

66 *The Knight, Death, and the Devil*, 1513–14
Albrecht Dürer
German, 1471–1528
Engraving: 9⅝ x 7⅜ in.
(24.4 x 18.7 cm.) Purchase,
Harris Brisbane Dick Fund,
1943 (43.106.2)

PRINTS BY ALBRECHT DÜRER

The turn of the fifteenth century was a time of great religious upheaval in Europe, and it seems to be a recurrent fact of European art that religious strife and doubt lead to a brooding exploration of the Apocalypse story. In 1498, Albrecht Dürer published fifteen large woodcuts in a series illustrating the Book of Revelations in the New Testament. In Northern Europe unrest and resentment against the papacy would shortly lead to the Reformation under the leadership of Martin Luther. Dürer, who eventually became an ardent Lutheran, may have used this Apocalypse series as a rallying hymn against the pope.

He was obviously inspired by his subject matter and gave the fantastic visions of Saint John a strong sense of reality. *The Four Horsemen of the Apocalypse* (Plate 65) is full of motion: The riders gallop ahead in close formation, callously ignoring their victims—a chilling reminder of the imper-

sonal cruelty of fate. The technical work is almost indistinguishable from the artistic inspiration, leading to the speculation that Dürer cut his own woodblocks.

Dürer quite evidently enjoyed experimenting with mediums, and he tried many types of print. Referring to *The Knight, Death, and the Devil* engraving pictured here, Vasari, the Renaissance painter and art historian, commented that it was among "...several sheets of such excellence that nothing finer can be achieved...." Dating from 1513–14, the work was originally called simply *Reuter* (*Rider*). The apparently allegorical subject matter is still debated. There is a multiplicity of detail in this intricate engraving, but the tones are very subtle, confined to a limited range of intermediate shades. Within his chosen vocabulary, Dürer has provided as much contrast as a painter, carrying the earlier experiments of Martin Schongauer to unsurpassed mastery.

67 *Poynter Apollo*, 1501–03
Albrecht Dürer
German, 1471–1528
Pen and brown and black ink;
8⅝ x 5¾ in. (21.8 x 14.5 cm.)
Gift of Mrs. William H. Osborne,
1963 (63.212)

ALBRECHT DÜRER
Poynter Apollo and *Adam and Eve*

As his artistic career advanced, and in particular as his exposure to Italian art grew, Dürer became increasingly preoccupied with the study of ideal human proportion. He struggled to portray the perfect male and female forms, and both works illustrated here are evidence of this determination.

The *Poynter Apollo*, named for one of several collectors who have owned the work over the centuries, is one of four studies of the male nude based on classical prototypes and the canon of Vitruvius, the ancient Roman architect whose written works were reexamined with close, respectful attention during the Renaissance.

The *Apollo Belvedere*, which had been recently discovered and which was considered the perfect example of male beauty until the beginning of the nineteenth century, was known to Dürer through drawings and was a source of inspiration in his search for the perfect anatomy. This drawing was made in two distinct stages, as can be seen from both the color of the inks and the nature of the lines. The contours, in light-brown ink, may have been traced from the Apollo in Dürer's picture of Apollo and Diana, now in the British Museum. The hair and modeling lines may have then been added freehand, providing the artist with an exercise in alternative ways of rendering the same subject.

Adam and Eve is believed to have been made just before Dürer's second journey to Italy. The two figures stand like statues in a woodland setting. The very busyness of the background, its charm of detail and natural symbolism, may result in part from the artist's lingering over the area of the work that came more easily to him. Indeed, he filled in all of the background before he even attempted the figures, leaving extra space around the blank profiles in case he needed to make changes.

There is a wealth of complex symbolism in the background, ranging from the choice of four animals (cat, ox, rabbit, and elk) to represent the four temperaments of man and their unleashing after the Fall; to the mountain ash whose bough Adam grasps and which stands for the Tree of Life; to the Tree of Wisdom (a fig tree curiously bearing an apple). All is still and peaceful, but the many symbols give all the necessary clues to the imminent tragedy.

The technical brilliance of this engraving added great luster to Dürer's reputation. He modeled the flesh of his subjects in great detail and with painstaking care, using fine dots to create such a variety of textures that the shading almost creates the illusion of color.

68 *Adam and Eve*, ca. 1504
Albrecht Dürer
German, 1471–1528
Engraving;
9¾ x 7⅜ in. (24.8 x 19.4 cm.)
Bequest of Ida Kammerer,
in memory of her husband,
Frederic Kammerer, M.D., 1933
(33.79.9)

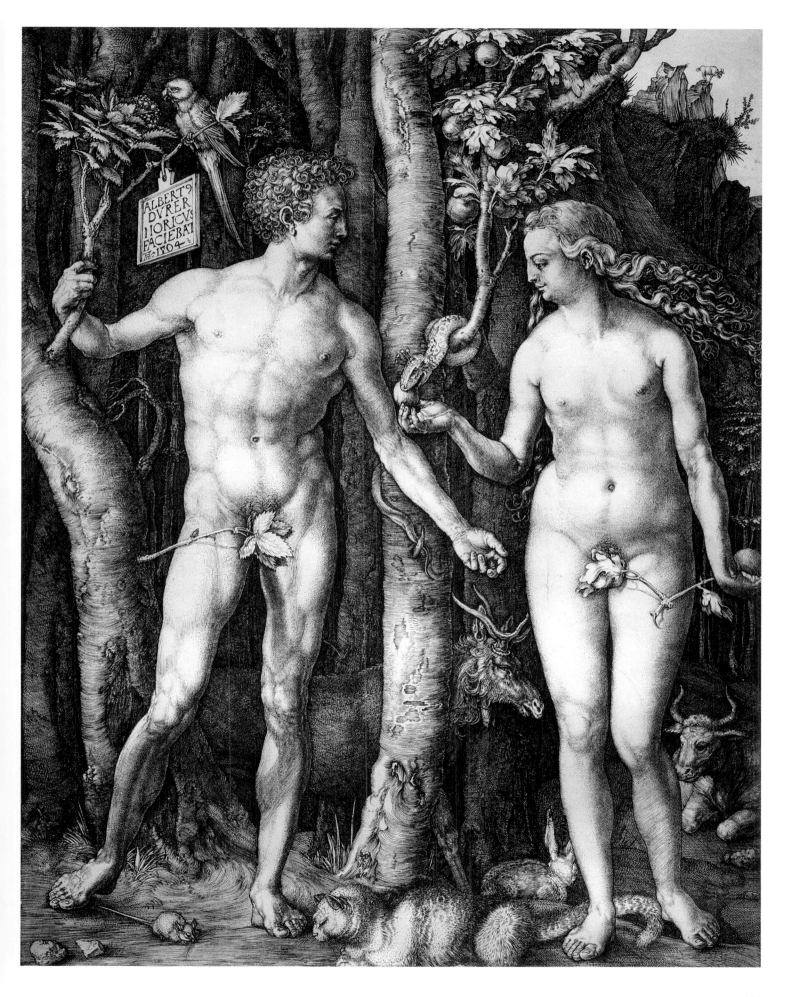

69 The Dead Christ, ca. 1507
Hans Baldung Grien
German, 1484/85–1545
Pen and ink on paper,
6⅝ x 9½ in. (16.9 x 24 cm.)
Robert Lehman Collection,
1975 (1975.1.855)

70 Saint John on Patmos, ca. 1511
Hans Baldung Grien
German, 1484/85–1545
Tempera and oil on wood;
35¼ x 30¼ in. (89.5 x 76.8 cm.)
Purchase, Rogers and Fletcher Funds,
The Vincent Astor Foundation, The
Dillon Fund, The Charles Engelhard
Foundation, Lawrence A. Fleischman,
Mrs. Henry J. Heinz II, The Willard
T. C. Johnson Foundation, Inc., Reliance
Group Holdings, Inc., Baron H. H.
Thyssen-Bornemisza and Mr. and Mrs.
Charles Wrightsman Gifts and Joseph
Pulitzer Bequest; and John Stewart
Kennedy Fund, Gifts of Henry W.
Canon and J. Pierpont Morgan and
Bequest of Lillian S. Timken,
by exchange, 1983 (1983.451)

HANS BALDUNG GRIEN

Hans Baldung Grien, one of Renaissance Germany's greatest religious painters, is well represented by the two works reproduced here. The drawing entitled *The Dead Christ* reveals his skill as a draftsman. Rendered in a light, curvilinear line, the figure of Christ, lying on the ground in a twisted pose, is sensitively and expressively drawn. The work shows clearly the influence of Dürer, Baldung's master.

Saint John on Patmos was one of the wings of a triptych that had as its center panel *The Mass of Saint Gregory,* now in the Cleveland Museum of Art.

Saint John was exiled by the Roman emperor Domitian to the island of Patmos, where he is said to have written the Book of Revelations. Here he is depicted seated on a rock, pausing from his writing and gazing upward in meditation.

In the background is a romantic landscape. Before the saint a vision of the Virgin, standing on a crescent moon and tenderly holding the Christ Child, appears in a yellow aureole surrounded by a ring of clouds. An eagle, John's attribute, which is often represented as the agent of his divine inspiration, is perched on a closed book at the lower left. This passage, with the eagle's imposing outline and beautifully drawn claws (marked by the highlights that are a hallmark of Baldung's style), as well as the foreshortened book and the powerful contrasts of black, turquoise, and gold, is one of the most arresting areas of the painting.

The composition of this panel was adapted by Baldung's workshop about five years later for the right wing of the Schnewlin Altarpiece in Freiburg im Breisgau.

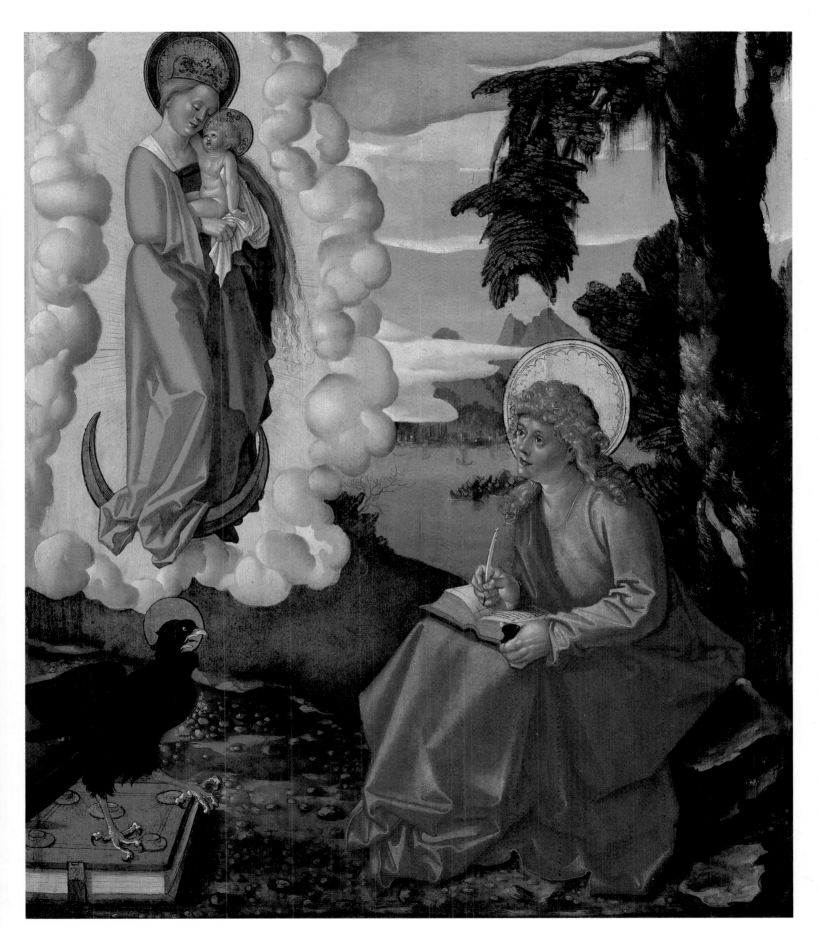

71 Bust of a Man, 1522
Wolfgang Huber
German, 1485–1553
Black chalk, heightened with
white, on red-washed paper;
11⅝ x 7¾ in. (29.4 x 19.8 cm.)
Harris Brisbane Dick Fund,
1950 (50.202)

72 *Death Killing the Lovers*, ca. 1510
After Hans Burgkmair
German
Chiaroscuro woodcut in three blocks;
9 x 5^{15}/$_{16}$ in. (22.9 x 14.9 cm.)
Purchase, Joseph Pulitzer Bequest,
1917 (17.50.39)

WOLFGANG HUBER
Bust of a Man

This drawing is a study for the figure of a soldier in Wolf-gang Huber's *Raising of the Cross*, in the Kunsthistorisches Museum in Vienna. The artist signed the drawing with his initials in the left center and dated it in the upper right corner.

Huber's primary interest in this drawing was the expression of intense emotion. The man's exaggerated features—with his open mouth, staring eyes, and marked creases between the eyebrows—as well as his rather contorted, twisted pose, convey a sense of great anguish. The warm red wash of the paper and the use of white highlights add to the sense of drama.

AFTER HANS BURGKMAIR
Death Killing the Lovers

The influence of the Italian Renaissance is evident in this print executed by Jost de Negker after a design by Hans Burgkmair. Hans Burgkmair the Elder, a native of Augsburg, was a painter, etcher, and draftsman who developed the German method of making colored woodcuts.

Death Killing the Lovers shows Death as a wizened figure with huge tattered wings and a skull for a face. He puts his foot on the chest of the fallen warrior, whose helmet and shield lie useless nearby, and uses both hands to dislocate his victim's jaw while catching the cloak of the fleeing lover between his greedy teeth. Though the costumes are classical, the architecture is that of the Italian Renaissance, and the prow of a Venetian gondola is just visible, emerging from a pilaster.

73 Seated Hercules
German, ca. 1535
Bronze; H. 9 in. (22.9 cm.)
Gift of Irwin Untermyer, 1964
(64.101.1546)

GERMAN ARTIST
Seated Hercules

The nude and bearded Hercules is seated on a tree stump over which a lionskin is draped. The head of the lion, in low relief, may be seen on the back of the stump. Hercules turns his head to his left while raising his left arm in front of his chest, fist clenched as if to protect himself. He probably once held a club.

The statuette gives evidence of the artist's admiration for classical antiquity. The titanic quality of the torso, noticeable especially in the back muscles, was inspired by the marble sculptural fragment known as the *Belvedere Torso* in the Vatican. More than one Renaissance artist strove to "complete" the ancient torso by adding arms and legs to make imaginary reductions in the form of bronze statuettes. This practice is rare north of the Alps, however, and indicates a Northerner with knowledge of Italian Renaissance art as well as ancient prototypes. One such sculptor was Peter Vischer the Younger (1487–1528) of Nuremberg, who traveled in Italy and whose style is recalled in the statuette—if not in all of its aspects, certainly in its robustness.

LUCAS CRANACH THE ELDER
The Martyrdom of Saint Barbara

According to legend, Saint Barbara was beheaded by her father, the heathen nobleman Dioscurus, when she refused to renounce her Christian faith. From childhood he had her locked in a tower to discourage suitors. The tower had only two windows, but while her father was away Barbara convinced workmen to build her a third to symbolize the Trinity. During her father's absence she also managed to sneak a priest disguised as a doctor into her chamber to baptize her. When her father returned she told him what she had done. He was furious, and she fled and sought refuge in a rocky crevice. Betrayed by a shepherd, Barbara was dragged from her refuge to her execution. Cranach has chosen this moment for his painting. Her hiding place can be seen behind the figure of Dioscurus at the right. The four sinister-looking spectators may be the Roman authorities who tortured her in an attempt to persuade her to sacrifice to pagan gods. The arms at the lower right are those of Rehm, a patrician family of Augsburg.

74 *The Martyrdom of Saint Barbara,*
ca. 1510–15
Lucas Cranach the Elder
German, 1472–1553
Oil on wood;
59⅜ x 53⅛ in. (150.8 x 134.9 cm.)
Rogers Fund, 1957 (57.22)

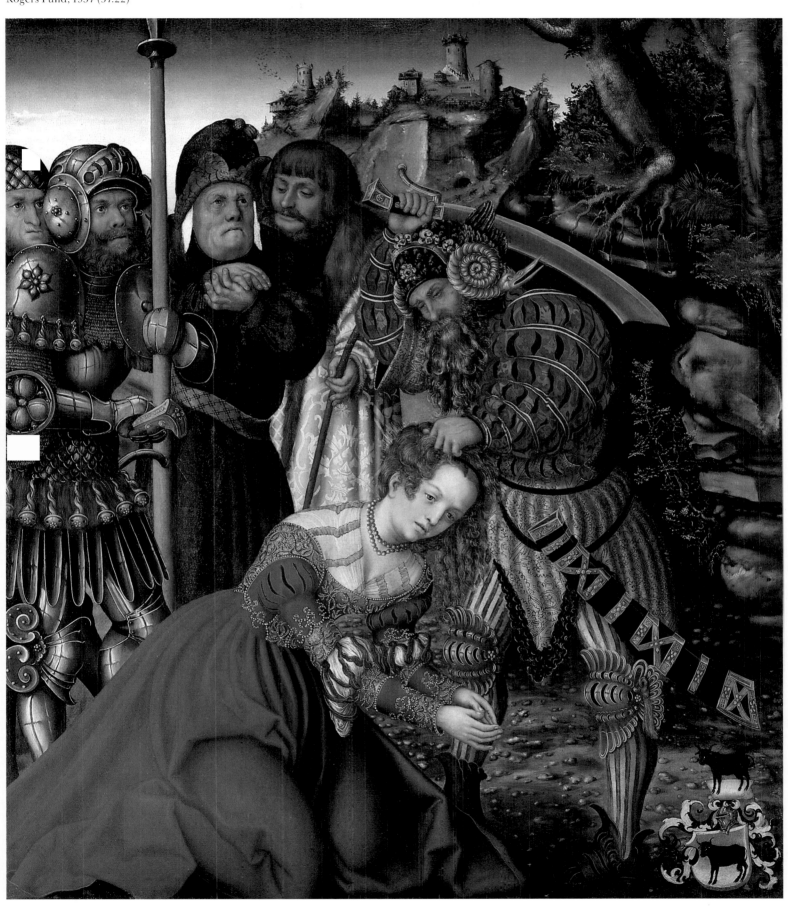

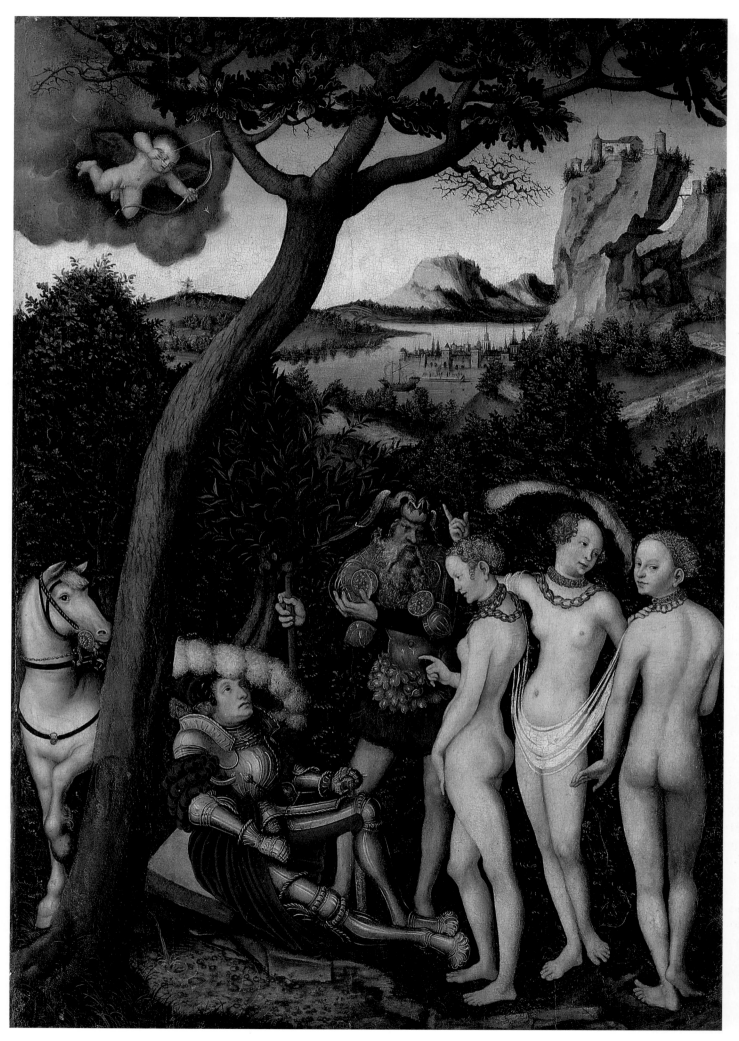

75 *The Judgment of Paris*, ca. 1528
Lucas Cranach the Elder
German, 1472–1553
Tempera and oil on wood;
40⅛ x 28 in. (102 x 71.2 cm.)
Rogers Fund, 1928 (28.221)

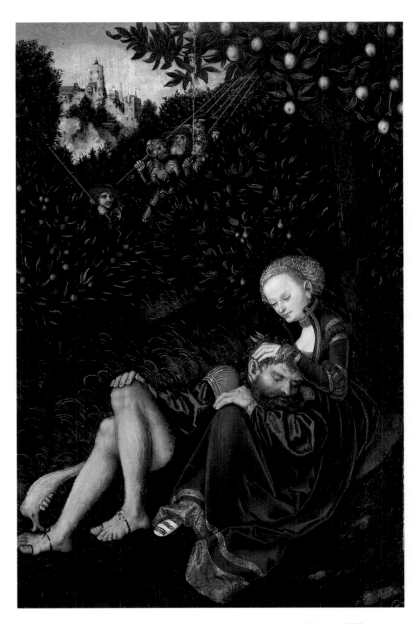

76 *Samson and Delilah*, ca. 1529
Lucas Cranach the Elder
German, 1472–1553
Tempera and oil on wood;
22½ x 14⅞ in. (57.2 x 37.8 cm.)
Bequest of Joan Whitney Payson,
1975 (1976.201.11)

LUCAS CRANACH THE ELDER
The Judgment of Paris

Lucas Cranach the Elder was one of the most versatile artists of the Northern Renaissance. He was a staunch partisan of the Reformation and a close friend of Martin Luther, for whom he produced didactic religious paintings. He also produced his own erotic ideal of the female nude—a type that has had enduring appeal to the present day. Little is known of Cranach's early years, except that he was much influenced by the humanist learning prevalent in Vienna, where he spent time in his youth.

Cranach was a prolific artist, leaving behind a great many paintings, engravings, and woodcuts—but in true humanist style he not only served as painter and architectural adviser to the ducal court at Wittenberg but was burgomaster of the town and also owned a bookshop and a pharmacy.

Cranach favored mythological and classical subjects, and during the course of his career he returned again and again to the story of the Judgment of Paris. His first version was a woodcut made in 1508; this painting is thought to date some twenty years later.

In the classical tale, a favorite among humanists, the shepherd Paris is asked to judge the beauty of the goddesses Venus, Juno, and Minerva, and to present the fairest with a golden apple. Cranach followed the medieval German version of the story: Paris, resting beside a stream, is presented with the three goddesses in a dream. Mercury, who transports the contestants, is seen·in dress appropriate to the Nordic messenger god Wotan. Instead of a golden apple Mercury holds a glass orb. According to the legend, each goddess offered Paris a different bribe. Juno offered power, Minerva wisdom, but for the love of the most beautiful woman on earth, Helen, Paris awarded the prize to Venus.

Cranach alludes to the victory of Venus by placing Cupid in the upper left; she points toward her son, the symbol of love, and he aims his arrow in her direction. In his representation of the women Cranach makes a visual tour of his ideal female nude, showing the sensual outlines of her form from a variety of perspectives. The painting is signed in the right foreground with a winged serpent, Cranach's emblem.

LUCAS CRANACH THE ELDER
Samson and Delilah

In the Old Testament account, the judge Samson, famous for his great strength and notorious for his amorous exploits, took the Philistine woman Delilah as a lover. The Philistines were Samson's enemies: He had once avenged their taunting by killing thousands of them with the jawbone he holds here in his right hand. When the Philistines heard of Delilah's intimacy with Samson, they bribed her to betray him and discover the secret of his strength. Delilah asked Samson; he lied three times but finally confessed that his strength lay in his hair, which had not been cut since his birth. Cranach's painting shows Samson asleep on Delilah's lap. Having lulled him with alcohol, she is cutting the locks from his head. Philistines wait in the background.

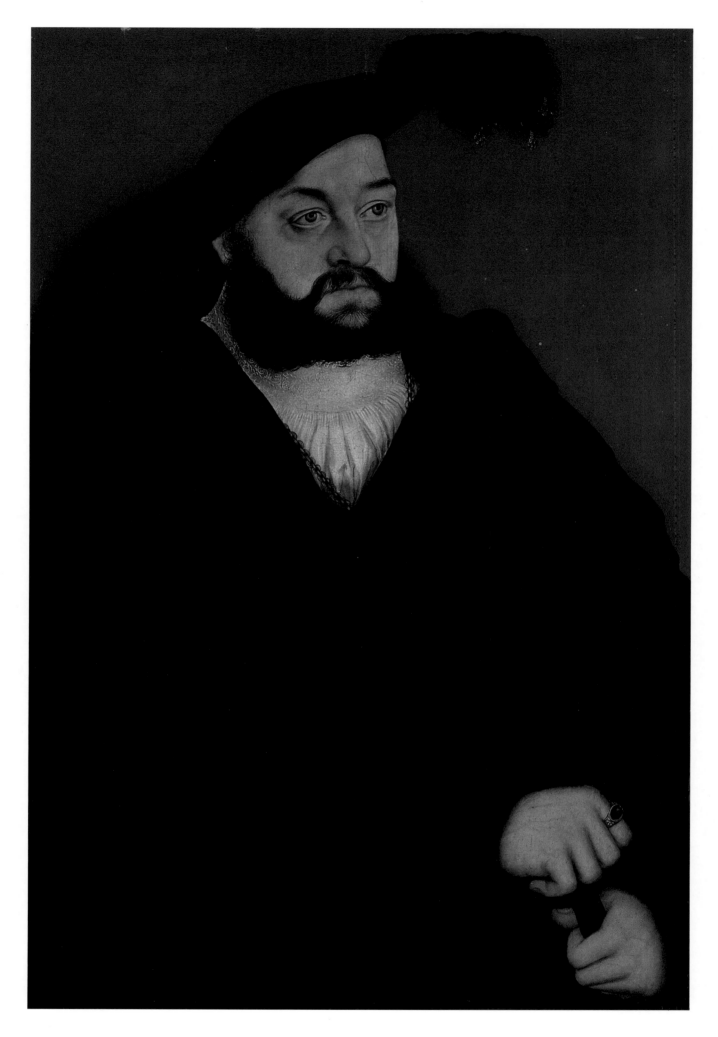

LUCAS CRANACH THE ELDER
John, Duke of Saxony

By the spring of 1505 Cranach was working as a court painter to the electors of Saxony at Wittenberg. He served in succession Frederick the Wise, John the Steadfast, and John Frederick the Magnanimous. Frederick the Wise was a noted humanist who in 1502 had founded a university at Wittenberg. Here Cranach met Martin Luther, who was made a professor of theology at the university in 1508.

The sitter in this portrait was a member of the Albertine branch of the family. The bold design, intense color, and capricious but graceful outline of the costume are typical of the style Cranach developed as portraitist to the court. The picture has been dated about 1537, the year of the sitter's death.

LUCAS CRANACH THE ELDER
Martin Luther as a Monk

This small engraving shows Martin Luther in the guise of a monk of the Augustinian order, which he joined in 1506. The artist, Lucas Cranach, was an intimate friend of Luther's and is said to have produced the only lifelike images of the man. This particular engraving was made in 1520, the year Martin Luther published a series of pamphlets in which he questioned the Church's sale of indulgences and denied the supremacy of the pope. Cranach supervised the printing of the pamphlets.

Many states of this engraving exist. They vary both in the density of their inking and in the degree to which a small profile portrait of a bearded man is visible in the upper left-hand corner. In darker impressions, the profile appears to have rays of light emanating from its forehead in the direction of Luther; in our impression the lines are faint, and in some the face is not visible at all. The medieval Latin inscription that runs beneath the image implies that though Luther's reflections may be eternal, this scrap of paper, its subject, and the artist will all pass away.

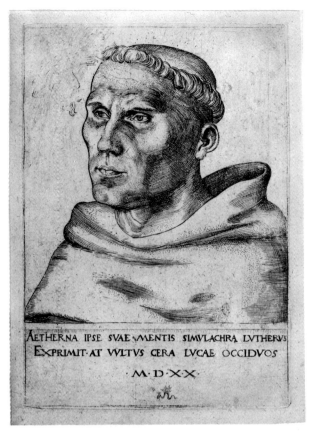

78 *Martin Luther as a Monk*, 1520
Lucas Cranach the Elder
German, 1472–1553
Engraving
6¼ x 4¼ in. (15.9 x 10.8 cm.)
Purchase, Felix M. Warburg Gift,
1920 (20.64.21)

O V E R L E A F :

LUCAS CRANACH THE ELDER (Pages 112–113)
The Tournament with Lances

In woodcut technique Lucas Cranach followed the lead of Albrecht Dürer, who had raised what was once a popular form of visual information to the level of fine art (see Plate 65). The amount of detail, nuances of texture, and refinements of perspective all suggest the engraving technique; the reverse, however, is true. Instead of lines engraved into the soft surface of a copper plate, the black lines printed here are the raised portions that are left when the wood surrounding them is removed. Even the manner of Cranach's signature—the letters *LC* and the date—takes its cue from Dürer.

One of a series of three woodcuts showing tournaments, the print commemorates festivities held at Wittenberg on November 15 and 16, 1508. Cranach must have made sketches at these events and worked them into woodcuts the following year. The woodcut shows the tournament with lances. Riders are dressed in ceremonial armor, with elaborate plumes protruding from their helmets. A motley band of trumpeters carries on in the back left corner of the print, and knights and ladies, identified by the pair of Saxon shields, line the staircase on the right.

77 *John, Duke of Saxony*, ca. 1537
Lucas Cranach the Elder
German, 1472–1553
Tempera and oil on wood;
25⅝ x 17⅜ in. (65.1 x 44.2 cm.)
Rogers Fund, 1908 (08.19)

79 The Tournament with Lances,
ca. 1509
Lucas Cranach the Elder
German, 1472–1553
Woodcut; 11¼ x 16¼ in.
(28.6 x 41.3 cm.)
Harris Brisbane Dick Fund,
1927 (27.54.26)

Page 111: Text

80 Backplate, Hoguine, and Sleeves
German, ca. 1525
Steel, etched and partly gilt;
27 x 18 in. (68.6 x 45.7 cm.)
(Backplate and hoguine) Gift of
Bashford Dean, 1924 (24.179);
(sleeves) Mrs. Stephen V. Harkness
Fund, 1926 (26.188.12)

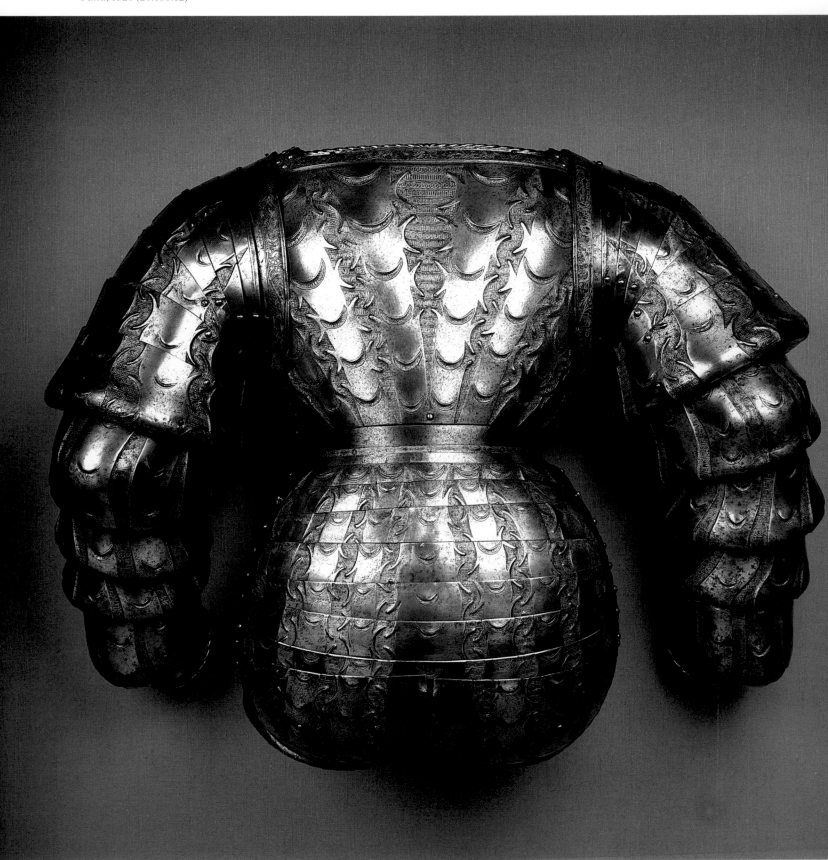

81 Helmet with Mask Visor
German, 1st half 16th c.
Steel, etched and partly gilt
Rogers Fund, 1904 (04.3.286)

COSTUME ARMOR

The relationship between armor and clothing has existed
since the idea of sheathing men in steel for protection was
first conceived. By the sixteenth century armor had achieved
its peak, both as protection in battle and as ceremonial pa-
raphernalia. Because of the cost of its production, fine armor
was considered a symbol of status and was worn as a kind of
all-over body jewelry. The accomplished armorer was judged
by his ability to reproduce in steel elaborate details from
contemporary costume. The cascading sleeves of this ar-
mored torso are in direct imitation of the puffed-and-slashed
dress of foot soldiers, in particular the German *Landsknechte*.
Each sleeve is composed of ten telescoping steel plates elab-
orately decorated by embossing, etching, and gilding to imi-
tate textile fashions. The slashes indicated in the material, a
contemporary fashion in clothing, might be likened to the
rugged chic of torn and patched jeans today.

The helmet with mask visor pictured at the right partakes
of the same ceremonial spirit. Embossed with a grotesque
face, this type of helmet was called a *Schembart*, after the
masks worn at local Shrovetide mummeries. Tournaments,
which often included jousters in earthy and funny disguises,
were part of these Shrovetide pageantries, and this helmet
was probably made for such an occasion.

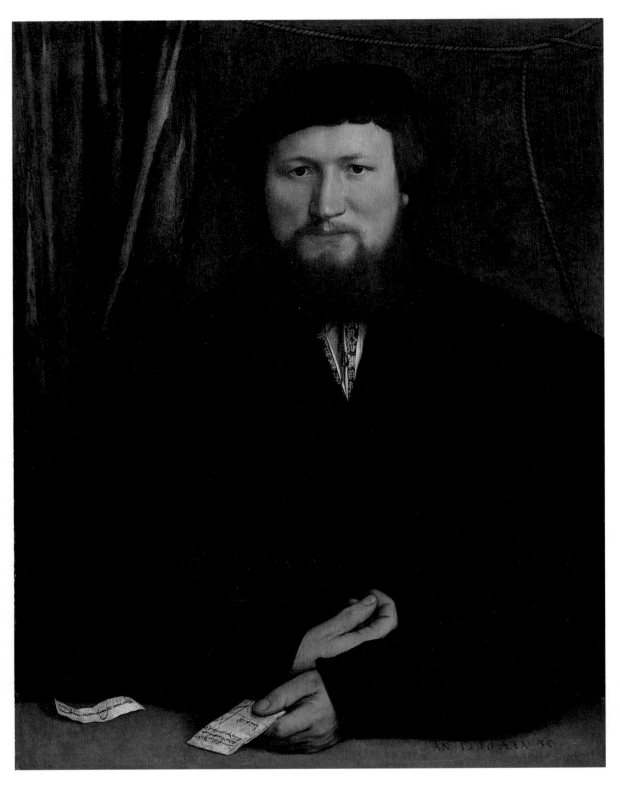

82 *Dierick Berck*
Hans Holbein the Younger
German, 1497/98–1543
Oil on canvas,
transferred from wood;
21 x 16¾ in. (53.3 x 42.6 cm.)
The Jules Bache Collection,
1949 (49.7.29)

HANS HOLBEIN THE YOUNGER
Dierick Berck

Like the young man portrayed in Plate 84, Dierick Berck was one of the wealthy German merchants of the Hanseatic League, whose members enjoyed trading monopolies and other privileges in London. They lived in the Steelyard, an enclosed quarter on the banks of the Thames above London Bridge, and were quite influential in London.

Facing squarely front, with a complacent expression on his face, Dierick Berck is the very image of a wealthy bur-gher. His massive bulk is offset by the thin red rope that runs across the top of the picture and loops around and down at the corner, framing his head and shoulders, as well as by the delicate design and tassels of his shirt collar. Berck holds a letter inscribed, in translation, "To the honorable . . . Dierick Berck, London at the Steelyard." On the *cartellino* at the left is a quote from Virgil's *Aeneid:* "Someday it will be pleasant to remember."

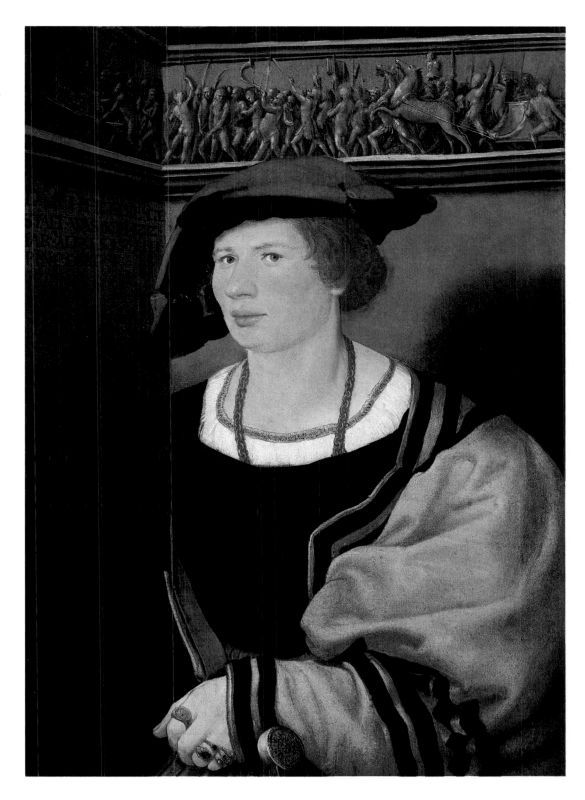

83 *Benedikt von Hertenstein*, 1517
Hans Holbein the Younger
German, 1497/98–1543
Oil on paper, mounted on wood;
20⅝ x 15 in. (52.4 x 38.1 cm.)
Rogers Fund, aided by subscribers,
1906 (06.1038)

HANS HOLBEIN THE YOUNGER

Benedikt von Hertenstein

In 1517 the young Hans Holbein traveled from Basel to Lucerne to decorate the newly built mansion of Jakob von Hertenstein, mayor of Lucerne. This portrait of the mayor's eldest son, Benedikt, was also painted in 1517, the year he was elected to the city council. The inscription on the wall at the left translates: "When I looked like this I was 22 years old. 1517. H. H. painted it."

The sitter is undeniably a successful young man. Slightly plump, with full, red lips, he wears a luxurious costume and six rings on his left hand. (The one on his index finger bears the seal of the Hertenstein family.) Despite his success and promising future, Benedikt von Hertenstein would die five years later, while serving as a Swiss mercenary soldier at the Battle of Bicocca.

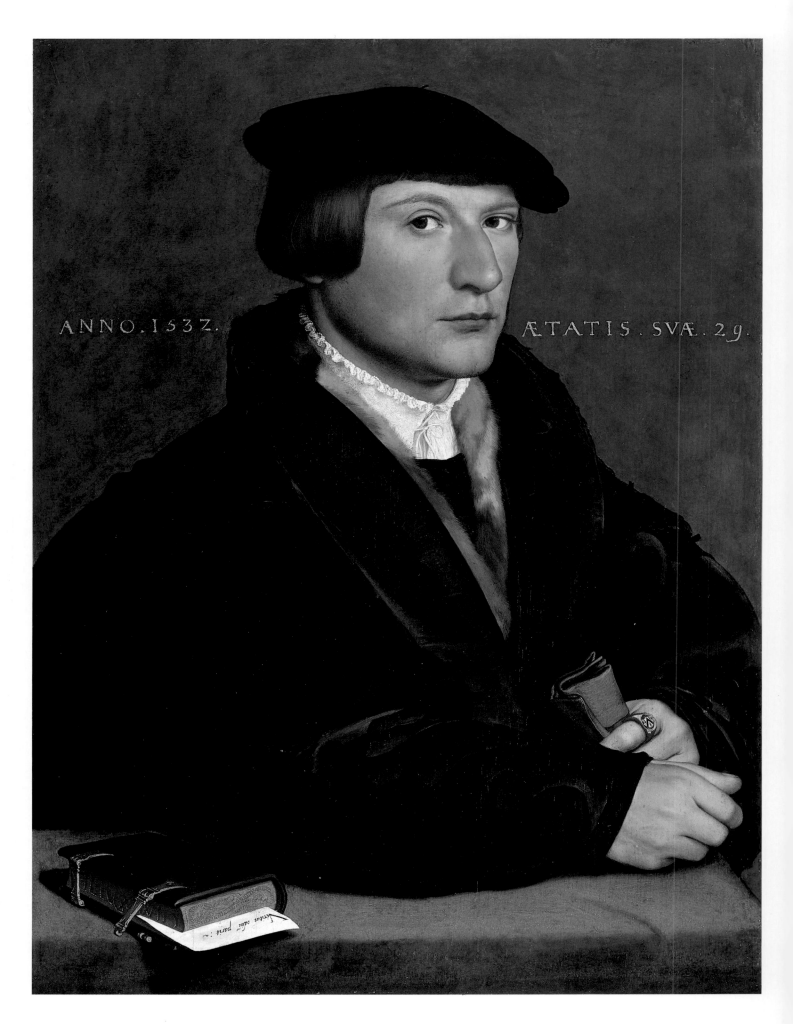

ANNO.1532.　　　ÆTATIS.SVÆ.29.

Hans Holbein the Younger
Erasmus of Rotterdam

Holbein was introduced to humanist circles in Basel in 1516, and he painted a number of portraits of their members, including the Dutch scholar Erasmus. The two went on to become close friends, and Erasmus proved to be very helpful in securing commissions for his artist friend.

This portrait, one of many Holbein painted of Erasmus, was probably completed after 1523. In it the "king of humanists," wearing a simple furred robe, is represented in a dignified pose. Although his strong facial features have been softened, Erasmus's determined, unbending character is clearly transmitted. The *cartellino* at the upper left is a seventeenth-century addition. Its inscription is illegible, but it may be the painted sign that was the mark of the collection of the earl of Arundel.

Hans Holbein the Younger
Portrait of a Member of the Wedigh Family

Hans Holbein was a true Renaissance man. Equally at home in Basel and London, he was a friend of the great humanists of his day and produced works ranging from book illustrations to stained-glass designs to paintings. But it is as one of the world's greatest portraitists that Holbein is best known. The sharp eye and precise realism he brought to the many portraits he painted in the England of Henry VIII have left us a record of that country during one of her most prestigious and powerful epochs.

When Holbein went to England for the second time, he found many clients among a wealthy community of German merchants in London who belonged to the Hanseatic League. The arms on the ring of the sitter here, as well as the lettering on the pages of his book, indicate that he was a member of the Cologne trading family named Wedigh; presumably he was their representative in England. The young man, who looks out with a penetrating gaze, has been portrayed with a cool objectivity. The crisp, explicit characterization, the precise technique, and the clarity of color make this a highly engaging portrait.

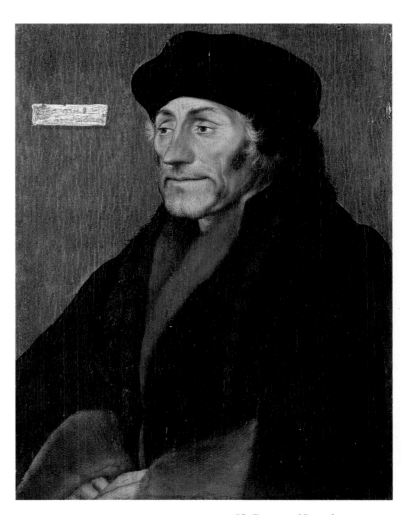

85 Erasmus of Rotterdam
Hans Holbein the Younger
German, 1497/98–1543
Oil on wood;
7⅜ x 5¾ in. (18.7 x 14.6 cm.)
Robert Lehman Collection,
1975 (1975.1.138)

84 Portrait of a Member of the Wedigh Family, 1532
Hans Holbein the Younger
German, 1497/98–1543
Tempera and oil on wood;
16⅝ x 12¾ in. (42.2 x 32.4 cm.)
Bequest of Edward S. Harkness,
1940 (50.135.4)

HANS DAUCHER
Allegory of Virtues and Vices at the Court of Charles V

The carvings of Hans Daucher have a superb graphic strength and a narrative vitality that relate them to the prints of Dürer and Hans Burgkmair. This honestone relief, signed with his monogram and dated 1522, is Daucher's most complex work, involving the greatest number of figures.

The relief was probably commissioned by the young Habsburg emperor, Charles V, who is depicted as the most prominent horseman at left center. Issuing through the arch

to the right of the emperor is Frederick II, Count Palatine. Above this group is a Turkish encampment, a reminder of imperial warfare against the Turks. At right, passing through the arch, are court ladies with the court intellectual, Willibald Pirckheimer, in their midst. Below, struggling in the water underneath the bridge, are rebellious knights, among whom the features of one of the insurgents, Franz von Sickingen, have been detected.

86 *Allegory of Virtues and Vices at the Court of Charles V*, 1522
Hans Daucher
German, ca. 1485–1538
Honestone with traces of gilding,
10⅞ x 18⅜ in. (27.6 x 46.7 cm.)
Gift of J. Pierpont Morgan,
1917 (17.190.745)

Above left: detail

121

87 Hafnerware Jug
Workshop of Paul Preuning
German, Nuremberg, ca. 1550
Lead- and tin-glazed earthenware;
H. 14 in. (35.6 cm.)
Gift of R. Thornton Wilson,
in memory of Florence Ellsworth
Wilson, 1950 (50.211.202)

Workshop of Paul Preuning
Hafnerware Jug

Hafnerware, of which this is a fine example, derives its name from the *Hafner*, or potters, of Germany and Austria. For the most part, these men built the huge tiled and enclosed stoves used as the primary source of heat in German castles and homes, but they also created occasional pieces such as the one seen here. This jug was made in the workshop of Paul Preuning of Nuremberg (act. 1540–50), one of the best-known producers of these elaborately decorated wares. The workshop combined the deeply colored lead glazes tradi-tionally used by the *Hafner* with the more recently imported white tin glaze.

The curved tile set into the cutaway front of this jug pre-sents the spectacle of two men attacking each other with axes and is thought to refer either to the recent Peasants' Revolt in Germany or, in general, to the gathering religious turbulence there. This new technique of ornamenting tra-ditionally thrown pots with molded Renaissance figure dec-oration used printed source material for its inspiration.

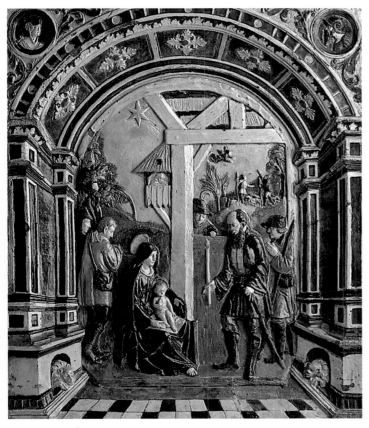

88 *Stove Tile*, ca. 1570
Hans Resch
Austrian, act. 1563–98
Lead and tin-glazed earthenware;
25⅝ x 21½ in. (65.1 x 54.6 cm.)
Gift of R. Thornton Wilson, in memory
of Robert Francis Kennedy (1925–1968),
Senator from New York, 1968 (68.81.1)

HANS RESCH
Hafnerware Stove Tile

During the sixteenth century, the elaborate tiled superstructure of stoves was enlarged, giving the *Hafner* opportunities to make larger tiles with more pictorial importance. Hans Resch, who worked in Salzburg, a thriving city, was one of the few makers of hafnerware whose name is known today.

This tile, depicting the Adoration, is among the largest multicolored ceramic tiles ever produced, and its composition, like that of its companion piece, also in the collection of the Metropolitan Museum, reveals a complete absorption of Renaissance imagery. Framed by an Italianate arch, in a loggialike setting with a tiled floor that bears not the slightest resemblance to the New Testament manger, the Virgin holds Jesus on her lap, flanked by worshipers. The figure on her left, holding a candle, may have been intended to represent Saint Joseph but is also thought to be a portrait of the man who commissioned the stove. In the background, the angel is giving the news of Christ's birth to the shepherds.

The piece is one of a group of glazed polychrome stove tiles attributed to Resch that depict scenes from the life of Christ. Its companion, similar in composition, illustrates a scene from the Old Testament, the execution of the five kings of the Amorites.

OVERLEAF:

CASPAR BEHAIM (*Pages 124–125*)
Astronomical Table Clock

Most sixteenth-century clocks were enclosed in metal cases, some architectural in nature, others engraved and embossed with designs that rival the work of goldsmiths of the day. We know this astronomical table clock to be the work of Caspar Behaim from an inscription on the side.

The clock case is elaborately made of gilt bronze with a domed top decorated in *relief ajouré* (pierced or perforated metalwork) with a scene of men hunting bear. The face of the clock shows five dials, each marking a different measure of time. The largest dial has four concentric rings, the outer one marked with minutes, the next with the quarter hours, and the third and fourth with the hours of the day and night. The large dial at the base is composed of a number of interchangeable plates that indicate the days of any two months along with their corresponding dominical letters, saints' days, and fetes. The three smallest dials are marked with the letters A to G, the signs of the zodiac, and the numerals 1 to 8.

A large astrolabe dial fills most of the back of the clock. It is surrounded by two concentric circles, one giving the Italian hour (marked 1 to 24), the other giving time as recorded in the rest of Europe (I to XII). A small dial below indicates the days of the week and shows figures of deities associated with each day. The base is decorated with the triumphal procession of Pluto and Proserpina.

89 *Astronomical Table Clock*, 1568
Caspar Behaim
Austrian, act. 1568–84
Bronze-gilt and steel; H. 14¼ in.
(36.2 cm.), L. 8¼ in. (21 cm.), W. 5¾ in.
(14.6 cm.) Gift of J. Pierpont Morgan,
1917 (17.190.634)

90 Shrine Incorporating a Triptych, 1598
Silversmith: Matthias Wallbaum, 1554–1632
Painter: Anton Mozart, 1573–1625
German
Ebony, silver, silver-gilt, gouache on
parchment; 17 x 17¼ in. (43.2 x 43.8 cm.)
Gift of J. Pierpont Morgan, 1917
(17.190.823)

Opposite: two views

91 Madonna and Child Enthroned
German, late 16th or early 17th c.
Ivory; H. 11¼ in. (28.6 cm.)
Bequest of Mary Clark Thompson,
1924 (24.80.93)

MATTHIAS WALLBAUM AND ANTON MOZART
Shrine Incorporating a Triptych

Matthias Wallbaum was one of the best goldsmiths in sixteenth-century Augsburg, and elaborate shrines of an almost neo-Gothic character were the specialty of his workshop. This jewellike example, in the form of a triptych, documents episodes from the New Testament in hierarchical order. Atop the shrine is a Visitation scene with figures of Saints Anne and Elizabeth, and an announcing angel. On the front of the doors of the triptych silver figures enact the Annunciation. The doors open into a miniature triptych painted in gouache by Anton Mozart, with the Nativity at the center, the Presentation on the right wing, and the Circumcision on the left. A tiny panel illustrating the Flight into Egypt forms the predella of the altar. On the stem of the shrine a silver Christ bears his cross to Calvary; beneath, his collapsed figure hangs from his mother's arms in a Pietà. On the four sides of the base the Evangelists, identified by their various attributes and symbols, record the events pictured above.

GERMAN IVORY CARVER
Madonna and Child Enthroned

German figural sculpture reached a peak of refinement in the Bavarian cities of Augsburg and Munich during the late sixteenth century. This ivory carver emulates such masters of large-scale sculpture as Hubert Gerhard and Hans Reichle in his pursuit of monumental forms and elevated expression. The Virgin's draperies are particularly striking in the studied arrangement of their masses. There is much in common here with the work of Christoph Angermair (d. 1632/33), the best ivory carver of the Wittelsbach court in Munich.

LUTE

The European lute derives from the Arabic instrument called the ud, brought to Europe with the Moors when they occupied Spain (711–1492). There are no extant European lutes made before about 1450, and our knowledge of early lutes derives from paintings, sculpture, and writings. The instrument shown here is dated 1596. It consists of a pear-shaped body made of twenty-five narrow strips of dark wood with inserted ivory lines. The spruce soundboard is decorated with ivory edging, called "lace," and the sound hole is decorated with a fretwork rosette—a pattern derived from Arabic models.

After lutes went out of style in the eighteenth century, many were restrung as guitars, a more popular instrument. Thus the peg box of this example, which originally had fourteen pegs, is now furnished with six. Likewise, the bridge attached to the soundboard had seven pairs of strings and now has six strings.

93 Virginal
German, ca. 1600
Wood and other materials;
L. 17⅜ in. (44.1 cm.), W. 8⅝ in.
(21.8 cm.), D. 3⅝ in. (9.1 cm.)
The Crosby Brown Collection of
Musical Instruments, 1889
(89.4.1778)

VIRGINAL

Virginals, or small, laterally strung harpsichords, were portable instruments; they could even be taken along when traveling. This virginal's pitch was too high to play with other instruments or even to accompany a singer, and it was more a decorative object than an instrument for a serious musician. Virginals are usually depicted being played by young women—perhaps a sign of their status as novelty or bibelot.

This virginal's case is made of ebony and dark-stained wood and has two small drawers in the lid. The inside of the lid is decorated with colored paper prints, most likely a later addition. The sound hole is decorated with a beautiful pattern much like that of the rose window of a Gothic cathedral.

LAURENTIUS HAUSLAIB
Claviorganum

A claviorganum is actually two instruments—an organ and a harpsichord—superimposed. In the example illustrated here, one of the oldest dated German harpsichords, a pentagonal spinet (an early harpsichord) originally slid into the drawer above the organ's keyboard. The two instruments coupled and could be played simultaneously. The instrument's soundboard is decorated with a pierced-wood and parchment rose and has painted borders of flowers and berries. The central drawer has a bronze medallion showing the Deposition from the Cross. (Unlike the other drawers, this one has no back, and through it one can see the organ pipes.) An inscription on the jackrail gives the name of the maker, Laurentius Hauslaib, and the year in which the claviorganum was built: 1598. Nuremberg, where this example was made, was an extremely important center of musical-instrument production.

92 Lute
German, 1596
Wood and other materials;
29 x 12 in. (73.7 x 30.5 cm.)
Gift of Joseph W. Drexel, 1889
(89.2.157)

94 Claviorganum, 1598
Laurentius Hauslaib
German
Wood and other materials;
L. 26 in. (66.1 cm.), W. 11 in.
(28.1 cm.), D. 3¾ in. (9.5 cm.)
The Crosby Brown Collection
of Musical Instruments, 1889
(89.4.1191ab)

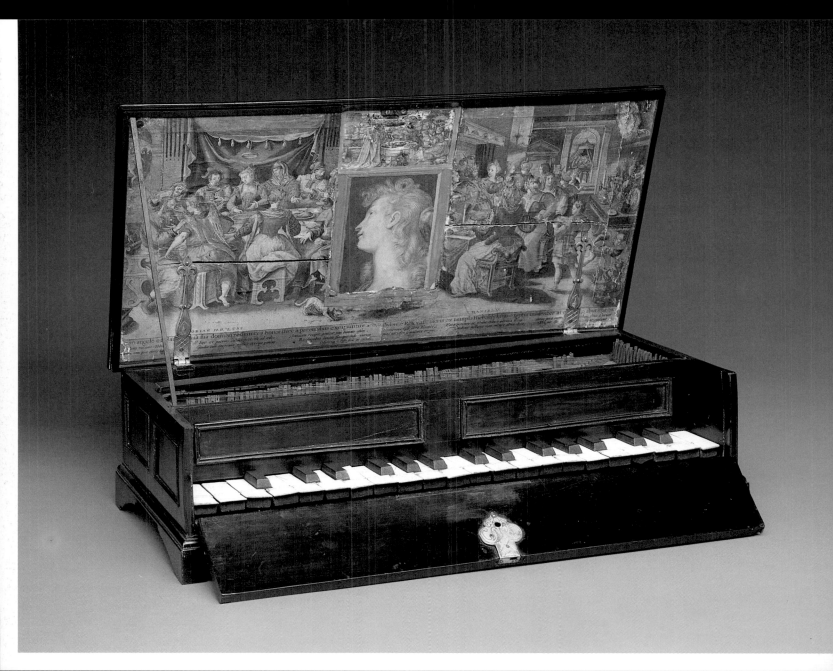

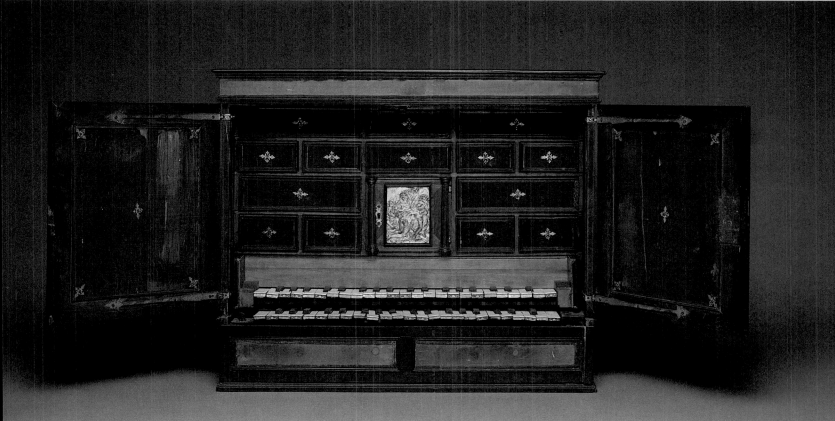

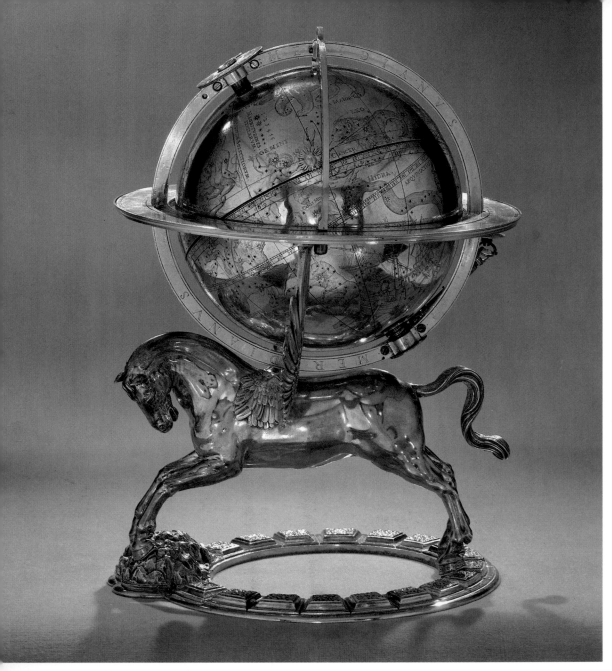

95 *Celestial Globe with Clockwork*
Austrian or Bohemian, 1579
Case: silver, partly gilded, and brass;
movement: brass and steel;
10¾ x 8 x 7½ in. (27.3 x 20.3 x 19 cm.)
Gift of J. Pierpont Morgan, 1917
(17.190.636)

96 *Römer*
German, late 16th c.
Glass; H. 11¼ in. (28.6 cm.),
Diam. 5⅞ in. (14.9 cm.)
Gift of Mrs. Samuel P. Avery,
1904 (04.24)

CELESTIAL GLOBE WITH CLOCKWORK

This globe was described in an early-seventeenth-century inventory of the Prague Kunstkammer of the Holy Roman emperor Rudolph II (1552–1612). It houses a movement made by Gerhard Emmoser, imperial clockmaker from 1566 until his death in 1584, who signed and dated the globe's meridian ring. The movement, which has been extensively rebuilt in the course of its existence, rotated the celestial sphere and drove a small image of the sun along the path of the ecliptic. The hour was indicated on a dial mounted at the top of the globe's axis, and the day of the year on a calendar rotating in the instrument's horizon ring. The silver globe, with its exquisitely engraved constellations and its Pegasus support, is the work of an anonymous goldsmith who was probably employed in the imperial workshops in Vienna or possibly in Prague.

RÖMER

The great age of discovery—with its charting of earth, seas, and stars—led to increased interest in mapmaking all across Europe. Germany and the neighboring areas witnessed a great flowering of regional maps in the sixteenth and early seventeenth centuries. Sebastian Münster's compilation of regional geography, the *Cosmographia*, went through more than forty editions from 1544 to 1650.

The *Römer*—a type of wine glass—illustrated here is evidence of the widespread popularity of regional maps. It bears, engraved with a diamond point, a map of the Rhineland and neighboring states that shows churches as well as the arms of the cities and duchies.

Römers, which first appeared in the late sixteenth century, are still used for drinking Rhine wine. They are made of *Waldglas*, or forest glass, a green glass made mostly in the Rhineland and in the Böhmer Wald on the border between Bavaria and Czechoslovakia. Their stems are decorated with applied drops called prunts. The foot of the example here, a zigzag ring, is characteristic of early *Römers*.

JEAN FOUQUET

Jean Fouquet, born in Tours, was the major painter at the royal court in the latter half of the fifteenth century. While the range of the work he produced is broad, he is perhaps best known as a miniaturist. The miniature reproduced in Plate 98 is from a Book of Hours (a book with prayers for the canonical hours of the day) that belonged to Etienne Chevalier, treasurer of France. It was illuminated after Fouquet's return from Italy in 1448, most probably in 1452. Illustrated in luminous colors, its compositions enriched by the subtle use of gold, this Book of Hours united the achievements of French and Italian art. The illuminated page shown here represents the descent of the Holy Spirit upon the faithful, who are shown in medieval Paris. The unusual setting for this scene constitutes the earliest known topographical view of the city. The most famous monuments shown are Notre-Dame, the Pont Saint-Michel—then a covered bridge —and the Petit Châtelet. The text at the bottom of the page is the beginning of the Vespers of the Holy Spirit.

Plate 97 shows one of the finest surviving portrait drawings from the fifteenth century. Fouquet's draftsmanship is direct, strong, and authoritative, and the figure is endowed with a sense of solidity: We can feel the weight of the scarf knotted at the ecclesiastic's neck, and the flesh of his double chin.

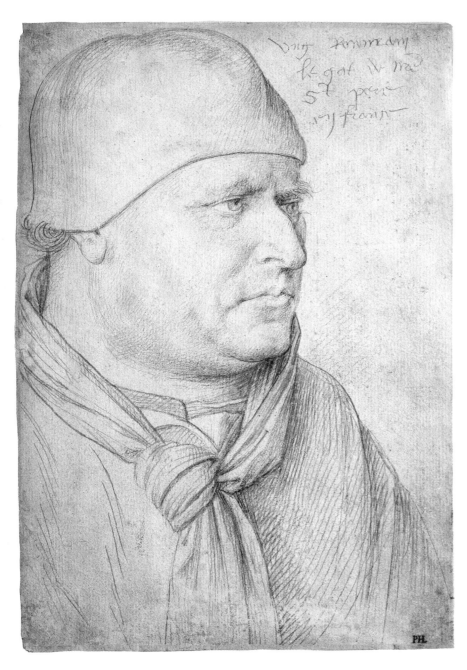

97 *Portrait of an Ecclesiastic*
Jean Fouquet
French, ca. 1420–81
Metalpoint and a little black chalk
on white prepared paper;
7¹³⁄₁₆ x 5⁵⁄₁₆ in. (19.8 x 13.6 cm.)
Rogers Fund, and Gift of
Mrs. Benjamin Knower, Bequest of
Ogden Mills, and Bequest of
Collis P. Huntington, by exchange,
1949 (49.38)

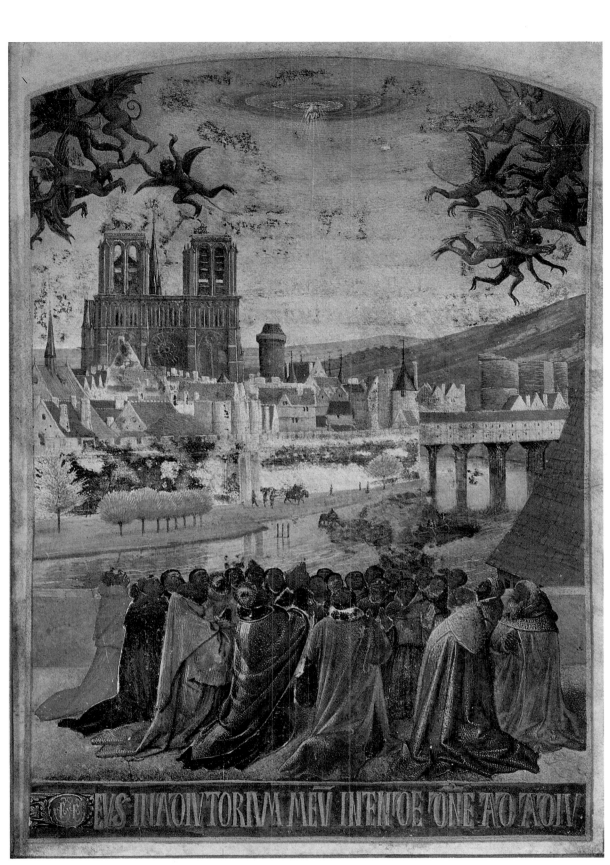

93 *Descent of the Holy Ghost upon the Faithful*, ca. 1452
Jean Fouquet
French, ca. 1420–81
Illumination; 7¾ x 5¾ in.
(19.7 x 14.6 cm.)
Robert Lehman Collection, 1975
(M, 194)

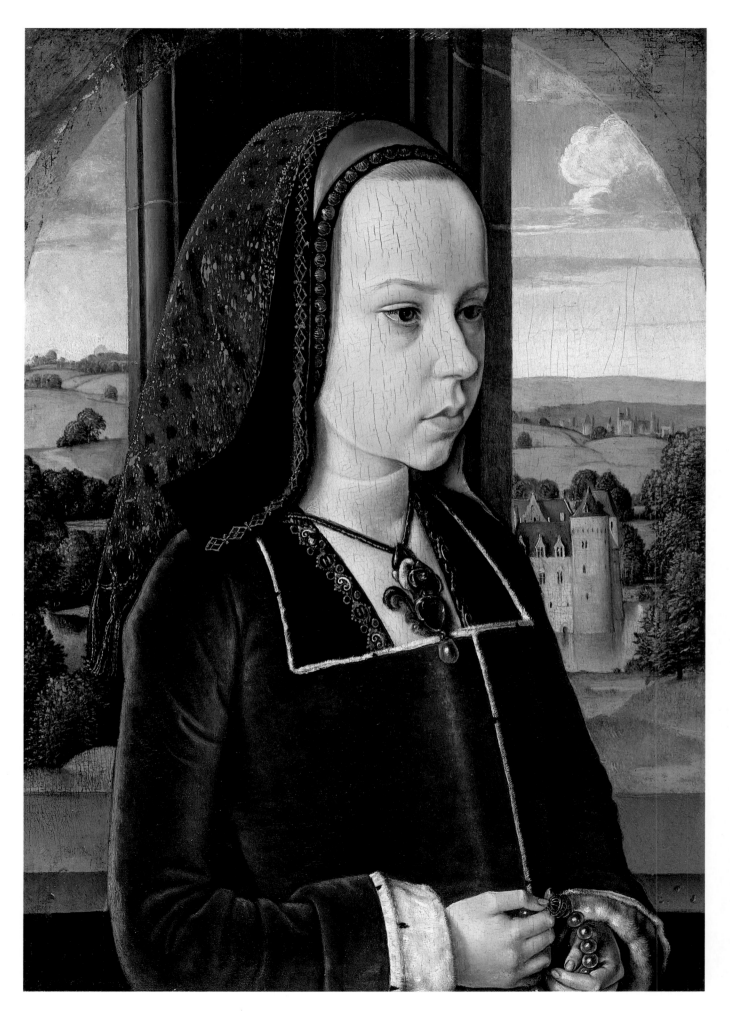

99 Portrait of a Young Princess,
probably Margaret of Austria, ca. 1490–91
Jean Hey, called Master of Moulins
poss. Flemish, act. 1480–1500
Tempera and oil on wood;
13½ x 9½ in. (34 x 24 cm.)
Robert Lehman Collection, 1975
(1975.1.130)

MASTER OF MOULINS
Portrait of a Young Princess

The subject of this portrait, believed to be Margaret of Austria (1480–1530), was the daughter of Emperor Maximilian I. At the age of ten or eleven she was betrothed to Charles VIII of France and sent to live with the French royal family at the château of Amboise. The short-lived marriage ended in 1491, which effectively dates the painting to 1490–91. Margaret went on to marry two more times. After the death of her third husband her father appointed her regent of the Netherlands, in 1507, in which capacity she considerably extended Habsburg domination over the area. She also became an accomplished musician and poet and a great collector of art.

At the time of this painting, however, Margaret of Austria was a sad little girl, lodged in an alien household and unhappily betrothed. Many scholars have identified the Master of Moulins with Jean Hey, an artist who if not Flemish himself was influenced by the Flemish style. He was active in central France between 1480 and 1500. Here he has captured the sullen, withdrawn mood of the lonely child imprisoned in her elaborate clothing—royal crimson robe, heavy fleur-de-lis pendant, and elaborate headdress—and has enlarged the scope of the portrait by placing her against an imposing backdrop. She is standing by an open window from which can be seen the peaceful vista of the Loire Valley stretching far into the distance. The juxtaposition creates an interesting balance between the closed-in expression of the child in her confinement and the free, open spaces behind her. There is, too, a fusion of French and Flemish tradition in the clarity and precision of detail.

FRENCH ARTIST
The Annunciation

In the last two decades of the fifteenth century highly elegant woodcuts were produced in France, some in Paris and others in Lyons and the Savoy. Most of them were approximately the same size and fitted easily into the lids of document boxes. They were popular and frequently copied.

The Annunciation seen here was made in Paris and was removed from a missal printed in Nuremberg in 1491. It is in almost suspiciously good condition, leading some experts to think that at some point it may have been cleaned and repainted. It is completely French in character, with a subtle color scheme that juxtaposes different shades of the same colors—burgundy against red, aqua against light blue. The clarity, the gentleness of the figure types, and the grace of their movements are all characteristic of the French School in the fifteenth century. The work represents the final period of the older style of woodcut, in which the figures were heavily contoured and then shaded with a primitive and limited amount of hatching. At this time crosshatching, soon to revolutionize print illustrations and carry them to a new level of art, was being developed in Germany.

100 The Annunciation
French, ca. 1491
Woodcut, colored by stencils;
image 7½ x 5⅞ in. (19 x 15 cm.)
Bequest of James Clark McGuire,
1930 (31.54.144)

101 The Retable of Le Cellier, 1508–09
Jean Bellegambe
French, b. 1467/77–d. 1535
Tempera and oil on panel;
central panel 40 x 24 in. (101.6 x 61 cm.),
left wing 37¾ x 10 in. (95.9 x 25.4 cm.),
right wing 37½ x 9½ in. (95.3 x 24.1 cm.)
The Friedsam Collection, Bequest of
Michael Friedsam, 1931 (32.100.102)

JEAN BELLEGAMBE
The Retable of Le Cellier

Although this altarpiece, one of the earliest works of Jean
Bellegambe, is named after the chapel in Colombe-le-Sec
where it was discovered in 1861, it was commissioned for
the abbey of Flines. The interior of the altarpiece, repro-
duced here, depicts the Virgin and Child enthroned with
Cistercian monks and donors presented by Saint Bernard
of Clairvaux on the left and by Saint Malachy O'Morgair—
primate of Ireland and friend of Bernard's—on the right.
The group of kneeling figures in the central panel has been
variously identified. It has been suggested that the entire
group represents Saint Bernard's family, whom he is pre-
senting to the Virgin: Bernard's pious parents, members of
a noble Burgundian family, may be the two regally dressed
lay figures in the central panel; the five kneeling monks may
be his brothers and the Benedictine nun his sister. The cou-
ple at the center has also been identified as Margaret of
Flanders and her son, Guy de Dampierre, thirteenth-century
founders of the abbey of Flines. The nun may also be Jeanne
de Boubais, abbess of Flines from 1507 to 1533, who proba-
bly commissioned this as well as several other works from
Bellegambe. Her coat of arms, slightly changed by restora-
tions, appears in the right wing. (The coat of arms on the
left wing is Saint Bernard's, used by all Cistercian founda-
tions.) On the exterior of the altarpiece is a grisaille depic-
tion of the miraculous appearance of the Virgin to Saint
Bernard.

Bellegambe worked in Douai, today in northern France
but in earlier days ruled by the counts of Flanders. He may
have spent time in Antwerp, as his style shows the influence
of the Antwerp Mannerists. The detailed backgrounds (that
of the left interior panel shows the city of Douai, including
buildings of the abbey of Flines) and the Virgin's face re-
mind us of Flemish painting as well.

102 *The Fall of Troy*
French, Limoges, ca. 1530–40
Painted enamel;
8⅞ x 7¾ in. (22.5 x 19.7 cm.)
Gift of Henry Walters, 1925 (25.41)

LIMOGES PLAQUES

Around 1530 the enamelers of Limoges produced an unusually large series of painted enamel plaques based on the classical story of Virgil's *Aeneid*. It is not known who the artist was nor how many plaques were originally made, but seventy-four still exist, probably part of the decorations made for a room such as the *cabinet des émaulx*, in Catherine de' Medici's palace in Paris. It has been tentatively suggested that the series was made by the painter Jean I Pénicaud, who is generally referred to as the Master of the Aeneid. The Metropolitan Museum owns fifteen of these plaques, each telling a different part of the great saga of Aeneas's journey from Troy to Italy.

The Limoges plaques are based on the woodcuts from the works of Virgil printed by Johann Grüninger in Strasbourg in 1502. There were several editions of this work, but, based on evidence that may be circumstantial but is nonetheless convincing, it has been determined that the 1502 edition was used: Enamelers were not learned men and frequently made mistakes in transcription or copied errors blindly, even in their own language. That here they did not copy errors caused by woodblock wear in the later editions seems a clear indication that the earlier edition was used. But despite the early style of the painting and design, the fact that the backs of the plaques are coated with *fondant*, a transparent, vitreous substance that came into general use for counter-enameling only after 1520–25, helps to date these works as being of later manufacture. Also, there are touches of modernity where the enameler modified the original woodcut design to accommodate the new taste for elegance that was developing in the Renaissance.

103 *Helenus and Andromache Give Presents to Aeneas*
French, Limoges, ca. 1530–40
Painted enamel;
8¾ x 7¾ in. (22.2 x 19.7 cm.)
Gift of J. Pierpont Morgan, 1925 (25.40.1)

104 *The Fleet of Aeneas Arrives in Sight of Italy*
French, Limoges, ca. 1530–40
Painted enamel;
8¾ x 7¾ in. (22.2 x 19.7 cm.)
Gift of J. Pierpont Morgan, 1925 (25.40.2)

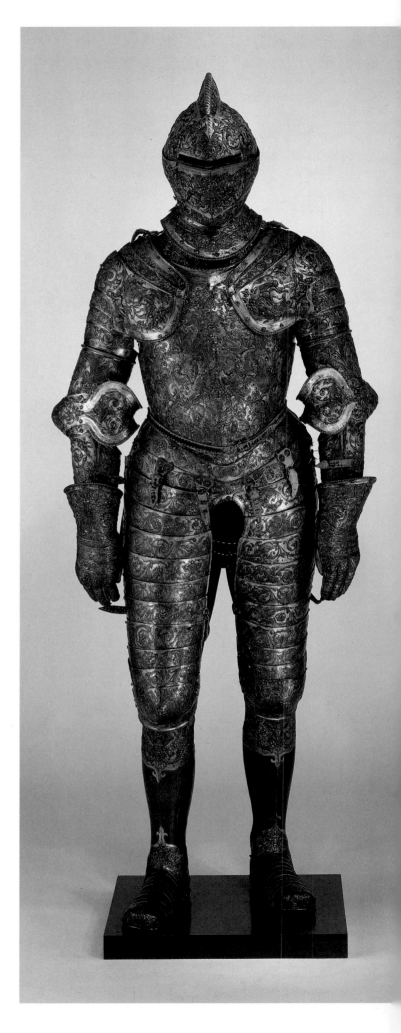

Etienne Delaune

Parade Armor of Henry II of France

It is clear from the most superficial glance that the ornate surface of this suit of armor was never intended to endure the impact of a lance or the stab of a sword. Requirements of defense are completely subordinated to purposes of display. This sumptuous parade armor was made, probably in the Louvre Atelier of Royal Armorers, for Henry II (r. 1547–59), son of Francis I, and was meant to adorn him in state processions amid much pomp and pageantry. The decoration shows the influence of Italians such as Primaticcio and Benvenuto Cellini, who worked for the king of France. The elaborate surface is decorated with a variety of techniques that include embossing, damascening, and gilding. The embossing alone required the attention of three goldsmiths. The figures that compose the design, contained in arabesques of acanthus, tell a symbolic tale of triumph intended to reflect the king's military achievements.

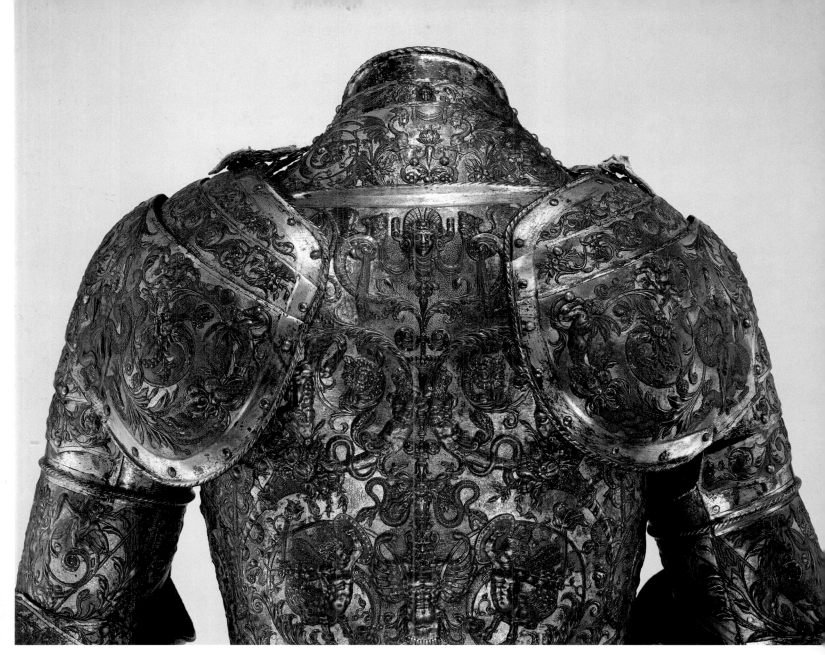

105 *Parade Armor of Henry II of France*
Designed by Etienne Delaune
French, 1518/19–1583
Steel, embossed and gilded, damascened
with gold and silver; brass, leather,
red velvet; H. 5 ft. 9 in. (1.75 m.)
Harris Brisbane Dick Fund, 1939 (39.121)

Above and below: details

106 *The Deluge*, 1531
Valentin Bousch
French
Glass, painted and stained;
H. 11 ft. 10¼ in. (361 cm.),
W. 5 ft. 7 in. (170 cm.)
Purchase, Joseph Pulitzer
Bequest, 1917 (17.40.2)

Opposite: detail

VALENTIN BOUSCH
The Deluge

This stained-glass window, which shows the Deluge, was made for the abbey of Flavigny, near Nancy in eastern France. In the center of the composition, as rain pours down and the water rises, men and women clamber onto rocks in a vain attempt to reach safe ground. In the foreground a nude man steps onto the highest mountain peak (the Bible says that after it rained for forty days and nights, even the mountains were covered with water) and a soldier climbs to join him. Noah's ark, covered against the rain, is in the background. Noah's hand reaches through the open hatch to free a dove in order to discover if the earth is habitable. Beneath the dramatic composition are depicted Moses and Isaiah holding tablets. The inscription of one translates as, "Lo, I will bring the waters of a flood upon the earth and will destroy all flesh in the water," the other as, "The waters were increased and lifted up the ark above the earth."

The scale and breadth of conception and composition mark this window as a product of the Renaissance. The chaos of the Deluge is vividly conveyed by the asymmetry of the composition, the active poses of the figures, and the swelling waters. The fully modeled figures and spacious design attest to a collaboration between designer and stained-glass maker in which the limitations of working with small pieces of glass were overcome.

MANNER OF BERNARD PALISSY
Oval Dish

The sixteenth century is marked by a scientific interest in natural phenomena and their behavior. New worlds had been discovered, occupied by animals and human beings the likes of which had never been seen in Europe. Museums of curiosities abounded, and self-styled naturalists such as Cosimo de' Medici gilded armadillos from the Americas and placed them on pillars in their palaces. Native Indians of the Americas toured the courts of Europe, and the taste for the exotic flourished.

It was in such an atmosphere that the talented French potter Bernard Palissy began practicing his trade. An original and enthusiastic natural scientist, Palissy used local fish,

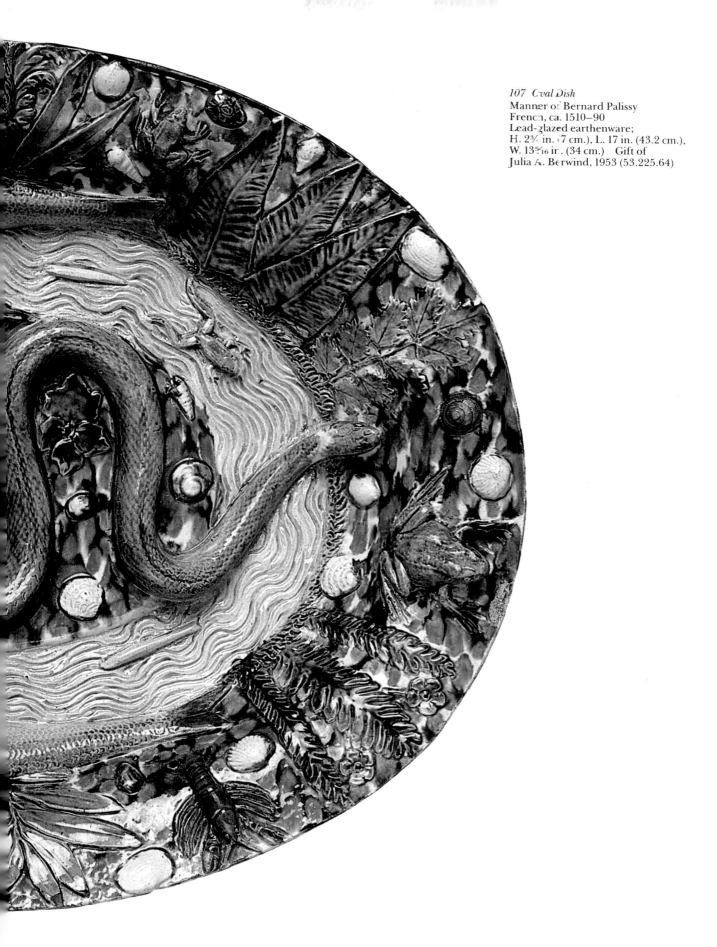

107 Oval Dish
Manner of Bernard Palissy
French, ca. 1510–90
Lead-glazed earthenware;
H. 2¾ in. (7 cm.), L. 17 in. (43.2 cm.),
W. 13⁵⁄₁₆ in. (34 cm.) Gift of
Julia A. Berwind, 1953 (53.225.64)

plants, and reptiles—he made casts of actual specimens for use in his modeling—fashioned in a range of colored glazes, to develop what he called "pastoral pottery." Though he is recorded as having produced his rustic ware in abundance, the only work documented as his is the grotto in the garden of the Tuileries, now destroyed.

An example in the manner of Palissy is pictured here: an oval dish in the shape of a pond surrounded by water and plant life. A plethora of slithering creatures swim, cling, and perch on the plate. They comprise fish, frogs, a twisting snake, a lizard, a water beetle, crayfish, and a variety of occupied shells.

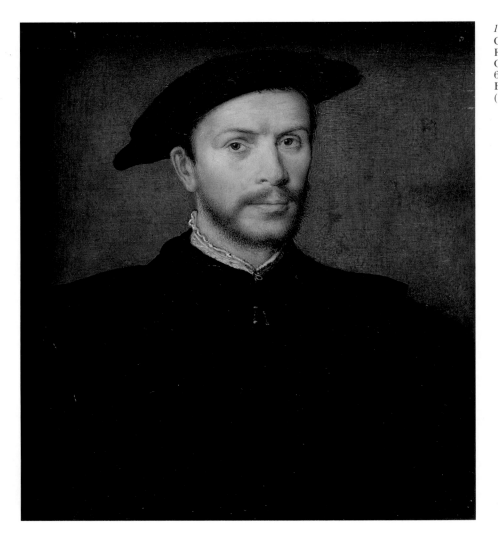

108 Portrait of a Man
Corneille de Lyon
French, act. by 1531–d. after 1574
Oil on wood;
6¾ x 6¼ in. (17.1 x 15.9 cm.)
Bequest of George D. Pratt, 1935
(1978.301.6)

CORNEILLE DE LYON
Portrait of a Man

Corneille de Lyon painted mostly members of the French court. Born in Holland, he was established in Lyons by 1534, where he was painter to Queen Eleanor. In 1541 he worked at the court of the dauphin. In 1547 he was made painter to King Henry II, and then, in 1564, to Charles IX.

Corneille's type of portraiture—characterized by small size and a uniform background (usually of green or blue)—was very popular in France, Germany, the Netherlands, and Italy. This exceptionally well-preserved example, with the detailed physiognomic description and subtle modeling of the sitter's face, exhibits Corneille's successful combination of realism and courtly elegance. This portrait was once in the collection of Horace Walpole at Strawberry Hill, where it was thought to be by Holbein.

JEAN CLOUET
Guillaume Budé

Jean Clouet, who came from a family of Franco-Flemish painters, was appointed painter-in-ordinary to King Francis I about 1516 and rose to chief painter a few years later. His son François eventually succeeded him as court painter. Little else is known about Clouet, and many of the works attributed to him may in fact have been painted by his son or someone else entirely, but it is known that his portraits were highly praised by his contemporaries and were notable both for their delicacy and for their force of characterization.

This portrait of Guillaume Budé is definitely attributable to Clouet since it is mentioned in Budé's manuscript notes, from which it is datable to about 1536. Budé (1467–1540) was a French scholar who acted as librarian to Francis I and was responsible for the founding of the library at Fontainebleau (now the Bibliothèque Nationale). He was also an ambassador, the chief magistrate of Paris, and the founder, in 1530, of the Collège de France. His writings caused a revival of interest in Greek language and literature among scholars in France.

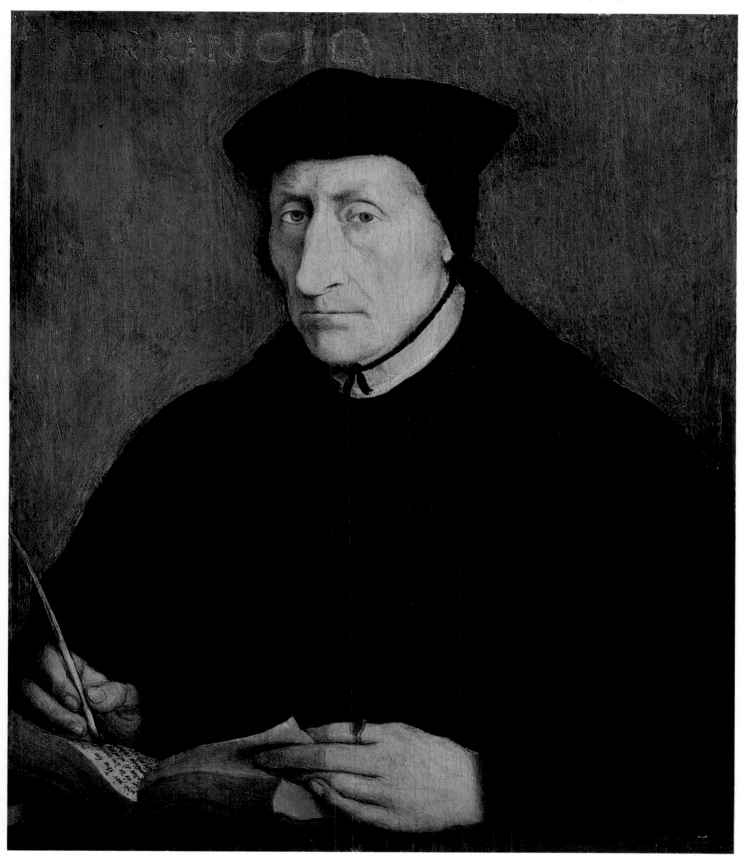

109 *Guillaume Budé,* ca. 1536
Jean Clouet
French, act. by 1516–d. 1541
Tempera and oil on wood;
15⅝ x 13½ in. (39.7 x 34.3 cm.)
Maria DeWitt Jesup Fund, 1946
(46.68)

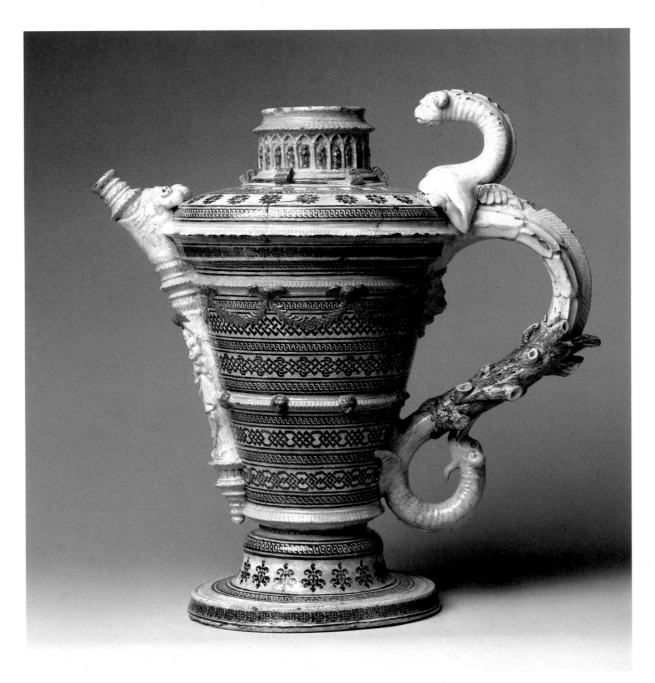

110 *Saint-Porchaire Ewer*
French, ca. 1530–50
White earthenware with inlaid clay
decoration under a lead glaze; H. 10⁵⁄₁₆ in.
(26.1 cm.) Gift of J. Pierpont Morgan,
1917 (17.190.1740)

Saint-Porchaire Ewer

For many years the origin of the distinctive, highly elabo-
rate pottery, now known to have been made at the Saint-
Porchaire factory in France, was unknown. In the first half
of the nineteenth century it was called *"Henri Deux* ware"
and was attributed to various places and makers. After 1864
it was thought to come from Oiron in France. It was not
until 1888 that its true source was established.

Saint-Porchaire pieces, such as this ewer, required much
careful hand preparation after the basic shapes had been
achieved. The plastic decoration, such as the festoons, saints
in niches, and lion masks of this piece, were made in molds
and then applied. The geometric ornamentation was made
by pressing metal dies into the unfired surface and filling
the depressions with brown clay. The surface was then cov-
ered with a transparent lead glaze. The white body was lightly
fired and very breakable. For this reason it is most probable
that Saint-Porchaire ware was always meant to be decorative
rather than functional. The devices or armorial bearings of
royalty and nobility that mark many of the examples testify
to the restricted circle in which it found patrons. Only sev-
enty examples of Saint-Porchaire ware survive, and it is prob-
able that even in its own time it was extremely rare.

JEAN DE COURT
Pair of Candlesticks

Enameling is a technique whereby a vitreous substance, often containing pigment, is fused with metal to produce a glossy surface. This decorative process was often augmented by the work of enamel painters who added ornaments such as tiny landscapes and figures in grisaille.

Limoges became a center for ecclesiastical enamel painting as early as the twelfth century, when the art flourished in monastic workshops. In the late fifteenth century Limoges emerged as a center of secular as well as ecclesiastical enamel work, and the school flourished throughout the sixteenth century. Among the most famous of the enamel painters practicing in sixteenth-century Limoges was Jean de Court, who is responsible for this pair of candlesticks.

They are decorated in the Mannerist style with an abundance of mythological references. The base of the candlestick on the left side shows the Labors of Hercules in twelve oval repoussé medallions. The Labors are based on a series of engravings made by Heinrich Aldegraver in 1550. The twelve medallions on the other candlestick enclose gods and goddesses identified by their various attributes. Visible from left to right are Diana and a stag, Jupiter astride an eagle and holding a thunderbolt, Juno with a peacock, and Neptune with a trident. The *bobêches*, saucerlike plates that support the nozzles, are decorated with amorini, putti, and animals in playful procession; the nozzles themselves show alternating terms and swags.

111 Pair of Candlesticks
Jean de Court
French, act. 1550–75
Enamel on copper; H. 6 in. (15.2 cm.),
Diam. 7½ in. (19.1 cm.) Gift of
Ann Payne Blumenthal, 1939 (39.66.1,2)

112 *Henry II Between France and Fame*, ca. 1548
Jean Duvet
French, 1485–ca. 1561
Etching; 11⅝ x 8¼ in. (29.5 x 21 cm.)
Harris Brisbane Dick Fund, 1925 (25.2.93)

JEAN DUVET
Henry II Between France and Fame

Until Jean Duvet began dating prints at Dijon in 1520, we know of no French engraver by name. Duvet adapted his figures from prints by Mantegna, Dürer, Marcantonio, and others. Some of his work even passed for Italian. Duvet dedicated twenty-three violent visions of the Apocalypse to Henry II, whose coronation in 1547 and love for Diane de Poitiers inspired the work reproduced here, apparently executed on the occasion of Henry's rededication of the order of Saint Michael, saint of the church militant, in 1548.

Here Duvet depicts Henry in the guise of Saint Michael, perhaps symbolizing Henry's role as leader of Catholic France. He stands victorious with his wings outspread, sword in hand, and demon beneath his feet. The pommel of his sword is in the form of a fleur-de-lis, emblem of the French kings, and the figure at the left holds an escutcheon with three fleurs-de-lis. The crescent above Henry's head—the attribute of the goddess Diana—is a symbol of Diane de Poitiers.

Duvet himself was gripped by the struggle between Catholics and Protestants. He joined a fanatic Catholic fraternity in France and then defected to the enemy in Geneva, where he designed coins, stained glass, and fortifications for the Calvinists.

COMMESSO

The *commesso* was a rare form of jewelry in which carved semiprecious stones were combined to form an integral part of the design. The technique flourished only briefly, in the rarefied atmosphere of the sixteenth-century French court, where Italian and French artists collaborated. (This uniting of French and Italian genius resulted in the works of the school of Fontainebleau and in such works as the *Descent from the Cross*, Plate 115.) One of the most important figures in the invention of the *commesso* was Matteo da Nassaro of Verona, who was first lured to Paris in 1515 by Francis I. Matteo installed hydraulic wheels in ships in the Seine, establishing the first center for cutting and polishing precious stones in France.

The almost perfectly preserved *commesso* shown here was described in the inventory prepared after Henry II's death as having "a small figure of agate who admires herself in a diamond." The figure is Prudence, identified by the mirror into which she gazes and the serpent she holds in her other hand. The mirror signifies self-knowledge, the source of Prudence's great wisdom. The serpent derives from Matthew 10:16: "Behold, I send you forth as sheep in the midst of wolves: be ye therefore wise as serpents, and harmless as doves." Prudence was one of the four Cardinal Virtues. She guards Henry II's tomb at Saint-Denis and has been associated as well with Henry's queen, Catherine de' Medici. The reverse of the *commesso* shows Diana with two hounds. The contemporary vogue for Diana of the Hunt (*Diane chasseresse*) was inspired by Henry II's mistress, Diane de Poitiers, and the figure may well have been intended as an homage to her.

113 *Commesso,* 1550–55
Reverse after design of Charles Etienne Delaune
French, 1518/19–probably 1583
Gold, enamel, jewels, and chalcedony;
L. 2½ in. (8.9 cm.), W. 2 in. (5.1 cm.)
Gift of J. Pierpont Morgan, 1917 (17.190.907)

Above: front and back views

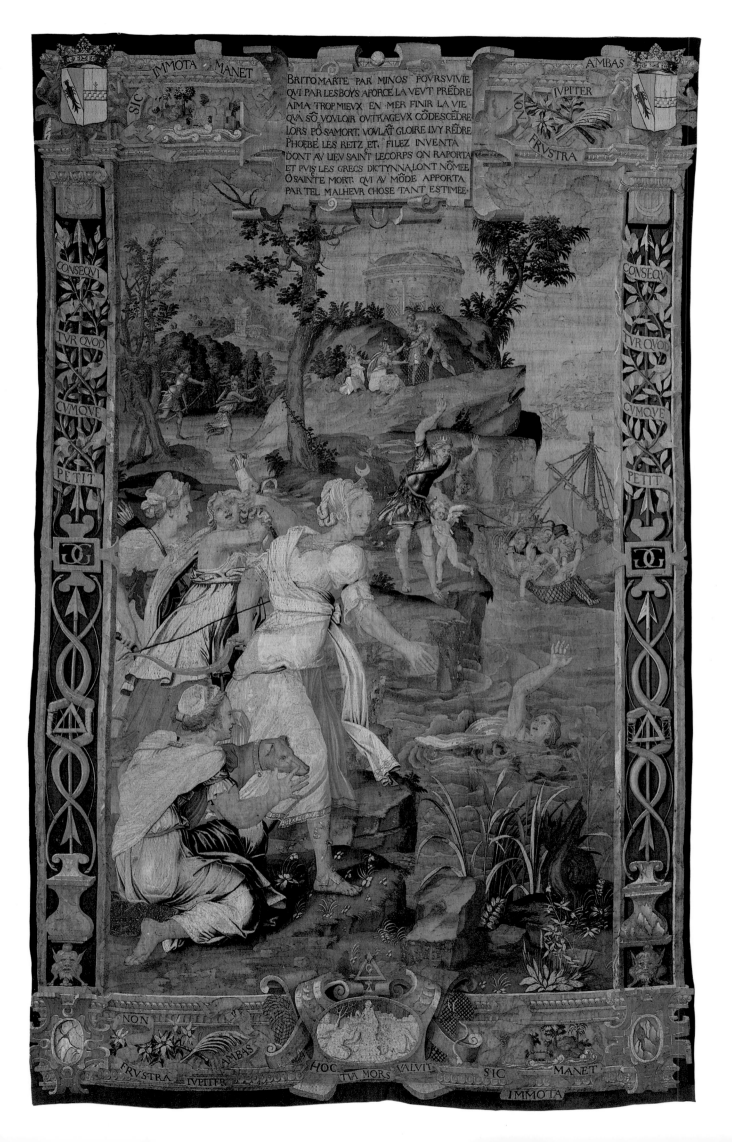

SIC IMMOTA MANET

AMBAS

IVPITER

FRVSTRA

BRITOMARTE PAR MINOS POVRSVIVIE
QVI PAR LESBOYS AFORCE LA VEVT PRĒDRE
AIMA TROP MIEVX EN MER FINIR LA VIE
QVA SŌ VOVLOIR OVTRAGEVX CŌDESCĒDRE
LORS PŌ SAMORT VOVLĀT GLOIRE LVY RĒDRE
PHOEBE LES RETZ ET FILEZ INVENTA
DONT AV LIEV SAINT LECORPS ON RAPORTA
ET PVIS LES GRECS DICTYNNALONT NŌMEE
O SAINTE MORT QVI AV MŌDE APPORTA
PAR TEL MALHEVR CHOSE TANT ESTIMEE

CONSEQVI

CONSEQVI

TVR QVOD

TVR QVOD

CVMQVE

CVMQVE

PETIT

PETIT

NON

AMBAS

IMMOTA MANET

FRVSTRA IVPITER

HOC TVA MORS VALVIT

SIC MANET

IMMOTA

114 *The Drowning of Britomartis*, 1547–59
Prob. designed by Jean Cousin the Elder
French, ca. 1490–1560/61; poss. woven by
Pierre II Blasse and Jacques Langlois
Both: French, act. 1540–60
Wool and silk; 15 ft. 3 in. x 9 ft. 6 in.
(4.65 x 2.9 m.) Gift of the children of
Mrs. Harry Payne Whitney, 1942 (42.57.1)

Right: detail

JEAN COUSIN THE ELDER (?)
The Drowning of Britomartis

This tapestry is from a set depicting scenes from the story of Diana made probably for the château of Anet, about forty miles west of Paris, which was the chief residence of Henry II's mistress, Diane de Poitiers. She herself, born in 1499, was named after the goddess, a sign that the Renaissance, with its emulation of classical antiquity, had come to France.

The inscription in French verse on the upper border of the tapestry tells the story depicted:

> Britomartis, pursued by Minos, who wished to take her by force in the woods, greatly preferred to end her life in the sea rather than submit to his outrageous will. Accordingly, wishing to give her fame for her death, Phoebe [Diana] invented fishnets and snares, with which the body was brought to a holy place, and since then the Greeks have called her Dictynna ["fishnet"]. O holy death, that gave such a valuable thing to the world by means of such a misfortune!

Diana stands in the center of the tapestry, a crescent on a support above her forehead. To the right the drowning Britomartis raises one hand above the water. In the middle distance Minos, king of Crete, stands looking into the water with his arms raised in astonishment, while Britomartis's body is being fished out of the water to the right. In the left background we see Minos pursuing Britomartis, and farther back, to the right, Diana hands a net to two men.

The version of the story shown here is not precisely that found in the writings of any classical author, and the invention of the net by Diana does not seem to be a classical idea at all. It is here in order to glorify Diane de Poitiers, who is portrayed in the guise of the goddess. The borders of the tapestry are marked by the Greek character delta and other symbols of Diane.

SCHOOL OF JEAN GOUJON
Descent from the Cross

This relief, which probably served as an altar frontal, has been installed as such in the Museum's reconstruction of the contemporaneous chapel from La Bastie d'Urfé. The relief portrays Saint John receiving the body of Christ from Nicodemus and Joseph of Arimathea. On the right is a distant view of Jerusalem. In the lower corners are the arms of the original patron surmounted by crozier heads. He was possibly Claude de Saint-André, bishop of Carcassone, or Jean de Saint-André, a canon of Notre Dame in Paris.

The style is markedly indebted to the great Jean Goujon, sculptor of the Fountain of the Holy Innocents in Paris and a specialist in sinuous drapery effects in relief. His influence is especially visible in the plangent rhythms of the aggrieved Marys gathered at the foot of the cross.

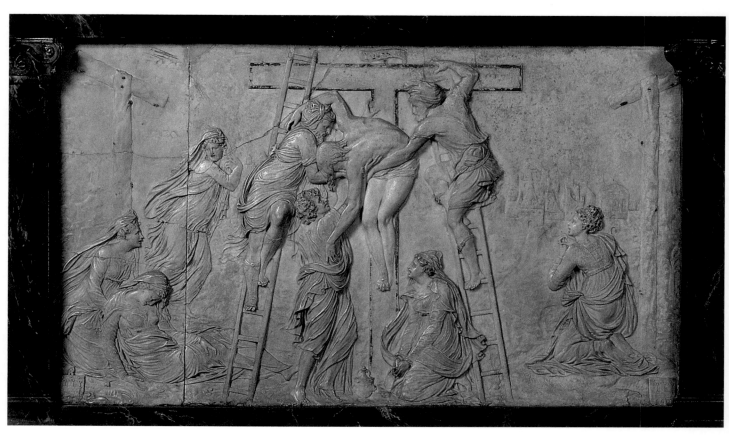

115 *Descent from the Cross,* ca. 1550–60
School of Jean Goujon
French, ca. 1510–ca. 1567
Marble;
43¼ x 24½ in. (109.9 x 62.2 cm.)
Fletcher Fund, 1929 (29.56)

Opposite: detail

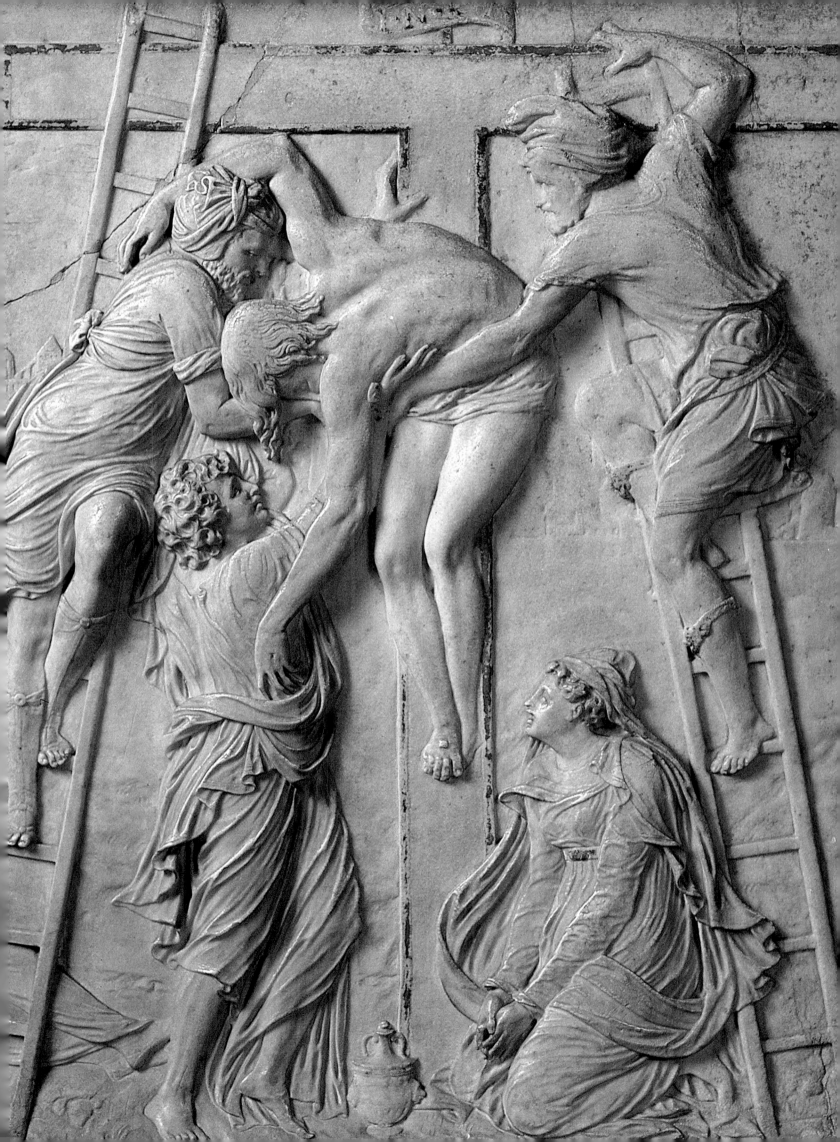

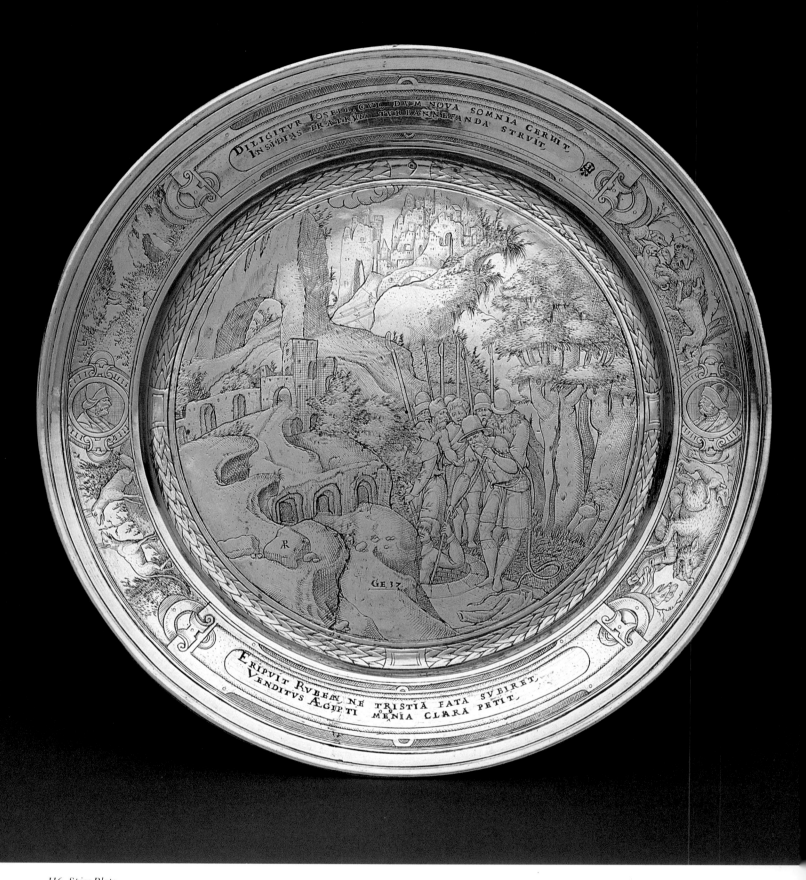

116 *Spice Plate*
English, ca. 1567–73
Silver and parcel-gilt;
Diam. 7¾ in. (19.7 cm.)
Gift of C. Ruxton Love, Jr.,
1965 (65.260.2)

ENGLISH SPICE PLATE

This plate, known as a "spice plate" or "demiplatter," is one of a set of twelve in the Metropolitan's collection. Only three sets of plates of this sort exist, richly engraved all over the surface and evidently intended for display rather than use. The Museum's set is illustrated with stories of the patriarchs from the Book of Genesis. The images were taken from woodcut illustrations by Bernard Salomon for the 1553 edition of the Bible published by Jean de Tournes in Lyons. This edition proved to be very popular and was reissued several times over the next decade, and in several different languages. This was a period when printmaking was a dominant influence in the formation of style, and graphic sources were freely reinterpreted by metalworkers, carvers, and weavers. Salomon's woodcuts were copied as embroidery patterns (a set of sixteenth-century valances with related scenes from Genesis is in the Irwin Untermyer Collection at the Museum). It is not surprising, therefore, to find Salomon's scenes reproduced on Elizabethan silverware.

This plate shows Joseph, son of the patriarch Jacob and his wife Rachel, being lowered into a pit by his jealous half brothers, who then sold him into slavery. In the Middle Ages certain episodes of Joseph's life were considered to be a prefiguration of events in the life of Christ, which is why he plays an important role in Christian art.

PORCELAIN EWER

The sixteenth century in England, especially during the reign of Queen Elizabeth I, was a time of great enterprise, exploration, and learning, and the accumulation of great wealth. The nobility associated with the court lived in style, building new palaces and surrounding themselves with objects of transcendent beauty. One of the most powerful men of the period was William Cecil, Lord Burghley, lord treasurer to the queen. It is from his descendants' collection, by way of the estate of J. P. Morgan, that the Museum has acquired at least four and probably all of the five pieces of Chinese porcelain of the Wan Li period (1573–1619) with Elizabethan English silver-gilt mounts. Chinese porcelain reached England by a circuitous route at this time. It was greatly prized, and proud owners set the pieces off with elaborate mounts in silver-gilt or gold made by ambitious and innovative contemporary metalsmiths. The mounts of this ewer are even more important than the porcelain they enclose, being original in design and of exceptionally fine workmanship.

The Chinese ewer seen here exhibits birds and flowering trees arranged in vertical panels, and the English silversmith chose to emphasize the panels by creating six narrow vertical straps that frame the scenes. The straps, too, are adorned with birds and flowers. As an entirely new element, the silversmith created a cover embossed with fruit, heads of cherubs, three small dolphins, and a minute frog.

117 Ewer
Chinese porcelain of the Wan Li
period (1573–1619) with
English silver-gilt mounts (ca. 1585)
Hard-paste porcelain and silver-gilt;
H. 13⅝ in. (34.6 cm.)
Rogers Fund, 1944 (44.14.2)

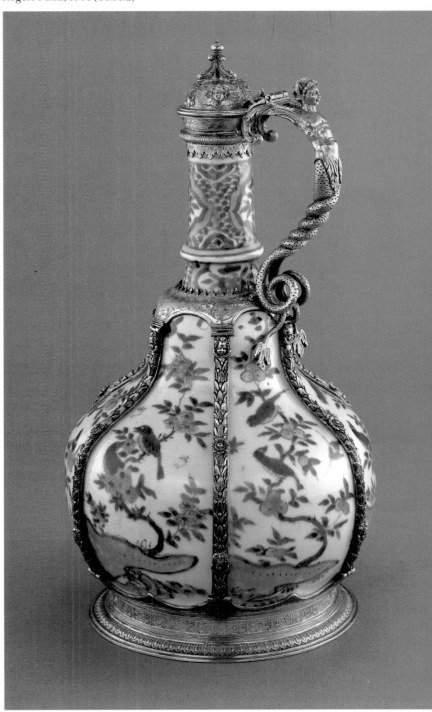

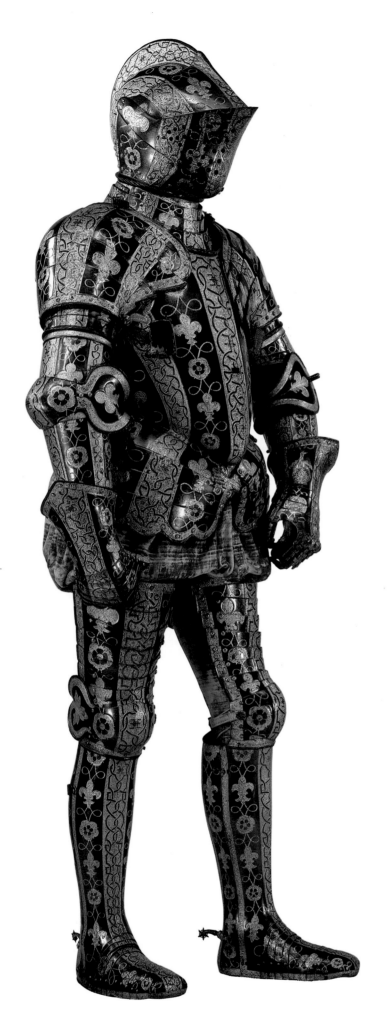

ARMOR OF GEORGE CLIFFORD, EARL OF CUMBERLAND

In 1590 George Clifford, third earl of Cumberland (1558–1605), was appointed Champion of the Queen—to represent her in all tournaments and jousts—and the suit of armor illustrated here was probably a royal present on this occasion. The decoration of the armor combines Tudor roses, fleurs-de-lis, and the addorsed initials of Clifford's patron, Queen Elizabeth I.

The armor was made by the most famous English armory of the sixteenth century, located at Greenwich, and constitutes the best example of Elizabethan armor in existence. In addition to the basic suit illustrated here, there are eleven pieces that adapt to make a harness appropriate for jousting tournaments (see Plate 79).

George Clifford was not only Queen Elizabeth's personal representative at affairs of state but was a judge at the trial of Mary Queen of Scots. He sailed the Spanish Main and commanded the force that captured the great castle of El Morro in San Juan, Puerto Rico.

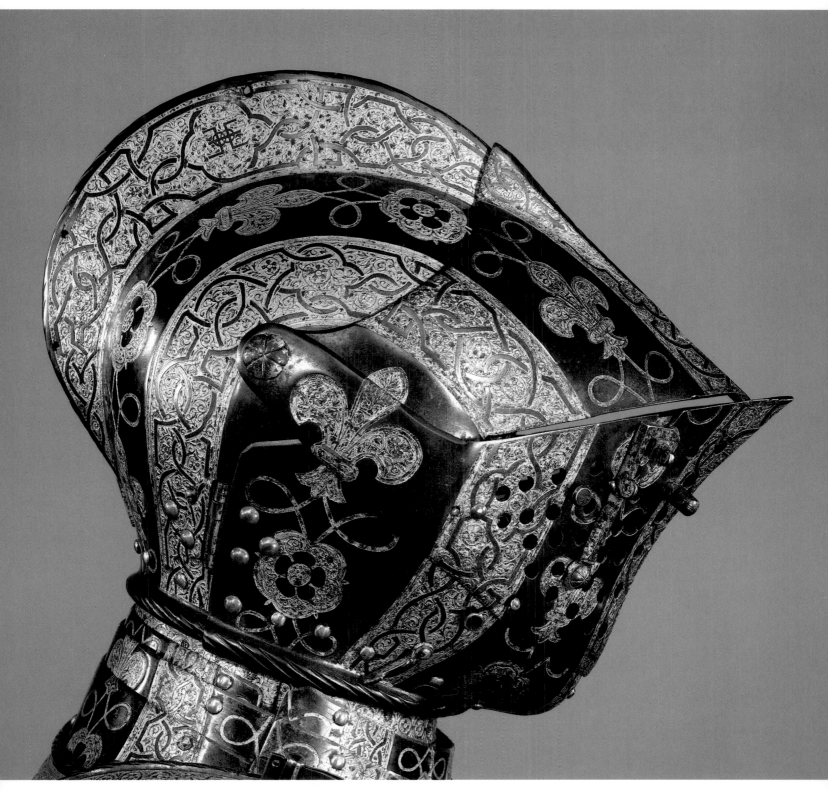

118 Armor of George Clifford, Earl of Cumberland
English, ca. 1590
Steel, gilt; H. 5 ft. 9½ in. (1.77 m.)
Munsey Fund, 1932 (32.130.6a–y)

Above: detail

FRANCE

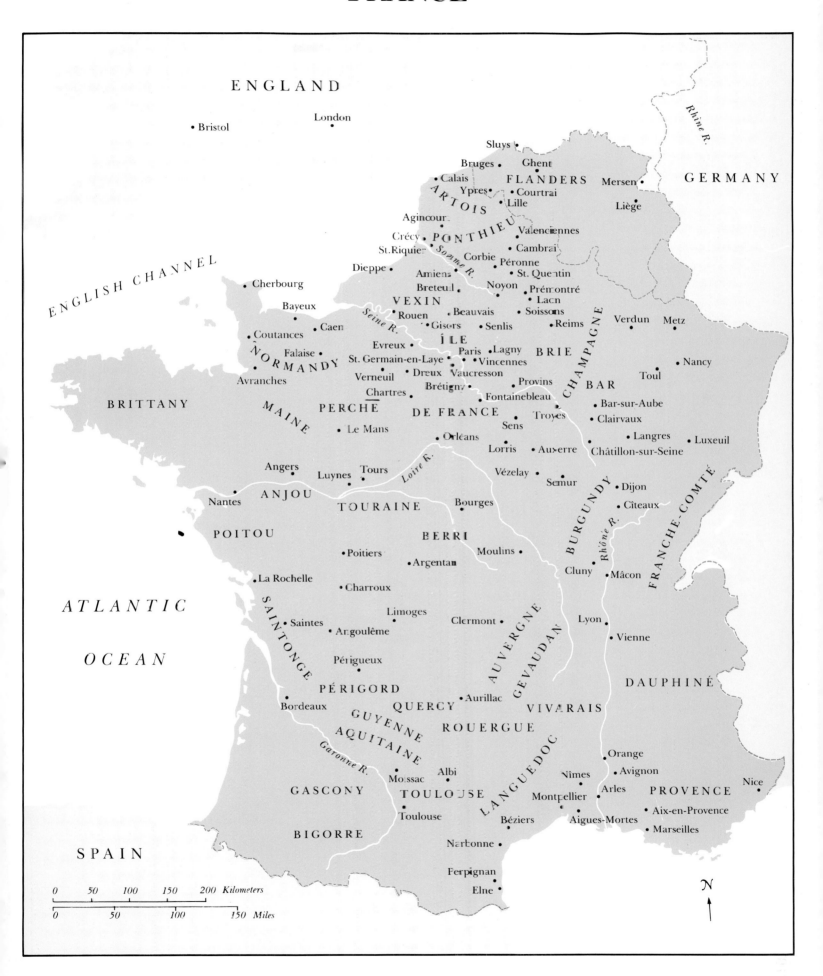

ENGLAND

• Bristol • London

ENGLISH CHANNEL

Sluys •
Bruges • Ghent •
• Calais FLANDERS Mersen • GERMANY
Ypres • • Courtrai
ARTOIS • Lille Liège •
Agincourt • PONTHIEU Valenciennes •
Crécy • Cambrai •
St.Riquier • Somme R. Corbie • • Péronne
Dieppe • Amiens • • St. Quentin
• Cherbourg Breteuil • Noyon • Prémontré •
Bayeux • VEXIN Laon •
Coutances • • Caen Seine R. • Rouen Beauvais • Soissons • Verdun • Metz •
Falaise • • Gisors Senlis • Reims •
NORMANDY Evreux • ÎLE Paris • Lagny • BRIE Nancy •
Avranches • St. Germain-en-Laye • • Vincennes CHAMPAGNE BAR Toul •
Verneuil • Dreux • Vaucresson • Provins •
Chartres • Brétigny • Fontainebleau • Bar-sur-Aube •
BRITTANY MAINE PERCHE DE FRANCE Troyes • Clairvaux •
• Le Mans Sens • Langres • Luxeuil •
Orléans • Châtillon-sur-Seine
Lorris • Auxerre •
Angers • Luynes • Tours • Loire R. Vézelay • Semur • BURGUNDY Dijon •
ANJOU Citeaux •
Nantes • TOURAINE Bourges • FRANCHE-COMTÉ
POITOU BERRI Moulins •
Poitiers • Rhône R.
• Argentan Cluny • Mâcon •
La Rochelle • Charroux •
ATLANTIC SAINTONGE Limoges • Clermont • Lyon •
Saintes • AUVERGNE
OCEAN Angoulême • GEVAUDAN • Vienne
Périgueux •
PÉRIGORD DAUPHINÉ
Bordeaux • QUERCY Aurillac • VIVARAIS
GUYENNE ROUERGUE
AQUITAINE Orange •
Garonne R. Albi • Nîmes • Avignon • Nice •
Moissac • Arles • PROVENCE
GASCONY TOULOUSE LANGUEDOC Montpellier • • Aix-en-Provence
Toulouse • Béziers • Aigues-Mortes • • Marseilles
BIGORRE
Narbonne •
SPAIN Perpignan •
Elne •

0 50 100 150 200 Kilometers
0 50 100 150 Miles

N

THE ARTS IN ITALY AND SPAIN

1302	Pulpit, Pisa cathedral, commissioned from Giovanni Pisano (ca. 1248–d. after 1314)
1305	Fresco cycle in Arena Chapel, Padua, by Giotto di Bondone (1266/67–1337)
1307–21	Dante Alighieri's *Divine Comedy*
1308–11	*Maestà* by Duccio di Buoninsegna (ca. 1255–ca. 1318)
1310	*Ognissanti Madonna* by Giotto
1315–28	Frescoes in Palazzo Pubblico, Siena, by Simone Martini (act. by 1315–d. 1344)
1334	Giotto made chief architect of Florence cathedral; begins campanile
1336	South doors, Florence Baptistery, by Andrea Pisano (ca. 1290–1348)
1338	*Good and Bad Government*, frescoes in Palazzo Pubblico, Siena, by Ambrogio Lorenzetti (act. 1319–47)
1341	Francesco Petrarch crowned with laurels in Rome
1348–53	Giovanni Boccacio's *Decameron*

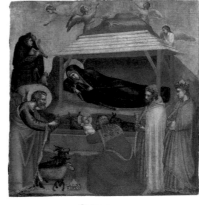

a GIOTTO
The Epiphany

| 1359 | *Mystic Marriage of St. Catherine* by Lorenzo Veneziano (d. 1372) |
| ca. 1390 | Cennino Cennini's *Libro d'Arte* |

d LORENZO VENEZIANO
Madonna and Child

SOCIETY, RELIGION, AND POLITICS

1304–14	Pope Clement V
1306–29	Robert I ("the Bruce"), king of Scotland
1307	Edward I, king of England, succeeded by Edward II (to 1327)
1308–13	Henry VII (Luxembourg), German king and Holy Roman Emperor
1309–78	Papacy resides at Avignon (the "Babylonian Captivity")
1314	Philip IV ("the Fair"), king of France, succeeded by Louis X ("the Quarrelsome"); to 1316
1314–47	Louis IV (Wittelsbach), German king and Holy Roman Emperor
1315–18	Edward Bruce, king of Ireland
1316	John I ("the Posthumous"), king of France
1316–34	Pope John XXII
1317–22	Philip V ("the Tall"), king of France
1322–28	Charles IV ("the Fair"), last Capetian king of France
1323	Thomas Aquinas canonized
1327–77	Edward III, king of England
1328–30	Nicholas V, antipope
1328–50	Philip VI, first Valois king of France
1330	Edward (the "Black Prince") born to King Edward III of England
1334–42	Pope Benedict XII
1337	Edward III of England claims French throne, beginning the Hundred Years War (to 1453)
1342–52	Pope Clement VI
1346	English defeat French in Battle of Crécy
1348–49	Black Plague reaches England

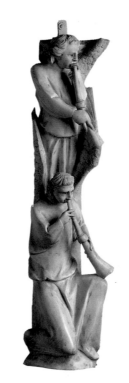

b GIOVANNI PISANO
Pilaster with Angels

1350–64	John II ("the Good"), king of France
1352–62	Pope Innocent VI
1355–78	Charles IV (Luxembourg) Holy Ron Emperor; issued Golden Bull of 135 settling election of German kings
1362–70	Pope Urban V
1364–80	Charles V ("the Wise"), king of Fran
1369	Philip the Bold, duke of Burgundy, marries Margaret of Flanders
1370–78	Pope Gregory XI
1371–90	Robert II, first Stuart king of Scotla
1377–99	Richard II, king of England
1378	Great Schism begins (to 1417): Two elected: Urban VI (to 1389) in Ron Clement VII (to 1394), antipope in
1378–1400	Wenceslaus (Luxembourg), Germa and uncrowned Holy Roman Emp
1380–1422	Charles VI ("the Mad," or "Well Be of France
1381	Peasant revolt in England led by Wa
1389–1404	Pope Boniface IX, in Rome
1394–1423	Benedict XIII, antipope in Avignon
1398	Tamerlane invades India
1399–1413	Henry IV, first Lancastrian king of

THE ARTS IN NORTHERN EUROPE

| 1323–26 | *Belleville Breviary* by Jean Pucelle (act. ca. 1300–50) |
| 1325 | *Hours of Jeanne d'Evreux* by Jean Pucelle |

c JEAN PUCELLE
Book of Hours of Jeanne d'Evreux

ca. 1350	*Sir Gawain and the Green Knight*
1362	*Piers Plowman* by William Langland
1387–1400	*Canterbury Tales* by Geoffrey Chauce
1394–99	*Retable de Champmol*, by Melchior Broederlam (act. 1385–1400) and Ja de Baerze (act. ca. 1375–1400)
ca. 1395	John Purvey's edition of Wycliffe's English translation of the Bible

g Reliquary Shrine

Northern Europe
in the Renaissance

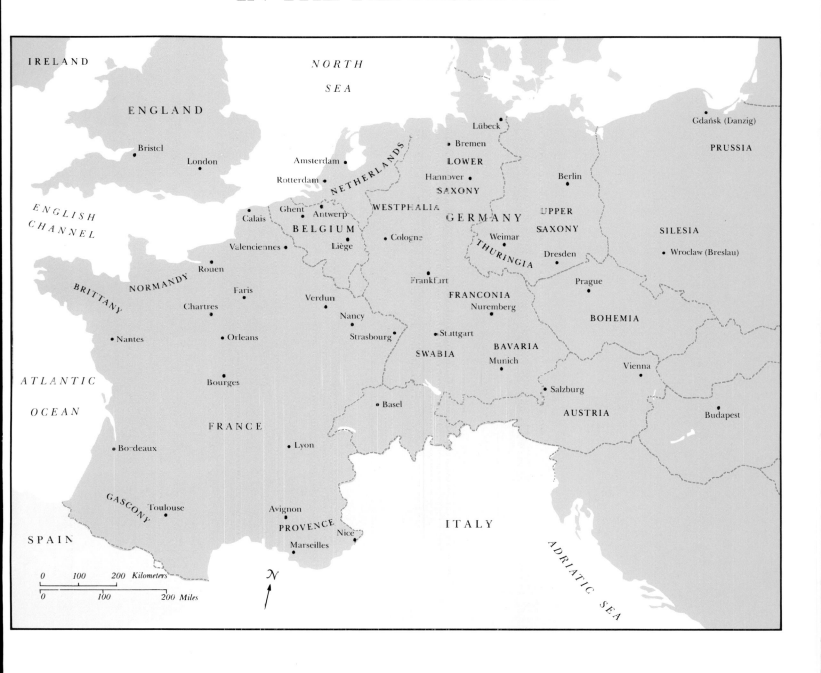

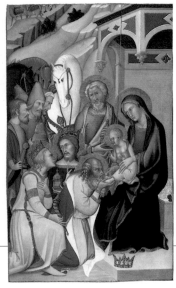

f BARTOLO DI FREDI BATTILORI
Adoration of the Magi

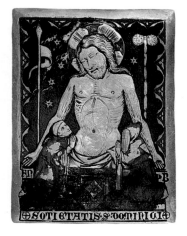

e Man of Sorrows

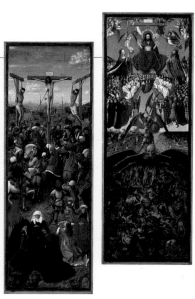

i JAN VAN EYCK
The Crucifixion; The Last Judgment

1401	*Sacrifice of Isaac* by Lorenzo Ghiberti (1378–1455), winning entry in competition for north doors of Florence Baptistery
1403–24	Ghiberti's Baptistery doors executed
1414–19	*Coronation of the Virgin* by Lorenzo Monaco (1370/72–1425/26)
1421	S. Lorenzo, Florence, by Filippo Brunelleschi (1377–1446)
1420–36	Dome of Florence cathedral by Brunelleschi
1423	*Adoration of the Magi* by Gentile da Fabriano (d. 1427)
ca. 1425–30	*David* (bronze) by Donatello (1386–1466)
1425–52	*Gates of Paradise*, east doors of Florence Baptistery, by Ghiberti
1425	*Holy Trinity with the Virgin and St. John* by Masaccio (1401–28)
1425–28	Frescoes in Brancacci Chapel, S. Maria del Carmine, Florence, by Masaccio
ca. 1430	Pazzi Chapel, S. Croce, Florence, by Brunelleschi begun

1431–38	Cantoria for the Florence Duomo by Lu della Robbia (1399–1482)
1435	*Treatise on the Art of Painting* by Leon Battista Alberti (1404–72)
1438–45	Frescoes in monastery of S. Marco, Florence, by Fra Angelico (1387–1455)
1445–50	*Equestrian Monument of Gattemelata*, Piazza del Santo, Padua, by Donatello
1445–50	Tomb of Leonardo Bruni, S. Croce, Florence, by Bernardo Rossellino (1409–
1446–51	Palazzo Rucellai, Florence, by Alberti
1447	*Last Supper* by Andrea del Castagno (1390–1457)

j LORENZO MONACO
The Nativity

1400–10	Rupert (Wittelsbach), German king and Holy Roman Emperor
1404–06	Pope Innocent VII, in Rome
1406–15	Pope Gregory XII, in Rome
1409–10	Alexander V, antipope of Pisan line
1410–15	John XXIII, antipope of Pisan line
1410–37	Sigismund (Luxembourg), German king and Holy Roman Emperor
1412	Jan Hus excommunicated for heresy (executed 1415)
1413–22	Henry V, king of England
1414–18	Council of Constance; ends Great Schism
1415	English defeat French at Agincourt

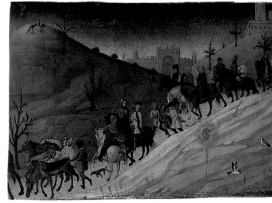

h SASSETTA
Journey of the Magi

1416	Death of Jean de France, duc de Berry
1417–31	Pope Martin V, in Rome
1419–67	Philip the Good, duke of Burgundy; greatly expands Burgundian possession in France and Low Countries
1420	Henry V of England marries Catherine of France; English enter Paris
1422–61	First reign of Henry VI, king of England
1423–29	Clement VII, antipope in Avignon
1425–30	Benedict XIV, antipope in Avignon
1429	Charles VII of France crowned at Rheims (reigns to 1461), accompanied by Joan of Arc
1430	Salonika falls to Ottoman Turks led by Sultan Murad II
1431–47	Pope Eugene IV, in Rome
1431–49	Council of Basel
1434	Cosimo de' Medici establishes the preeminence of his family in Florence
1438–39	Albert II, first Habsburg German king and Holy Roman Emperor
1440–93	Frederick III, German king and Holy Roman Emperor
1447–55	Pope Nicholas V
1450–66	Francesco Sforza, duke of Milan

ca. 1400	*Chronicles* by Jean Froissart
1416	Last work on *Très Riches Heures* of the duc de Berry by Limbourg brothers (act. before 1399–ca. 1439)
ca. 1418	*Rohan Hours*, Paris
ca. 1425	*Annunciation Altarpiece* by Robert Campin (act. by 1406–d. 1444)
ca. 1427	*Imitation of Christ*, ascribed to Thomas à Kempis
1432	Dedication of Ghent altarpiece by Jan (act. by 1422–d. 1441) and Hugo (ca. 1370–1426) Van Eyck
1434	*Arnolfini Wedding Portrait* by Jan Van Eyck
1444	*Altarpiece of St. Peter* by Konrad Witz (ca. 1400–ca. 1445)
1446	*Edward Grymestone* by Petrus Christus (act. by 1444–d. 1472/73)
1447	*Presentation* by Stephan Lochner (act. 1410–51)

k PETRUS CHRISTUS
Saint Eligius

THE GERMANIC PROVINCES

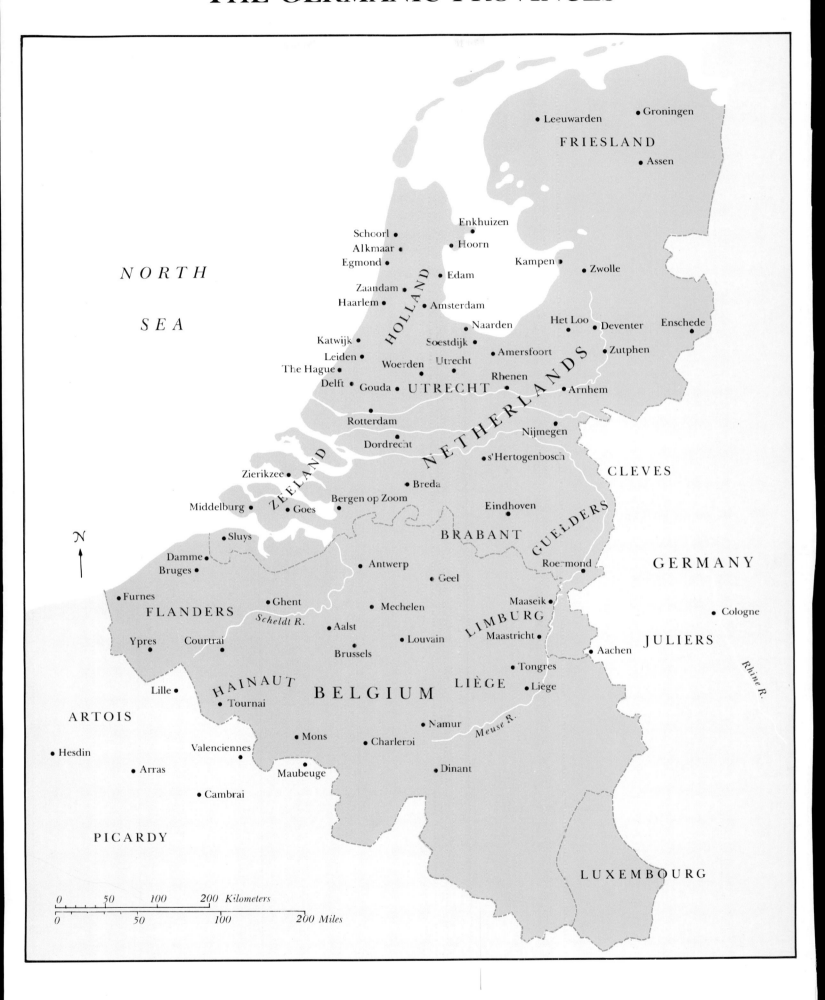

NORTH

SEA

FRIESLAND

Leeuwarden • • Groningen

• Assen

Enkhuizen
Schoorl •
Alkmaar • • Hoorn
Egmond • Kampen • • Zwolle
• Edam
Zaandam •
Haarlem • • Amsterdam
Naarden Het Loo • • Deventer • Enschede
Katwijk • Soestdijk
Leiden • Amersfoort • • Zutphen
The Hague • Woerden Utrecht
Delft • Gouda • Rhenen
UTRECHT • Arnhem

Rotterdam •
Nijmegen
Dordrecht •
• s'Hertogenbosch CLEVES

Zierikzee •
• Breda
Bergen op Zoom
Middelburg • • Goes Eindhoven • GUELDERS GERMANY
• Sluys BRABANT Roermond •
Damme • • Antwerp
Bruges • • Geel
Furnes • • Maaseik • • Cologne
FLANDERS • Ghent • Mechelen LIMBURG
Scheldt R. • Aalst • Louvain Maastricht • JULIERS
Ypres • Courtrai • • Aachen
Brussels
HAINAUT BELGIUM LIÈGE • Tongres
Lille • LIÈGE • Liege
• Tournai

ARTOIS • Namur
• Hesdin • Mons • Charleroi Meuse R.
Valenciennes •
• Arras Maubeuge • • Dinant

• Cambrai

PICARDY

LUXEMBOURG

Rhine R.

0 50 100 200 Kilometers
0 50 100 200 Miles

ca. 1525	*The Assumption*, fresco on dome of Parma Cathedral by Correggio (1489/94–1534)
1526	*Descent from the Cross*, S. Felicità, Florence, by Jacopo da Pontormo (1494–1556)
1527	*The Book of the Courtier* by Baldassare Castiglione (1478–1529) published (written 1514)
1527–34	Palazzo del Tè, Mantua, by Giulio Romano (1492/9–1546)
1534–41	*Last Judgment*, fresco in the Sistine Chapel, by Michelangelo
ca. 1535	*Madonna with the Long Neck* by Parmigianino (1503–40)
1536	Library of S. Marco, Venice, begun by Jacopo Sansovino (1486–1570)
1539–43	*Saltcellar of Francis I* by Benvenuto Cellini (1500–71)
ca. 1546	*Venus, Cupid, Time and Folly* by Bronzino (1503–72)
1546–64	Remodeling of St. Peter's by Michelangelo

n PAOLO VERONESE
Mars and Venus
United by Love

1550	*Lives of the Painters* (first edition), by Giorgio Vasari (1511–74) published
ca. 1567–70	Villa Rotunda, near Vicenza, by Andrea Palladio (1508–80)

1551	Palestrina (1526–94) appointed conductor at St. Peter's, Rome
1560	Uffizi, Florence, by Vasari, begun
1563	Escorial in Spain begun
1566–67	*Christ before Pilate*, Scuola di San Rocco, Venice, by Tintoretto (1518–94)
ca. 1555–64	*Rondanini Pietà* by Michelangelo
1565	S. Giorgio Maggiore, Venice, by Palladio
1568	Il Gesù, Rome, begun by Vignola
1570	*Christ Crowned with Thorns* by Titian
1573	*Christ in the House of Levi* by Paolo Veronese (ca. 1528–d. 1588)
1581	Torquato Tasso's *Gerusalemme Liberata*
1583	*The Rape of the Sabine Women*, by Giovanni Bologna
1585	*La Galatea* by Cervantes
1597–98	*The Calling of St. Matthew* by Caravaggio (1571–1610)
1597–1604	Frescoes in Palazzo Farnese, Rome, by Annibale Carracci (1560–1609)

1517	Martin Luther posts his 95 theses on door of castle church at Wittenberg
1519–58	Charles V, Holy Roman emperor; as Charles V, king of Spain (1516–56)
1521	Martin Luther excommunicated
1522–23	Pope Adrian VI
1523–34	Pope Clement VII
1524–26	Peasants War in Germany
1527	Sack of Rome by French
1532	Francisco Pizarro begins conquest of Peru
1533	Catherine de' Medici marries future French king Henry II
1533–84	Ivan IV ("the Terrible"), grand duke of Moscow, first Russian ruler to adopt title of czar
1534	Act of Separation makes Henry VIII head of Church of England
1534–49	Pope Paul III
1535	Sir Thomas More beheaded for refusing to accept Act of Separation
1536	John Calvin's *Institutes of the Christian Religion* completed in Basel
1537	Cosimo I de' Medici duke of Florence; in 1569 becomes grand duke of Tuscany (to 1574)
1540	Ignatius of Loyola founds Jesuit order
1543	*De revolutionibus orbium coelestium* by Nicholas Copernicus published
1543	*De humani corporis fabrica* by Andreas Vesalius
1545–63	Council of Trent; confronts crisis of Protestantism
1547–53	Edward VI, king of England
1547–59	Henry II, king of France

1550–55	Pope Julius III
1553–58	Mary, queen of England
1554	Queen Mary of England marries future King Philip I of Spain, restores papal supremacy in England
1555	Pope Marcellus II
1555	Charles V succeeded as emperor by Ferdinand I (to 1564); in 1558 succeeded as ruler in Low Countries and Spain by Philip II (to 1598)
1555–59	Pope Paul IV
1558–64	Ferdinand I, Holy Roman Emperor
1558–1603	Elizabeth I, queen of England
1559–60	Francis II, king of France
1559–65	Pope Pius IV
1560–74	King Charles IX of France
1561	Mary Queen of Scots, arrives in Edinburgh from France
1562–98	Huguenot wars in France
1564–76	Maximilian II, Holy Roman Emperor
1566–72	Pope Pius V (Saint Pius)
1568	Mary Queen of Scots, flees to England; imprisoned by Queen Elizabeth
1571	Battle of Lepanto ends Turkish naval supremacy
1572	Huguenots massacred on St. Bartholomew's Day in Paris
1572–85	Pope Gregory XIII
1574–89	Henry III, last Valois king of France
1576–1612	Rudolf II, Holy Roman Emperor
1580	Spanish conquer Portugal
1581	Northern provinces of the Netherlands, under William ("the Silent") of Orange, declare independence from Spain

p Celestial Globe with Clockwork

1582	Gregorian Calendar introduced
1584	William of Orange, stadtholder of the Netherlands, assassinated; succeeded by Maurice, prince of Nassau
1585–90	Pope Sixtus V
1587	Mary Queen of Scots, executed at Fotheringay
1588	British defeat Spanish Armada
1589–1610	Henry IV, first Bourbon king of France
1590	Pope Urban VII
1590–91	Pope Gregory XIV
1591	Pope Innocent IX
1592–1605	Pope Clement VIII
1598	Edict of Nantes gives Huguenots political equality
1598–1603	Boris Godunov, czar of Russia
1598–1621	Philip III, king of Spain

1519	Chateau of Chambord begun
1526	*Last Judgment* by Lucas Van Leyden (1494–1533)
1527	Francis I begins artistic program at Fontainebleau
1525–30	*Francis I* by Jean Clouet (act. by 1516–d. 1541)
1529	*The Battle of Issus* by Albrecht Altdorfer (ca. 1480–d. 1538)
1532	*Pantagruel* by François Rabelais
1536	*Prodigal Son* by Jan van Hemessen (act. ca. 1524–d. ca. 1564)
1539	*Henry VIII* by Holbein
1546	Court of Louvre, designed by Pierre Lescot (1515–78), begun
1548	*Fountain of the Nymphs* by Jean Goujon (ca. 1410–d. 1564/68)

o PIETER BRUEGEL THE ELDER
The Harvesters

1550	*Odes* by Ronsard
1553	*Tristan and Isolde* by Hans Sachs
1553	*Manners and Customs of the Turks* by Pieter Coeck (1502–50) published
1558	*Heptameron*, tales by Margaret of Navarre, published
1563	*Tomb of Henri II* by Germain Pilon (ca. 1530–90) and Francesco Primaticcio (1504–70)
1559	*Carnival and Lent* by Pieter Bruegel the Elder (act. by 1551–d. 1569)
1566	*Wedding Dance* by Bruegel
1588	*A Young Man Among Roses* by Nicholas Hilliard (ca. 1547–1619)
1595	*Romeo and Juliet* by William Shakespeare